WOMEN IN THE OFFICE

TRANSITIONS IN A GLOBAL ECONOMY

D1636058

WOMEN'S ISSUES PUBLISHING PROGRAM

Women
In the Office

TRANSITIONS IN A
GLOBAL ECONOMY

by

Ann Eyerman

SUMACH
PRESS

Canadian Cataloguing in Publication Data

Eyerman, Ann

Women in the office: transitions in a global economy

Includes bibliographical references and index.
ISBN 1-894549-03-1

1. Women white collar workers. 2. Women — Employment. I. Title.

HD6073.M39E93 2000 331.4'816513 C00-932129-2

Edited by Beth McAuley
Copyedited by Terra Page
Indexed by Jin Tan

Printed and bound in Canada by Webcom Ltd.
Cover photo of Janeth Avila

Published by

SUMACH PRESS

1415 Bathurst Street, Suite 202
Toronto, Canada M5R 3H8
sumachpress@on.aibn.com
www.sumachpress.com

Contents

Preface

THE ESSENCE OF THIS BOOK is the stories of twelve women office workers. The book comes out of my frustration of working in offices and never feeling like my voice was heard. I wanted to create a place where women office workers could tell their own stories about what was happening to them during this incredible time of technological and organizational change in our workplaces; a place where I could join with them in a discussion to explore what it is we are trying to voice. In particular, I wanted to understand what was happening to our sense of self in the workplace, our community, our occupation, and where to search for a voice that would give us some power in decisions made about our personal, social and economic well-being. This book is not intended as an attempt to advance the theoretical understanding of this subject nor is it meant to be a comprehensive treatment of any of the issues presented. It is an attempt to understand the issues important to women working in offices.

There are many people who contributed to this book coming together. I am grateful that I had the chance to talk to and get to know the eleven women whose stories are here. Their willingness to give their stories to this book made it all possible — it would never have happened without them. I shall always be indebted to Beth McAuley, my editor, who never let me forget how important it is that the voices of office workers be heard, and that I could write this book. Her confidence, dedication to this project, and her insightful and extensive editorial comments made this a better book than it ever could have been without her. The women at Times Change Women's Employment Service have been incredibly generous with their time, friendship and expertise during my five years here in Canada. In particular I want to thank Pat Bird and Holly Kirkconnell for their unwavering support and confidence that I had this book inside me. Gwen Johanson kept our office friendship and my memory alive.

Diane Hull pulled me more than once from the brink of total despair that this book would never be written; she also took time from work and home to read the manuscript and give me her insightful criticism. My teachers and friends, Gerda Wekerle and Deborah Barndt at York University, taught me the value of qualitative research and the importance of letting women's voices be heard, and provided continuing support from beginning to end. Susan Fenner at the International Association of Administrative Professionals, Cindia Cameron at 9to5, National Association of Working Women, and John Leopold and Sarah Zimmerman at Working Partnerships were all very open to my inquiries and generous with resources and enthusiasm for this project. Alice deWolff shared with me her considerable expertise and research about clerical workers in Canada. My time at the Office Workers' Career Centre focused my thinking and validated the need for this book. Jim Streb at the York University Staff Association provided invaluable insight about office workers and unions. Lorraine Zeller in California helped me throughout to keep my American perspective alongside my new Canadian one. Meg Luxton provided me a room of my own in which to begin thinking about this book, and Vee Farr supplied some good laughs and commiseration when the words wouldn't come. My old cat Mili used up all of her nine lives to accompany and comfort me until the end. Finally, I would like to thank my spouse, Ned Hagerman, for the endless hours of listening and discussing with me what must have seemed like every word in this book, his reading and re-reading of the manuscript, and the critical analysis he provided.

Desperately Seeking Survival:

WOMEN OFFICE WORKERS
FACE THEIR RESTRUCTURED
WORKPLACES

℘

EVERY DAY around the world millions of women get up, pull on pantyhose, pack lunches, take kids to daycare and go to work as support staff in offices. They are someone else's secretary, receptionist, teller, word processor, administrative assistant or perhaps "just the temp." Their income pays the rent, puts food on the table, pays for childcare, healthcare, pensions, clothing, education, transportation and, if there is anything left over, leisure. They are an important part of the economic and social well-being of their society. And they are now in the midst of a revolution that is changing their work world forever. It doesn't matter which sector they work in — law, banking, insurance, public service, universities, high-tech — if they're in an office, their experience is that of a changing and often degrading workplace. The women's stories that are here flush out the differences in those experiences.

From the time I was seventeen until I left my last job as a legal secretary in Washington, DC, at age forty-nine, I have spent most of my working life in this army of women. I, as many of these women, had been raised in North America in the 1950s and 1960s. It was an era of relative affluence, a shortage of labour power, high wages and low inflation; a time that some economic historians dubbed the

"Golden Era" in America.[1] Even acknowledging the disparity between the wages I could make doing my job compared with a male office worker, I felt spoiled.[2] A working-class girl from the wrong side of Cleveland Avenue could support herself on her labour. It was not a great deal of money to be sure, with no prestige or status attached, but it was always more than my warehouse-employed father would make. I had made the traditional leap from one generation of worker to the next.

That security came with certain expectations of our employers. I was taught — and believed — that if I was responsible, loyal and did the work as well as I could, I would in return receive a certain degree of respect from my employers and have a "good" job with benefits for as long as I wanted. In my case, this expectation was met, except perhaps for the respect, in my work as a secretary. It was not wonderful and interesting work particularly — but I always had a "good" job. With the salary that I earned doing it, I was able to maintain a certain degree of economic independence and well-being that allowed me to return to school in the evenings and earn a degree, take trips and send money home.

THE REVOLUTION IN OUR OFFICES

In the late 1980s and early 1990s things began to change. That was when I and most of the women in this group began experiencing wrenching changes to our sense of identity in the workplace. The massive organizational and technological changes of a globalizing economy were and are still shaking up the world of office workers — and here I am not referring to just anyone who works in an office, but office *support* workers. What has been called an "information revolution" can perhaps more correctly be named an "office revolution"[3] because there is no other workplace more affected by these changes than the office, and, consequently, no other segment of the workforce so seriously affected as office workers. It is a revolution not of our own making, but one that requires us to adjust to and become efficient in new work processes within workplace structures we've never encountered before. This is very serious business for us.

For many of us women who earn our living within offices, our work has changed beyond any recognition of what it was when most of us started our working careers. Joan, who works as a floater-secretary in a law firm and whose story comes up a little later, illustrates this beautifully when she talks of her own experience:

> It's no longer the "Take a letter, Miss Smith" secretaries of the past. The demands now are more like, "Create this database. Send this e-mail on the Internet. Look on the Internet for this. Pull up case law on Lawnet." There are all kinds of different skills that you never would have dreamed of having in the past.[4]

We are all caught at a transition point between our old work-places where our skills and values that we had were respected, and the new workplace where those same skills and values have not only become unnecessary or irrelevant, but in some cases unwelcome — especially when they challenge the new work structures or expectations. This puts us in a very vulnerable position. Loretta, making her way through piles and piles of insurance forms, finds that her own work ethic of "working hard, doing the best you can ... being reliable, being responsible" rubs against the expectations of her employer's time deadlines and intensifies her workload.[5] One is out of synch with the other. Lucia, currently a stay-at-home mom, left the workforce several years ago proud and secure in her fast and accurate typing skills; today these same skills are not enough to even get her in the door of a workplace.[6] And as my own co-workers at the law firm where we worked observed: now that they want quantity they don't care about quality. As our conscientiousness and careful typing skills are devalued in the name of productivity, perhaps the greatest harm done is that our own sense of self and our role within that workplace are devalued along with them and replaced with something too foreign and new to feel comfortable.

This new workplace also demands that we almost constantly upgrade our skills — often at our own expense — in order to keep up with technology. We have no say in the decisions affecting how our tools change (many times not to any great advantage), yet it becomes our responsibility to obtain the necessary knowledge and ability that might enable us to keep a job or to find work in this new

economy. The term "lifelong learning" has taken on a sinister, technological meaning. It is even more sinister for anyone who cannot afford to take the courses. It plays out like a riddle: without the training you can't get a job; without a job you don't have the money to get the training.

For many of us, and especially for older women, there is little that remains about our workplaces and our work that is familiar. The physical location where we work can be anywhere — at home, in a telecentre, in an overcrowded office; the hours of our workday are flexible within a 24-hour shift; and our contract with our employers can take any variety of shapes: part-time, temporary, contract, full-time. These changes have completely altered whatever relationship we had with our work and whatever control, albeit minimum, that we had over our economic well-being. This carries even more significance if work is, as Studs Terkel suggests, "about daily meaning as well as daily bread."[7]

Whether we like it or not, we in the workforce have also been forced to restructure and reorganize, and to adjust our expectations to fit the new structure. One of the old values we once knew was some sense of reciprocity — you work for the company and the company guarantees a full-time, secure income. Today, you work for the company when it needs you. If it doesn't need you, it doesn't have to pay you or worry about you. For all of our efforts, we can no longer expect to have one, full-time, lifelong job. In fact, in corporate culture, the word "security" is mocked. It is held in so much disdain that if we use it as a defence at the time of our being downsized out of a job, the firing becomes not the result of managerial decisions, but rather of our stupidity for holding onto such an old-fashioned idea.[8] Hence, we now know our working lives will be a series of many jobs — part-time, contractual — and quite possibly many jobs at once.

We workers are caught smack dab in the middle of all of these changes. Office workers have always expected a certain amount of change in how we did our work and what our workplace looked like. But it was manageable. Then there came the double whammy of technology and globalization. I don't think we were prepared for just

how dramatic and traumatic these technological and restructuring changes would prove to be, and the amount of additional stress and pressure that would be put on us to perform within the new workplace.

THE GLOBAL WORKFORCE

It is impossible to ignore the role that globalization has had on all of these changes in our workplaces. It used to be, and in some cases still is, that the company you worked for set the work standards, monitored your productivity, offered employee benefits packages. But with increasing competition, companies merged and created "super" companies or sold out to transnational corporations. These larger companies created workplace infrastructures that put profit over people. Workers are no longer seen as long-term, or as "part of a family" or as part of a "workforce." They are seen as short-term, flexible workers who are hired to meet the needs of companies/corporations driven by the ethic of restructuring to cut costs and maximize profits.

In today's marketplace, decisions that directly affect our economic well-being and security as office workers are being dictated by this "new transnational corporate hegemony."[9] Corporate interests are setting the standards not only within the corporations themselves, but also throughout society as a whole in order to participate in this new era of global competition. The global marketplace demands greater emphasis on competition and productivity, and less emphasis on workplace standards and economic justice. As political scientist Isabella Bakker writes, globalization "requires increased international competition between countries for investment and production, a greater emphasis on trade, and less government spending and regulation of the economy."[10] What that translates into in our everyday life is that countries, governments and corporations place greater importance on market competitiveness and flexibility. The corporate agenda requires just about every institution in our society to reorganize its internal structure in order to participate in the global economy. If an institution or company doesn't, it may find itself on the wayside, a victim of its own inability to change.

Globalizing Women in the Office

It was out of my own turmoil of trying to deal with these issues that this book was born. I knew what I had gone through and what I was feeling about my recent experience in the restructured law firm. And, for the most part, I knew what the other women in my office experienced as a result of the technological and organizational restructuring. What I didn't know was how other women office workers were feeling. I was curious to know how globalization and the technological revolution was affecting them. When I married my old friend and moved to Toronto in 1995, I didn't have a work permit for the first six months that I was here, so I couldn't look for work in a legal office — or in any other kind of workplace, for that matter. Instead, I decided to go back to school to pursue these questions through a master's degree in environmental studies. Living in Toronto gave me the ideal opportunity for comparing the experiences of women office workers in another major North American metropolitan area with my own. This had the added appeal in that I arrived here knowing no one except my spouse and so had no preconceptions or knowledge of what these women's experiences might be. The downside of this was that since I wasn't working here, knew no one, had no established networks of friends or colleagues, I had to search for a place to find women office workers.

This search brought me to the doors of Times Change Women's Employment Service. Times Change was founded in 1974 by a grassroots group of women wanting to provide employment services to women. Times Change has always been for all women, and only women, and has been run collectively — all decisions are made collectively with each member of the staff having equal say. There is no director and everyone shares the workload and gets paid the same amount. The emphasis at this organization has been and still is on helping women find secure and satisfying work. It concentrates first on giving women research and interview tools and helps them map out career paths. These tools help women build their sense of self-esteem and self-worth, which in turn guide their employment search. For my purposes, it was ideal; I could volunteer my time and skills,

and have an opportunity to meet women office workers who came in to use the services.

I quickly became part of this organization — a welcome occurrence for me since I had no other place where I felt connection or belonging. Here I was the volunteer receptionist, doing a job that I was very familiar with and in an environment that was both respectful and rewarding for the clients and the collective members. I remember during my first week there thinking how long it had been since I worked at a place where people laughed out loud in the hallways.

My volunteer work put me in the role of participant as well as researcher. The work gave me everything I needed for my research study into women office workers. It was here that I decided to interview women as part of my research — so I could hear about their experiences directly from them. Clients would come in to attend workshops or find out about the services, and we would talk and share our stories of workplaces and bosses, downsizing and technology. They helped ease my entry into the Canadian world of office work as much as I helped ease their entry into Times Change.

It was out of these experiences and my continuing work with Times Change that I met most of the women whose stories appear in this book. Joan and Lucia and I attended the same Career Planning workshop for five weeks in the spring of 1996. I met Meg, Norma and Loretta through their counsellors, who introduced them to me. I met Judith and Daphnie in 1998 while I was working at the resource centre at Times Change; and Louise, whom I have met several times over the years, has been a long-time user of the services at Times Change. I met Sam through a personal contact but she, too, had been to Times Change fifteen years before. Only Zoë and Stephanie have not used the services at Times Change, although Stephanie is now employed by the Office Workers' Career Centre, of which Times Change is a partner.

These women by no means represent a scientific sampling of all women office workers. Nor do they represent a particular sector or age group or ethnic background. They are as diverse as the city where they live. Joan was born in England and immigrated to Canada with her family when she was eleven. Daphnie is an African-Canadian

who spent much of her growing up travelling with her family to different locations where her father was posted as a diplomat. Stephanie came to Canada as a teenager from Ecuador so had to adjust to a new language as well as a new culture. Lucia is a first generation Canadian-Italian who is now working as a stay-at-home mom. Zoë is a Quebecoise who moved to Ontario for a chance to learn English. Norma grew up in a large Irish-Canadian family and moved from Montreal to the West to work outdoors. Judith, also from Montreal, migrated to Toronto for work after her epilepsy forced her out of university. Of those born in Ontario, Louise, who has a Scottish background, moved to the big city of Toronto from a nearby small town in Ontario. Sam, also from a Scottish background, was born and raised in Toronto where she has spent all of her life, except for an extended stay in Vancouver as a young woman. Meg grew up in Ontario, but spoke only French in the home and English only after starting school. And finally, Loretta, who is of Ukranian descent, has, like Sam, spent her life in Toronto — her extended stay away was to go to Europe for three months as a young woman. What they do have in common is that office work has been their main means of support now or at some time in their lives. As well, they all have had experiences with the technological and organizational changes in their workplaces.

Each of these eleven women has given me permission to use her story here — Meg, Joan, Norma, Loretta and Lucia were interviewed in 1997 and their stories were part of my master's paper; they agreed to have them reappear in this book. The remaining women were interviewed in 1999. The story-gathering has been an interactive process throughout. These women know as much about my situation as I know about theirs. We have tried to have a mutual exploration and dialogue between us about our work and our sense of our selves within that work. After the initial interviews, I continued to have e-mail and verbal communication with the women I could still contact.

I don't believe that any of these eleven women, like most of the women I've worked with in offices over the years, would describe herself as a "feminist," nor would she have been particularly

interested in participating in something called "feminist research." Yet I'm convinced they would all relate to Rebecca West when she said "people call me a feminist whenever I express sentiments that differentiate me from a doormat or a prostitute."[11] I think these women would describe that as the "I'm not a feminist but ... " syndrome. I am not here to put titles on anyone, but I think it safe to say that each of us who participated in this research did appreciate the very feminist-based, mutual give-and-take of the process, and the value of that process. Notwithstanding the fact that I remained the researcher and it is my interpretation of these stories that appears here, the interviews were open-ended with no preconceived set of questions. Each of the women talked about those issues that were most important to her own economic and personal well-being.

There have been some spontaneous meetings after the initial interviews. I have run into Louise, Judith, Stephanie and Lucia at various Times Change functions where we have caught up. I met Sam one day having her smoke break outside an office building and we talked about her latest contract job. Joan and Meg have called me often to keep me current on childcare woes and working with lawyers. I see Zoë each time I visit the university campus. These meetings have allowed us to have a continuing dialogue about the issues presented throughout the book.

There was really no way that I could, or would have wanted to, remove my own experiences from this research process — these women emphasized the need and worth of such a decision. I learned that individual lives are complex things and that the particular work issues I was concerned with could not be isolated, they had to become part of the woman's entire story.[12]

Most of these women, and I include myself in this group, were shy about telling their stories initially. "What have I got to say that's important?" they asked me. This undervaluing of our own stories helps others, I believe, to put us into the "just the office worker" status. But it's not surprising that we say it; we're women after all. Also, when was the last time we were asked our opinion about our own work? It seems that women — unless they are one of the Hillarys (Clinton or Weston)[13] — are not often invited to share their

thoughts on the state of the economy, even if that economy is their own. Office workers are one of the least likely groups to be asked about such matters — even though we number in the millions and form one of the largest employment groups in any economy. We are a very invisible, silent and underrepresented group of workers, and we are more used to having people from above (human resources, management, bosses) tell us what we think about changes that affect our lives directly rather than us telling them what we think. The very nature of our work makes us invisible; we are the behind-the-scenes workers, the support staff hired to hold up the infrastructure so the people we work for can get their work done. Some have called us the "glue" of an organization and anyone knows that if glue is used correctly, you don't see it.

We are so invisible, in fact, that thousands of us can be displaced or downsized and lose our jobs and no one knows about it. For example, in Toronto's metropolitan area, somewhere in the neighbourhood of 92,000 clerical jobs were lost over a ten-year period.[14] That is a staggering number but it still doesn't make front page news. There might be occasional stories of so many bank jobs being cut or telephone operators' work being outsourced from which we could add up the numbers ourselves. Being given the news in dribs and drabs is rather alarming, but not overwhelming. It may be sad to read about 2,400 telephone operators losing their jobs, but it does not give us a clear picture of the sheer massiveness of this revolution in office work and the displacement of people because of it.[15]

For all of these reasons, I knew that this book had to resonate with the voices of real women office workers if my inquiry was to hold even a kernel of truth about the situation. Ninety-two thousand is not just a number; it represents many stories of many people's lives being disrupted — sometimes for the better, but more often for the worse. Had they experienced what I experienced? How will we ever know? Even if I've only spoken with eleven others — a mere drop in the bucket — their stories enlightened this book and me. I knew that it was only through conversation with other office workers that I could tell if my reaction to what I experienced at that law firm was indeed just "in my head," perhaps a result of my bad attitude, or in

fact a valid observation of a revolution afoot in my work world. And I wanted to know how other women were coping with this in their own lives.

The importance of gathering oral histories of women when involved in this type of research is obvious. Who else can speak for them? But it is something more than even the words; it is where the words can go. As one feminist academic wrote:

> [T]he process of women telling their own stories creates new material about women, validates women's experience, enhances communications among women, discovers women's roots, and develops a previously denied sense of continuity.[16]

I can't think of a group of women who are more in need of this kind of validation and who desperately need a sense of continuity in their work lives than women office workers. Office work is so undervalued both for the recognition due to the position and because the monetary earnings are often so low. Each woman's participation in this book is a validation of her own work within an office and a validation for other office workers whose stories have not been gathered. Perhaps that is why each woman thanked me for listening to her, as I thanked her for talking to me.

So we present our stories in the hopes that other office workers may find some of their own concerns and issues echoed here. We need to speak to one another. We also need to send our voices out to the experts, human resources specialists, policymakers and organizers and ask them to listen closely to us. We need their help so we can change the seemingly inevitable downward spiral of our work lives.

This book is an attempt to help stop that downward spiral. Chapter 1 and chapter 2 explain why this downward spiral is happening and who is benefiting from it. Chapter 3 explores the growing world of contingency work and what that means for the economic well-being of women workers. Chapter 4 looks at the ramifications of all these changes on women's health. And chapter 5 provides examples of some organizations that are trying to help women workers turn it around. Interspersed throughout these chapters are the eleven women's stories — Loretta, Joan, Stephanie, Zoë, Norma, Judith, Meg, Sam, Louise, Daphnie and Lucia — and my own story. Each tells her own

individual experience of working in today's offices. Collectively, our words form the core from which the rest of this book emerged.

My Story

❧

LESSONS FROM LAW

*I am in my early fifties. I moved to Toronto
from the States five years ago when I decided to
marry a Canadian whom I had met thirty years
before. I have found the change from one culture
to the next strangely familiar, yet very different.
The move has helped me see the power of my homeland
in this global economy from a different perspective.*

I HAVE ALWAYS earned my living as an office worker. It was a
profession I slipped into when, at St. Francis de Sales High
School in Columbus, Ohio, the good nuns decided that
despite my academic achievements, a working-class girl like
me should not be preparing for university, but for the office. I
did go to university, immediately after high school, but not as
a student. I got a job as a typist for the History Department at
Ohio State.

This was in 1964 and I was seventeen years old; I got the
position largely because two of my sisters already worked on
campus and were well respected. It was a wonderful first job.
It was here that I learned how to work and where I
formed my values and attitudes that I carried everywhere
thereafter: work hard, do the best you can, be responsible and
respect what you do. This experience left a lasting memory of
what good and meaningful work could be. But at Ohio State I
was also taught my first lesson about the status of office work-
ers in the eyes of others. While walking across campus early in

a new term, two male students stopped beside me, they were lost: "Why don't you ask her?" said one. "She wouldn't know, she's an offie," said his friend.

In the late 1960s, I left Columbus for the big city of Washington, DC, to become a civil servant in the federal government. I worked at the Smithsonian Institution for two years until my boss made a pass at me and I decided it was time to move on. I wasn't afraid to leave a job then. I was confident in the knowledge that at that time I could get a job almost anywhere because I knew how to type — and I did. I moved in and out of offices all through my twenties and thirties. I never made a great deal of money during that period but I got by, mainly because I was operating on a budget that did not include a car, closets full of clothes or a fancy apartment. The money I made and the skills I had gave me a freedom to pick up and leave a job when the spirit moved me (it was the seventies with lots of spirits around). I travelled a lot, too, knowing I could find another position on my return. However, in the early 1980s when I returned to Washington after an extended absence, I decided that I had to be a little more serious about work and my future since I was growing older. Thoughts of retirement started to creep into my thinking.

I took my labour power to the highest bidder at the time: law firms. Having had no legal experience, I managed to get my foot in the door through temporary assignments. I worked for this same, large law firm for over a year before they hired me as a permanent employee. I remember, during my interview for this secretarial position, the lawyer asked, "Would you be able to make a commitment to stay for at least two years?" I told him no one could say what she would be doing in two years, so I compromised and gave him a year's commitment. I stayed there for fourteen and a half years!

It was a good place to work when I first started there. The office still enjoyed the laid-back atmosphere of the 1970s. The partners were young and they were making good money. I had, through my work as a temp, met a variety of people in the firm so I was already part of that informal culture where I learned how things got done, who to avoid and who to get on your side. There was never any question about the hierarchical reality of them versus us, but I could exercise my work values and express my attitudes and if they weren't accepted, my right to have them was respected.

This firm was not known for taking revolutionary steps quickly, so computer technology didn't make its way into our work lives until the late 1980s. That initial encounter was a friendly one. My new personal computer did not change the content of my job nor my own style and attitude about doing it. My own values about good work and responsibility stayed in tact; I just had a faster way of getting the work finished. Neither did this technology change the environment of my workplace. Initially, there was some complaining about the "monsters" on our desks, but those machines did not change the basic culture of our world. People still took time to help one another with work crunches; there were softball games that involved both attorneys and staff; secretaries still went out to lunch; and, when you walked down the halls, you could still hear laughter. I still had a good, well paid, and secure job.

It was really not until the early 1990s that this "firm with the heart" became a foreign territory for many of its workers, especially the older ones. By now there had been a considerable outlay of cash for technology to upgrade most if not all of the work functions. The outlay had to be recouped if the partners were to maintain their comfortable profits of the 1980s and stay competitive in their fee structure. They would have to cut operating costs somewhere. Staff became that somewhere.

The first thing the partners did was to hire a hard-line, no nonsense administrator (that is, she wasn't afraid to challenge anyone) as the executive director. We secretaries came to know our new boss by the scent of her perfume, often left behind in our offices during her rounds supposedly "to get to know the firm better." We suspected the real reason was to check on our workload and efficiency. There was a general unease that something was going to happen, we just didn't know what.

After about a year into her regime, the executive director sent each of us non-professional staff — secretaries, duplicating personnel, housekeepers, messengers, accounting personnel and receptionists — a memorandum advising us that we were to attend a "town meeting" on a certain date and at a certain time. Attendance was mandatory. Lawyers were given separate presentations and then sworn to secrecy until the staff had attended their own meetings.

Town meetings are usually touted as being "democracy in action" where all stakeholders have a say in the issues that affect them; that was not the case here. I attended my required "town meeting" with about one hundred of my fellow workers. The meeting was held in the partners' conference room, which was dominated by a U-shaped table seating about seventy people, the rest of us stood against the walls or sat on the floor. The room was darkened. There were no handouts.

As the head of human resources flipped overheads to illustrate the points, the executive director methodically and unemotionally changed each of our work lives. There were no members of the firm's executive committee or the partnership in attendance. No bosses were there to give us their support. Among the changes called for in the name of maintaining a competitive edge, were

• an increase in hours (with no increase in pay);

- a re-evaluation of secretarial assignments (computerization now made it feasible for a secretary to work for more than one or two lawyers);
- a decrease in the size of the word processing department; and
- an outsourcing of messenger and duplicating services.

There was no time for questions and answers in this town meeting. The presentation used up all of the available time and there were two meetings scheduled one after the other. The meetings were held on a Friday; the changes would become effective the following Monday.

I remember standing against the back wall of that large room feeling an overwhelming sense of anger and powerlessness. Throughout the twelve years I had been with this firm, I had always been an outspoken critic of their policies, which were made, I always thought, in the name of greed not progress. I had been called an angry, loud-mouthed socialist for my views, but I had been tolerated because I did good work for the firm. This town meeting presented a future of changes that was too overwhelming for my anger to find voice.

At that time, the average secretary had worked at this firm for at least five years, the majority for ten or more. For all of us there *was* something to fear. The "golden chains" of pension, high salaries, private offices, long vacations and "secure" jobs were being shaken. Also, it did not require high mathematics to figure out that if one secretary now worked for two lawyers and would soon be working for three to five lawyers, that the firm would soon need fewer secretaries.

There was resistance. A small but sharp group of secretaries (with the help of an accountant) calculated the profit to the firm that would come from the additional hours of secretarial work that *would not* be compensated:

1½ hour added to each day
2 ½ hours to a week
10 hours to a month
120 hours to a year

At an average of $20 per hour per secretary	$2,400.00
Add 10 hours of lost pension and leave	$1,200.00
Total "donated" to firm by each secretary	$3,600.00
Total for approximately 40 secretaries	$144,000.00

This was not an astronomic sum of money for the partnership, but it was for each of us being told to, in effect, "volunteer" one hundred and twenty hours a year to this firm by working that extra half-hour with no extra pay. With this information in hand, two secretaries took it upon themselves to call each of the other secretaries in the firm to ask them to sign a petition demanding a reconsideration of these new policies. The extra hours were not the issue; not being compensated for them was. There was strong but not unanimous support for the petition. The staff at this law firm had never been particularly cohesive; the firm was big and there were too many suspicions about salaries and perks to certain of the staff. (The "golden chains" also served to keep people's mouths shut.) I remember feeling a little flip of my stomach when I added my name; for the first time in my working career, I felt vulnerable.

The two women who had started the phone campaign met with the partners on the executive committee, who claimed that they had never had these policies explained to them by the executive director in just this way (lawyers do not read the small print). While the firm was not willing to negotiate pay for the additional hours of work, they did concede that they would add additional funds to our pension contributions and leave time. This was done only for the current workers and not for any future workers.

In the immediate aftermath, there was a slowdown of

work — secretaries walked rather than ran to copiers; there were unspoken warnings about disrupting the work of the firm; and fewer names appeared on the overtime list. I was spared much of the disruption because I was secretary to a senior partner who did not want her particular boat rocked. She was no more willing now than before to share her secretary and felt that the income she produced through her work was enough to warrant such an attitude.

Soon after the town meetings, the messenger services and the duplicating department were contracted out to other companies. People who had been employees of the firm for years were now hired by outside concerns. The messengers no longer had health coverage, pensions or full-time hours, but they were still invited to the firm's holiday party! Some secretaries were reassigned to work in different pairing schemes. The lawyers could use their "co-operation" in trying out these new arrangements as "business development" points towards their year-end compensation, while the secretaries involved had no choice.

All of us who worked as the support staff were almost instantly forced to change the established and respected roles that we had played within this organization, some for as many as twenty-five years. There was a deterioration of the confidence and respect that many of us had for our work and workplace. With the increase in our workload and the restructuring of the office, we no longer had the time to give extra care to our jobs and we began to feel that even less value was placed upon what we did. I remember one woman saying to me, "They used to want quality, now they just want quantity." The accumulated knowledge and skills of a lifetime of working were no longer valued.

There was also some ambiguity as to just what the role of a secretary was to be in this new workplace. Our lawyer bosses teetered on the fence between being true believers in the new

leaner and meaner system, and wanting the old times back when we were their "friends" who did those little extra things like paying personal bills or typing papers for their student-children. It was no wonder there was an increase in the number of secretaries who had a glass of wine with their lunch!

In the years following the town meetings, there was always an undercurrent of suspicion and distrust — what would the partnership do next? With the firm's late entry and big outlay into the computerized world, we knew that we would be required to learn more and more to keep up with the technology so they could keep up with the competition. We could also see that the younger people who were hired were much more adept at using computers than we older workers were. So we suffered the double whammy of knowing that if we didn't keep up technologically, there was always a younger, more technically experienced worker to take our place. But the belief that we could actually lose our job was far from our reality. It hadn't sunk in — we couldn't believe it. I think the most difficult task of the new administrator was to convince us of our new vulnerability in this workplace. Eventually, we began to understand that we were all as disposable as the Kleenex on our desks.

In 1994, a one-time-only buyout package was offered to secretaries. It was obvious to all that the proposal was designed to get rid of older workers, the ones who were costing the firm too much in pensions, leave and salary, and perhaps most importantly, whose memories were disrupting the new culture of the firm. There was a certain amount of sardonic humour circulating around lunchrooms and offices, as secretaries calculated their "worth" by the formula outlined in the package.

Of the twenty packages given out, three were taken by women close to retirement for whom this was a real windfall. Savvy younger women who had new jobs already lined up

took the majority of the remaining packages. For most of us ten-year-plus workers, the amount of money offered was not enough to cut the chains. We knew what we would lose by leaving there and starting new somewhere else. We just did not have the energy to start all over again.

Change itself was not the culprit here; workers have always dealt with change. It was how the change was planned and carried out. The changes in this law firm were done deeds before the town meetings were held. As workers, we were offered no real knowledge or information to help us understand and challenge the proposed changes in our work lives; any power or control (even if mythical) that we had felt we had over our lives in this firm disappeared. Even worse, any understanding of or solution to our unstable conditions, if it were to be forthcoming, would come from the same management that was causing this distress.

At the time, I felt betrayed by these people who had always considered the firm as "family." It never really was, but it at least had been a good place to work. I stopped participating in firm functions, and from that day to the day of my departure from the firm when I married and moved to Canada, these three signs were on the wall over my computer:

120
— For all those unpaid hours;
and to remind me to bill every extra minute I worked.

THEY ARE NOT YOUR FRIENDS!
— A message from a co-worker declaring the "firm with the heart" dead.

REMEMBER THE HUNTSVILLE WOMEN!
— A memorial to five insurance clerks in Huntsville, Alabama, who ignored hurricane warnings and stayed to finish the job. They were all killed. A powerful reminder of priorities.[1]

But Can She Type?
But Does It Matter?

EFFECTS OF THE
TECHNOLOGICAL REVOLUTION

2

"The Invisible Secretary"

*The voice-driven Wildfire Personal Assistant
is programmed to answer your phone with a
perky pleasing female voice that can actually
understand speech. It can also understand you.*[1]

COMPUTER TECHNOLOGY has revolutionized our offices in ways we
have never experienced before. There is no workplace anywhere that
has been more affected by this upheaval than the office. The com-
puter did not just replace our typewriter as the tool of our trade, it
transformed the structure of our work itself. For those of us who
work in offices, this marked the first really profound and dramatic
change in not only how we got our work done, but also in our very
relationship with our work and our work environment. It changed
our language, our consciousness and even our identity within that
workplace — disturbing the "ecology of our work," as one writer has
called it.[2] Technology isn't just the nuts and bolts of the machine; it
"involves organization, procedures, symbols, new words, equations,
and, most of all a mindset."[3] In other words, technology touches
every aspect of our work lives.

We are certainly not the first workers in history to experience such an upheaval. This current technological revolution is comparable to that of the Industrial Revolution that altered everything for workers at that time. It tore people and their work values out of the local craft industries and forced them into the mechanized factory systems. It was traumatic for the workers involved, just as the current revolution is for us. Our lives have been as dramatically changed by the information revolution of today as the mill workers' lives were changed at the time of the Industrial Revolution. Alice deWolff, who has done several studies on the future of clerical work in Canada, and who speaks often to groups of office workers, tries to emphasize the importance of our role in the new economy by making these comparisons to the Industrial Revolution. For deWolff, the similarities are worth noting:

> Look, you're in the midst of something that's pretty much the equivalent of an Industrial Revolution, and you are the front line in it. Think of yourselves as the wool mill workers of the previous Industrial Revolution. What's happening to your work is pretty close to [being] that profound. Where you're working is changing: who you're working with [and] the pace at which you're doing it [are changing]; and the technology is completely transforming itself. The kind of change, the rate of change, all of that is just about as big as it was when you think of the Industrial Revolution … Something very big is going on here — no wonder it feels so chaotic.[4]

It is important that we remember that. As the mass production of the factory system destroyed the crafts workplace and its culture, so has the technological innovations of today altered our workplaces. The machines in the factory allowed the work to be speeded up and the workers to be monitored, so too do computers in our offices allow our employers to expect more work in less time and to check our productivity without us even being aware of it. And in both cases — the information revolution of today and the Industrial Revolution of then — work values that were interlaced with those of the broader community are replaced by values that are reduced to how the bottom line can be achieved most efficiently.

When computers were first introduced, those of us working in offices weren't bothered so much about changing from one tool to the next. Our tools have always been in a state of flux. Those of us who learned to type in the 1960s pounded out speed practices and keyboard exercises on upright manual typewriters. As electric models made their way into our work lives, we learned to adjust our touch and speed to the sensitive feel of that machine. Then there were the Selectric typewriters with their spinning balls and even memory typewriters, which I admit I never mastered. Some of the transformations in office work were easier and more pleasant than others — for instance, trading carbon paper and Gestetner stencils for photocopiers was certainly one of those. I don't think there is an office worker in the world who would disagree. All of these "work-related" technologies did indeed make our work easier.[5] Furthermore, no matter which new machine was introduced, our basic understanding of the work process and our ability to apply our skills to the new machine saw us through the change — even though as with any change, there was a period of adjustment, inefficiency and finally, mastery.

But computer technology did not respect our old skills. Almost overnight, skills that had seen us through years of changes in our workplaces, no longer allowed us to do our work. We, like those factory workers, had to adapt to the machines that now controlled our work and our work production. Sure the basic keyboard was retained on the computer for easier transition, so our typing skills were of use. But unlike our typewriter that basically required us only to flip a switch and it was ready for us, computer technology demanded much more of *us* just to be able to use *it*. There was a whole new language to learn and apply — Control-F2, reveal codes, input, directories, log-off. And the learning never stops — mastery is never reached because there's always a new software being developed to make us more efficient and productive. So our work becomes as much about the technology and learning it, as it is about producing a good work product.

In pre-computer days there was a direct connection between we, the users, the machine — typewriter, Dictaphone, telephone, adding machine — and the final product. The more sophisticated the

technology, the more removed we become from the tool and our control over our own productivity. We may still be expected to take dictation or be given letters to type, but now the machines are processing the work, not us. And, because of this, it is assumed that we should be able to do more in less time. The technology dictates the amount of output, not those of us doing the work. We are valued more for the volume we can get out of the new automated tool than for the quality of work that we put into it.

The technological revolution in our offices also demanded that we change our attitudes. Values that we carried around with us — like those my working-class father taught to me — were now outmoded in this new workplace. New technology required new mindsets in changing workplaces. Our old values were swept away in the same storm that nullified our old skills. Values like "doing the best you can" conflicted with the demand for more productivity. Time did not allow for quality, only quantity. "Working hard" was certainly still in place, but it was dictated by the technology and not by us. Those of us who try to hold onto our old values are rewarded not with respect, but with more work.

When we walked into our pre-computer workplaces, we had unique skills as technological workers and as organizers of the office — skills not shared by our employers. We had low status jobs, but ones that played an intricate role in the workplace. Even though we, and most others, didn't acknowledge this, it was true. It was through not only our typing skills, but our intellectual and tacit knowledge — all that information stored in us through years of living — that produced the work and sustained the workplace culture. It was possible and valuable to use our creative as well as our production skills. There was more to it than just typing; enough so that our work values, such as doing the best we can and working hard, could be realized and respected. Now it seems, the value is placed on the technology, not on those of us who operate that technology. The tool, not the user, has become the best and only show in town. Rather than being a means to an end, computer technology all too often becomes the end in itself.

Everything Old Is New Again

Although it is the technological revolution of today that has most dramatically altered our work and our workplaces, new tools, efficiency and a promised increased productivity have always been used as good reasons by employers to rearrange our lives within our workplaces. Office work, like the factory, was particularly inviting for the introduction and application of new technologies. Most striking was the invention of the typewriter in the late nineteenth century; this heralded not only a new tool for the office, but a new workforce as well. Women were now hired as operators of the typing machines or "type-writers" — men still held the secretarial positions and the status and a better paycheque that went with them. For women, however, especially working-class women, these jobs offered another source of work that paid better and was cleaner than work in a factory or in cleaning houses.[6] My mother, who graduated from high school in 1927 with a two-year commercial degree, was able to take her typing skills and shorthand to the Roberts Cloak House at the corner of Gay and High Streets in Columbus, Ohio. She was not doing what she wanted to do, which was to go to Ohio State University, but she was able to make an income in a field that just a few years earlier was not even open to her.

As the bureaucracies ballooned and the paperwork increased in proportion, those male secretaries took their skills and status and moved into the new managerial slots. However, as the structure grew, "it was thought 'wasteful' ... to have a manager spend time typing letters, opening mail, sending parcels, making travel arrangements, answering the telephone and so on, when these duties could be performed by labor power hired at anywhere from one-third to one-fiftieth of the remuneration of the manager."[7] So the "type-writers" became the secretaries — minus the status and the paycheque of their male predecessors, of course. But it was still a better job than most that were open to women at that time.

From early on the new tool — the typewriter — made further change possible. Work of these secretaries, like my mother, that could be routinized and mechanized (typing form letters or doing data

entry) began to be removed from the "front office" and delegated to workers who for the most part worked out of sight in interior spaces or basements. The "front office" worker continued to do things that at that point could not be mechanized — answering the telephone, making reservations, keeping appointment books or dealing with clients who passed through the front office. By the 1960s, most major North American corporations had these "back offices" and called them "typing pools."[8]

The typing pool allowed for factory-like conditions to be imposed on the people working in them — crowded spaces, regulated breaks, frequently no windows — so that the typists could produce large quantities of routine work. The woman typing her day away was required to be fast and accurate. She wasn't supposed to display any other skills such as decision-making or prioritizing the work — those were out of her control. She was paid — not very much money — to turn out a lot of work during her eight hours there. These became easy entry points into office careers for many young women straight out of high school.

When I was in high school, one of the typing class's field trips was to a large insurance company in Columbus to see what our lives would be like as entry-level workers. A guide met us when we arrived at the lobby of this huge building downtown. She did not take us on the "up" elevator where the offices were, but rather down to the base-ment. Like the other back office workplaces in this company — the mail room and copy centre — the typing pool was out of sight of any visitors to the company. As I remember, the typing pool was a largish room filled with the noise of clacking typewriter keys and the ding of the bells. I don't remember how many people were working there — but I do remember they were all young women like me. For working-class girls, this was considered a good starting job with a future. You could literally move up and out of the typing pool and into the secretarial offices. I knew I didn't want to spend my time there even with the opportunities, and went instead to the job at Ohio State.

But I did go to work in the typing pool of an insurance com-pany, though it was much later in my career. In 1981, after a ten-year

absence, I returned to the US and to office work. I turned to "Kelly Girls"[9] in search of a job. My skills were very rusty by this time and I had no experience with word processing at all. So they sent me to a typing pool in an insurance company. I was the only one on a typewriter in that back office — the other ten or twelve operators were training on word processors. From nine a.m. to five p.m. every day we all typed form letters. It was very boring. There was no interaction with our work since we were just producing the same thing over and over again. I tried to relieve the monotony by making it into a race between me on the typewriter and the other women on the word processors. But since we each had our quota of letters to produce, my efforts failed; there wasn't much time for socializing. We couldn't even stare out the window since there wasn't one in the room!

Women in the "back office," like all of us in that typing pool, became and were often considered merely extensions of our machines — first, of typewriters and then in the 1970s and 1980s, of computers. In the early days of computerization, the women in the back offices were often the first to be trained on the new technology as their jobs became integrated with the new machines. Eventually, typing pools became word processing centres. For a short period of time, this knowledge gave these women a certain status and recognition within an organization. Their working conditions, however, did not change dramatically — they were still in small, windowless rooms and they still earned less than the front office secretaries. And they did not enjoy the status of their new skills for long — many of them were soon to lose their jobs. As many of us who work in offices know, some of the user-friendly technology has the very unfriendly effect of putting the user out of a job.

New Technology — New Roles

Computer technology causes a reassessment of all of our roles in the office, whether in banks or law offices, universities or insurance companies. As the technology of the typewriter created a new set of roles, so too would computer technology demand others. In my own experience, it wasn't until 1987, several years after I moved from the typing pool of the insurance company to the law firm, that my work

became computerized and I was to appreciate this fact more. It was then that the significance of this back office/front office division of duties became more relevant to my life.

When I was being trained on the new computers, I was told, like many other office workers, that this technology would relieve me of boring and routine work, and free me up to pursue interesting and exciting projects. (They never said where exactly I was going to find these in a law firm.) The myth being perpetuated was that technology would be a blessing for all; management would be able to increase productivity and efficiency, and all levels of workers would have the time to take on more rewarding and challenging work. That would indeed have benefited everyone.

I did find the initial training on the technology "interesting and challenging work" — I had been jealous of the word processors' ability to hit a few keys and send a document to print. However, what I and many others discovered after the initial fear and excitement of learning something new wore off, was that rather than eliminate our "boring and tedious work," the computer itself *transformed* much of what had been interesting about our job into "boring and tedious work." For instance, many secretaries like myself who knew shorthand were paid slightly more than other secretaries because that skill carried with it an implied knowledge of English language usage. In addition, all of us used our proofreading, spelling and grammar skills that we had developed throughout our work history. But with computerization, came built-in grammar and spelling checks; and the computer began to take over our roles as guardians of the language. Lucia, who worked as a legal secretary long before computerization of the office place, points out in her story that she was proud of having strong typing and proofreading skills and was frequently complimented on them. She now faces returning to a workplace where these skills that gave her value and some control over the work are devalued because of technology.

But not only was the technology transforming our work, so too was it changing the lives of our bosses. As we were becoming more proficient on our new tools, our employers were also becoming computer literate. This was not a bad thing in some cases, but in others it

challenged and often changed our roles within that office. In my own workplace, as soon as some of the lawyers began using computers, they began to tell us how to do our jobs — sometimes even sitting down at our computers and doing it themselves! They decided how much or how little they would use the technology; we were often left with their leftover work that could vary tremendously in content. In my own case, my job remained relatively unchanged since my boss did not use a computer; others had almost their entire work product removed from their desks. But it wasn't just the computer that changed our roles — voice mail and e-mail also played a part. It's not to say that there aren't great advantages to them — like being able to leave our desks — but they did remove some of the sociability from our work, and challenged our roles as office communicators and sources of knowledge about what was going on within the workplace.

This pervasive use of technology by all employees enabled management to close word processing centres and typing pools. In my own law firm, after one or two years of computerization, there were only one or two of the original seven word processing centres operating.[10] A few of the thirty or so women who worked there found jobs as secretaries in the firm, some others became floaters, a few kept their jobs as word processors and the rest left their jobs. Their work reverted back to the front office desks of the secretaries. The skills of the back office workers and the status of the front office workers became blurred.

Much the same thing happened at Zoë's university. As faculty and staff became skilled on computers, and voice mail removed answering phones from staff's job descriptions, the typing pool also was disbanded. It was assumed that faculty would take on more of their own typing, making it possible for faculty secretaries to be reorganized so fewer could work for more departments. Zoë went from having a private office in a department where she had interesting work and frequent telephone and in-person contact with faculty and students, to working in a secretarial pool. Now she spends most of her time on the computer doing routine work. The parts of her job that were meaningful — like proctoring language proficiency exams — have been removed from her job description. Whether they are

called pools, "clusters" or teams, the situation is the same; the traditional move from back office to front office has been reversed — the front office became the back office once again.[11]

INTENSIFICATION OF WORK

All of this was quite predictable. As we saw our employers making huge financial outlays for technology, it only followed that they would want to use it as effectively and efficiently as possible. Also there is the popular belief that the computer as the "Essential Enabler" will open up opportunities for us by relieving us of those tedious tasks associated with office work, thereby enabling us to take on more work.[12] Our working tool, in effect, has come to dictate what our job will be rather than the job dictating the tool.[13] So rather than freeing us up for more "rewarding and challenging" work, it is just freeing us up for more work.

This intensification of our work appears both in what we do and how much we do. New tasks are just assumed into the position without much discussion or debate — or compensation, for that matter. Loretta, who works in an insurance company, has found that her workload is almost too much for her to keep up with. She thinks her boss is fine to work for, but she has no idea how Loretta's work has intensified as the number of claims has grown, nor does her boss appreciate how much work is involved in processing one claim. Her boss expects that Loretta will get the work done even if there is no one to help her do it. The technology says it can be done, so it shall be done.

Technology also creates an atmosphere that requires us to be busy and producing all the time. There is no downtime. Like fast-food workers, we are expected to "clean don't lean" when we complete a task.[14] Joan says that in the law firm where she works, if she finishes a job, she is expected to go help someone else; Zoë's secretarial pool at the university is designed so that work gets pooled when necessary. The same efficiency and flexibility required of fast-food workers has permeated our work world. All fast-food workers know that "If it's dead, you have to clean." The same message is

perhaps more subtly but just as forcefully being given to office workers — if it's dead find something to do and do it fast!¹⁵

Another indication of this intensification of our work is the unspoken expectation of putting in overtime. For most of the women in this book, overtime is not a choice; it is a requirement to keep their job. In one of her earlier jobs with a law firm, Joan's employer continued to harass her about working overtime even though he knew she had childcare responsibilities, which Joan had clearly stated when she took the job. She had even taken a lower paying job of legal secretary rather than that of law clerk for which she was qualified because the latter position required overtime. It was as if "no" was not an acceptable answer. Even temporary workers are required to put in extra hours. Norma, who has worked temporary jobs for ten years, found this to be a tremendous challenge in her assignments. She worried about having the wrong attitude for today's workplace because "she works to live, not lives to work." Her chance at a full-time job fell through when she decided the amount of money offered her for regular, if not daily, overtime was not enough to give up her life for the job.

Yet not all women I spoke with felt overtime was a bad thing. This was especially true of younger workers for whom the new technology and the restructuring process are the only workplace realities they have known. Daphnie, who is in her mid-twenties and is comfortable working at whatever comes her way, embraces this "brave new world" of office work where the choice to stay late or not to stay is out of the control of the worker. She stays until the job gets done and wears a beeper around so she can be "on the job" whenever she's needed. She admits feeling disdain for nine-to-five clock-watchers.

Some employers are getting around paying overtime by operating on a 24-hour schedule. Now that the technology is available and with the global nature of business demanding more and more productivity, it makes "sense" to keep staff working around the clock. No longer is shift work reserved for teenage hamburger flippers, blue-collar factory workers or hospital staffs. Today, especially with the growing use of call centres in almost every sector of the business world, shift work is fast becoming a reality in workers' lives. Even

workplaces like my old law firm are contemplating adding a night shift rather than continue to pay overtime.[16]

But any flexibility in shift work, like overtime, is designed to suit the needs of our employers, rather than our own needs. For women with childcare concerns, any kind of nonstandard working day is an obstacle to getting a job. As flexible work schemes become the norm rather than the exception, there will be fewer and fewer opportunities for working mothers to find good jobs. Even for single women, it is difficult to plan a life around working shifts. Louise, who has been working most of her adult life in this type of work, still is not used to the idea and finds it all "sort of a nightmare." As more employers choose to use technology in nonstandard work situations, more and more of us may find ourselves in that same nightmare.

LIFELONG LEARNING

But perhaps the greatest stress associated with technology is that while our work is being intensified and our roles are shifting, our skills are becoming obsolete as we type. We can no longer relax into our jobs with the knowledge that we know what we are doing. When I started my working life in the 1960s, and even into the 1970s and early 1980s, anyone with basic typing skills could get an entry-level office job. Many an artist, musician or editor was told, usually by her mother, "Just learn to type so you won't starve!" Those skills gave us entry into almost any sector of business and kept us employed. The current shelf life for today's technological skills is three years.[17] That is not a very long time. What it means for us is that we have to be constantly learning new software — which means constantly relearning our job.

Computer technology changes the definition of our work and requires us to develop an ever-expanding set of skills to meet the new demands. And the onus is on us to learn how to use the technology. Training is not always forthcoming from our employers, and even if it is, there is very little respect for the time it takes to acquire a new skill.[18] After the first computer conversion of the law firm where I worked, one of the partners remarked that the tick-a-tack of typewriter keys coming from secretaries' offices made him very nervous. He saw

thousands and thousands of dollars flying out of the firm for a system that secretaries refused to use. He and his partners expected us to adapt rapidly and efficiently to the technology. What happened was that the secretaries who hadn't reached that level of competence on the computer stuck to the tool they could produce on — typewriters.

What I witnessed in that law firm is the reality in most companies — too little training is provided to get an employee, whether experienced or a new one, to a comfortable, proficient and profitable skill level on the new technology. Why? Because it takes time. In my workplace, the plan was good in that we were given off-site training for the initial conversion to computers. Workers were away from their bosses' demands and could devote their entire attention to the learning process. But the training was too limited, and once that minimum amount of training was finished, we were expected to be as proficient and productive on the computer as we had been three days earlier when we were still using our typewriters. That was unrealistic. There was no patience for slow learners, and certainly no respect for the dramatic change that was taking place in our workplace.[19]

Loretta found that the basic training she received at her insurance company — a three-hour course in Excel — was not enough to give her the confidence she needed to do the job. According to her employer, she had received "training." If she couldn't learn it all in that session, then that was her problem, not the insurance company's. It was up to her to look for additional classes, which her employer would not pay for or let her take on company time. What's even more annoying about this is that her employer, like many others, is willing to spend training dollars on certain members of their staff (for example, lawyers, managers, salespeople). These employees supposedly could walk to the competition without any trouble, while office workers are not extended that same treatment because they don't represent the same threat.[20] But still Loretta is willing to pay for the extra training because not doing her job well is against her basic values about work. Now she can't find a course that suits her time availability.

But some women may envy her even those three hours of training. Take Lucia and Zoë, for example. When computers came to

their offices, each of them was given a training manual for the soft-ware and told to sit down in front of the computer and learn how to use it. The fact that they were able to get to some level of compe-tency says much about their own intelligence and little about the training process. Neither of these women shied away from technol-ogy and, in fact, would have embraced it with open arms if they had been given more time — time to learn it properly, time to practise and time to understand its implications for their work.

Legal secretaries — Meg, Joan and myself — are expected not only to have current software skills, but are also required to use skills that were previously in the realm of para-professionals or profession-als. Skills such as doing library research, cite-checking and retrieving cases from the Internet. At one time, professionals who had these skills were paid professional salaries for their work. But because we are "secretaries" and not "lawyers," we earn less for the work we do that involves these skills, and our job descriptions become broader and more demanding in order to accommodate the additional workload.

In all fairness, there is the reality, as Norma notes, that once you learn a software, the revisions to it are easier to pick up. But the rapidity of the change is sometimes disconcerting — Joan quips that there have been as many upgradings of WordPerfect in her law firm as there have been months of her tenure there. And even though one version builds on the other and incorporates some of our skills and knowledge, with each revision comes a certain amount of disruption in our work production because we still need to familiarize ourselves with the differences of the new software program.

And there is the physical and psychological energy it requires of us. Suzi, a woman I worked with in the law firm, told me that there was to be yet another change in the accounting software at the firm. She isn't opposed to change per se, nor is she afraid to try new things, she's just tired.[21] She knows from past experience that this new change in how she prepares clients' bills may eventually make her job easier, but in the meantime it will make the next four months of her life more stressful and less productive. Any change takes a certain amount of start-up time before the anticipated results are felt. The

time in between can take more psychological energy than the training did."

Zoë, like my friend, is apprehensive about her ability to pick up more and more programs as she works her way towards retirement. At the moment, she says that new software is constantly appearing on her computer and that she is expected to just "pick it up" and use it without any formal training. She admits that she tries to ignore it as long as possible, but eventually has no choice but to learn it on her own, and she never feels that she truly "knows" the program. If she had been taught the basics of the system right from the beginning and developed a thorough understanding of the system rather than a hodgepodge learning of new software packages, she thinks that this subsequent learning would have come easier and faster. As it is, if she or another secretary want to acquire that kind of sound working knowledge of the technology, it is up to them to do it — and to pay for it.

It's such a double-edged sword: without the training, you'll be unsuitable for the job market; but constant training can cause financial, physical and psychological distress. If I were to go out today and look for a job, I would not qualify for the level of secretarial work that I left five years ago when I was at the top of my profession as a legal secretary. I would have to take and pay for courses in what is now current — Power Point, Excel, the Internet and Word for Office — not to mention the latest in desktop publishing and graphics. If I wanted to work for a temporary agency, I would need an even greater repertoire.

Meg temps occasionally in a law office that still uses WordPerfect 5.1, but is converting to Windows as she types. She'll have to learn Windows — probably Windows 2000. Judith, Sam and Norma, after many years of moving in and out of temporary jobs, admit to being able to pick things up fairly easily. However, if they're not hired on regular jobs, they're not getting the necessary experience for improving their skills and proficiency on the different software. And most of them do not have a computer at home to practise on.

That is another aspect of technology that should be considered here — the economic power to own it. Access to computer

technology and the many current softwares is paramount to surviving in today's workplace. Of the twelve women in this book, only three — Sam, Joan and myself — have home computers. Most women just plain and simple can't afford them. Current ads for computer packages advertise some for "as little" as $1,000. That's very reasonable to anyone who has been computer shopping. However, if you're working in precarious work situations and you don't know where the next paycheque may be coming from, this is a substantial amount of money. Some women, like Sam, buy secondhand computers. But too often these are not equipped with or able to handle the newer software packages that are being used in offices. They might be good for putting together résumés and cover letters; they are not so adaptable to learning new skills. Any office worker who does not have access to a state-of-the-art computer outside the workplace is at a great disadvantage both for keeping up with the latest software and for conducting job searches.

But even for office workers who have computers at home, pay for their own training or are provided some training on the job, the additional skills that each of us bring to our desks does not guarantee job security or an increase in pay. These sentiments were echoed by an office worker in an article entitled "Wage Rage": "employers demand that workers constantly retrain for what for most will be a low paying job in an uncertain work future."[23] Computer skills have become core requirements for the job — if you don't have them, you don't have much chance of getting a job.

The implication is that change is now a constant in the world of office workers, and that we have no choice but to embrace it and train ourselves to survive within it. The best skill that we could possibly possess at a time like this is the ability to learn quickly.[24] But there is something wrong when we have no choice but to make all of our lifelong learning job-related. That in itself can keep us in a constant state of anxiety. Where is our downtime? And who's to say that it is really necessary or even worthwhile to upgrade constantly?

❖

We don't want our typewriters back. Computer technology does make our lives easier in many, many ways. Most of us I think have, as Zoë admits, a love-hate relationship with computer technology. We love the speed at which we are able to make revisions or print documents; e-mail allows us to retain a certain sociability — albeit one that can be monitored quite easily. Even voice mail has its advantages when we can leave messages for people we don't want to talk to. But what we don't want is for our workplaces to become "electronic sweatshops"[25] — possessing all of the negative aspects that those words connote. What some of us hate are decisions made in the name of the technology and not the human operator. Like the seemingly inevitable need for constant upgrading that then requires retraining and increased demand for more production at faster speeds. And I for one hate this intensification of our work because we lost much of our sociability and our work culture as a result.

Loretta

✣

OVERWHELMED
AND UNDERTRAINED
AT THE INSURANCE COMPANY

I've always wanted to do more — but
for lack of money and time, I've
never been able to get my act together
to go back to school.

Loretta is a forty-five-year-old mother of three
teenagers, whose presence fills her very comfort-
able home with a vibrant energy. Her husband
teaches high school. She had dreamed of a career
as an archeologist but left school after Grade
Thirteen, having that dream snuffed out by an in-
sensitive guidance counsellor. She has steadfastly
held onto the desire to continue her education,
even though circumstances have forced her to
spend most of her adult life working at part-time
paid work, while doing full-time unpaid work at
home.

I didn't continue my education past high school. I was on a
track for academic, but I got talked out of it by my guidance
counsellor. I wanted to be an archeologist and basically he
said, "What do you want to do that for? Five archeologists
graduate in the world per year, one of them might get a job.
You don't want to do that, right?" That put me in a slump so I

couldn't figure out what else I wanted to do in university, so I didn't do anything. Had I had more self-confidence, I probably would have said, "The hell with you, I'm going to do what I want to do!" But I didn't.

Instead, I went out to work. My first job was at a bank; I was eighteen. I was a teller and I worked there for about a year. Then I moved on to a temporary position as a receptionist for a special examiner's office (that's somebody appointed by the government to hold discoveries in legal matters so that you're not wasting the court's time). Then, after that, I went to the attorney general's office where I worked for the summons bureau and then I became a clerk in night court and in day court, as well. I worked there for, I think, about two years and then I went to Europe for three months, came home and got married.

I went back into banking to work in the corporate trust department. I was in the unit that handled the issues of bonds and stocks for different companies. It was a good job for me because I did get to go out and meet clients and customers and shareholders. I was able to get out of the office and I talked on the phone with a lot of clients. So I didn't mind that. Actually, in my first job at the bank as a teller, I liked the people-aspect. I always liked dealing with people, but I didn't like standing on my feet! When I worked at the bank in those early years, the work was much more customer-related. You built your relationship with the customer; it was understood that you were there to serve your customer.

Well, that started to change when I took a permanent part-time job with them back in 1988 or 1989. I hadn't planned to go back to work then; I had been home almost ten years raising my family. Then one day I was in the branch where I knew the loan officer. She asked me if I was interested in a part-time job; I said, "Not really, but tell me about it." Six years later I was still there! That's the period when I saw the

bank changing. They decided that they really didn't want to deal with the nickel-and-dime people, like the hard workers who come in every week and deposit their paycheque, maybe even put twenty dollars in a savings account. As far as I was concerned, they were the total base of the bank's economy; these were the steady customers who always had money in the bank. These were the bank's loyal customers.

However, the bank didn't feel that way. I specifically left the banking field because I didn't like the direction it was going in. I'm not a salesperson and that's basically what they wanted all staff members in the branch to be. You had contact with the customer and that was supposed to be your time to make a sale. Sell, sell, sell! Meanwhile, you'd be trying to sell to the same customers over and over. Every time there was a campaign, you were expected to try to sell to each customer at your wicket. And you had monthly quotas that you had to make. Every teller had sales targets, and if you didn't meet them, they were not very happy. I never considered myself a salesperson. I'm not pushy; I can't hype up things that I don't believe myself. So I decided banking wasn't for me; it was a place to work until I could find something else or go back to school.

Well, I didn't get a chance to go back to school. I was debating that whole scenario again when I quit the bank. We had bought a bigger house, thinking that the extra cost would be covered by my husband's yearly increases from his teaching job and I could go back to school. But it didn't turn out that way. The Bob Rae government (Ontario New Democratic Party) came in and imposed the social contract so my husband didn't get any pay increase. So when this full-time job offer came in, it was very difficult to say no, especially when we had gone so long with just enough to get by and no extras. When you have three teenagers who eat you out of house and home every week, it's really difficult. They all have part-time

jobs, but you can't expect them to buy all their own clothing, shoes and food. We have to pitch in something. So the truth is, I really have to work right now.

I was pretty excited when I took the full-time job. I thought, "This will be great because I've never worked in insurance. It will be something new to learn; it won't be the bank!" But as it turns out, it looks like a bank, exactly — but I don't have any sales to do! This is my first full-time job since 1979. Well, you know, I am extremely lucky. I didn't have to sell myself with this job. Somebody recommended me for it; I went for an interview and I was hired the same day.

I'm working for an insurance broker in the claims department. Once again, I'm clerical — the clerical-support person! I work with the claims examiners who check all the claims that come in underwritten by Lloyds of London to see if they are valid or not; we are the only ones who handle the Lloyds claims. So my job is unique because Lloyds has their particular way that they want it done. So I'm entering all the payments onto the computer and printing out these spreadsheets and using up, like, fifty million trees a day just for Lloyds and their duplicate paperwork.

When I first started, they didn't inundate me; I was able to just sort of ease myself into the job. I thought, "Oh yeah, look what I've been missing all these years." Was I wrong! It's a two-person job, really, and there's only me doing it. There was a person who came in part-time who did it before me, but she didn't do all the work that I do. All she did was the basic entry. Well, I guess they figured now they had somebody full-time, they could bombard her with everything. On top of that, I think the claims have doubled or tripled since I started. It's just too much — if you could see my desk, you'd die because it's just stacks and stacks of paper. On top of that, there are time frames involved; so as I get closer to the deadline, my blood pressure gets higher and my nerves get shot. It's not

worth it! If there were any way that we could go on a part-time wage and I could go back to school, believe me, I would be jumping out the door and doing it. But I just have to tell myself everyday, "This is all I can do. If they think they can get somebody else to do it faster and better, be my guest." But nobody's complained yet.

It's just their unrealistic expectations — and it's throughout the whole office, it's not only me. Everybody you talk to there just feels terribly overwhelmed most of the time because there's too much work and too few people. They seem to value those people that bring in money — again, salespeople! Those are the people who seem to hold the value in the company. The clerical-support staff who make sure that everything's pushed through and done, the "i's" dotted, the whole thing, they're secondary. I don't know, since I've been there, I've seen a lot of comings and goings. Like people come and go and come and go; there's a high turnover.

I'm extremely lucky because the woman that I work for is wonderful. But even then, I don't think she knows what I do, totally. I don't think she knows how much is involved with even checking one claim that passes my desk. It's like if things don't match up, well then I'm not going to just blunder along and put the information in anyway. I'm going to see why isn't this matching up and that means delving through the file, and that is very time-consuming. I find that when you're under so much stress or pressure, that the job isn't done as well as it should be. I find that I'm making more mistakes now than I did when I first started and that bothers me because, again, I think it has a lot to do with the pressure.

When I started this job, I knew nothing about insurance and I had never worked on Excel. I had very limited computer knowledge. At the bank, they had these big old IBM computers where everything was F10 this and F12 that, and here they have Macs that were supposed to be so user-friendly. They

said, "Oh, it's OK, we'll teach you. We'll send you on courses." Yeah, right. They sent me on two courses that were about three hours long and it's just not the same. I have tried to find courses in Excel on Mac at one of the community colleges, but I haven't been able to find one. I would prefer going to a night course a couple nights a week or one night a week just to have that "hands on," just to feel more comfortable with the whole system. I can do everything that pertains to my job to a certain extent, but I'm still not great at formatting things.

Everything I've done, I learnt myself — on all my jobs. Because when you're at my level in the workplace, you're not considered high enough or whatever enough to be sent on courses. Except on this job, they do. But they think that three hours is a course! They think I should know the whole thing. Even to this date, the way that they speak to me about certain things, it's like I'm supposed to know. I think "Hold it! What are you talking about?" They just presume that I've picked up all this other stuff that I don't deal with. How could I possibly?

I really don't care much for office work, but that's what I've done my whole working life. I don't know, it's just mundane — "mundane" maybe is the right word. I've always wanted to do more — but for lack of money and time, I've never been able to get my act together to go back to school. It pulls at you that you don't like the job. No, I don't like what I'm doing very much. I'll do a good job because I'm paid to do it and I'm not a slacker. If I'm going to do something, I'll do it well until I get to the point where it's just too overwhelming or I won't get any help. Because, like I said, once you start getting overwhelmed and overworked, the job suffers because you're just not doing the job that you know you could be doing. So many of my friends are in the same boat. They do what they do because they have to do it, but it's not truly

what in their hearts they want to do. They've got mortgages; they've got children. They've got husbands who work as well, but they need the two salaries to keep going.

I think women seem to be the most vulnerable in the workplace. Even with the apparent leaps and bounds we supposedly made the past couple of years, I think we kind of slid back to the low point that we were many, many years ago. I think there are a lot of women like me who didn't necessarily go on to university or take any kind of postsecondary classes or courses. They may be single parents or single-income earners and they are very fearful that if they don't hang on to what they've got, they're not going to get anything else. Now, I'm sort of in a different situation. Yes, I need the job, but my husband always says, "We'll get by." And we would. We have. So it's not as urgent for me, even though these past months we certainly became accustomed to my money coming in, and all of the sudden we're able to do little things, like order out!

I have always had a loyalty to whomever I've worked for because I always felt way back that if you do your job properly, and you're loyal and you show that you're willing to do all the extra work, that in some way that's going to come back to you with increments or maybe the possibility of a better job or whatever. I don't think that's the case anymore. I'm not saying that in any way that I — I don't know how to put this — that I was a suck-up or anything like that. I just work hard. This work ethic of working hard, doing the best you can, you know, being reliable, being responsible, the whole nine yards. You'll get paid back for that. But I don't think so now. I really don't. Maybe one day I'll win the lottery, too!

Joan

❧

CHANGING BABY AND CHANGING WORK: MORE LESSONS FROM LAW

So at the moment,
work is not about
what I want to do,
it's about what I have to do.

Joan is a forty-two-year-old single mother to a two-year-old daughter, Sarah. They live together in a for-women-only apartment building, which offers the security and convenience to transportation that is essential for daily trips to daycare and office. Joan still speaks with a strong British accent that she brought with her to Canada at age eleven. She admits: "I'm still very British inside." The accent adds to her appearance as a strong, confident, straightforward and competent woman; an appearance that perhaps was developed after having to deal with more than her share of life's troubles. She considers herself a survivor who knows when to ask for help.

I left school halfway through Grade Twelve. I absolutely hated it. I took a job in retail, then I sort of drifted into secretarial work. I started off with a very small firm, but it was good experience and because it was so pinch-hit, I got to do nearly everything. Then I temped for a couple of years with no

purpose at all, really no idea of what I wanted to do or why I was doing it. I started to work for a large law firm in downtown Toronto. I started on a freelance basis and the money was terrific, but there was tons of overtime and I worked probably seventy hours a week, easily. You just stayed until the job got done. I continued on that way through to about 1988 when I realized I was very badly burnt out. I really wasn't respected as an individual; I was respected as a work-producing machine because I would always be there. So I decided it was time in my life to make room for other things and packed up everything, and within a month, I moved to Vancouver.

I didn't stay there long. It was the beginning of the recession there and I was bounced out of office jobs as fast as I got them, it seemed. So I decided to get out of Vancouver. I couldn't face Toronto again and its grinding work ethic so I went to London (Ontario). I went into law again for financial reasons, all the time hating it, not wanting to do it, not respecting the people I worked with, not feeling respected by them, but I did it.

A woman I had worked with in the early 1980s then offered me a job back in Toronto as her clerk. That was good because while I was in London, they were very reluctant to recognize clerks. Everybody is a secretary. I really resented being told, "Well, you're just a secretary like this other woman, who has two years' experience." Well, I'm sorry, I'm not — there's a big difference. I had done my training at the Institute of Law Clerks in the mid-1980s and I have very good qualifications.

So this job seemed like a great way to bounce back to Toronto. The money was certainly a lot better, and there was some potential for long-time security. However, it turned out to be one of the worst experiences I've ever had. We were grossly overloaded, so we never got a chance to finish things without interruption because there was just too much going

on and never any time to speak to one another. We communicated primarily by voice mail. She would phone me at home in the evening at nine-thirty and ten-thirty which I objected to because you had to stop at some point to regroup. I was really unhappy, but I didn't want to start looking for another job.

We were going to have a meeting about renewing my contract, and that was put off; then I discovered I was pregnant. I spent three days in bed in shock. I came back to work and we sat down and had a brief meeting about whether or not I could cope with the job. I said I could, she said I couldn't, and a week after that I was laid off. In the space of about a month, I lost the job, my partner, Michael, left and I discovered I was pregnant. How I stayed sane, I don't know.

So I had to find another job in about a week. I had been offered a permanent job by someone who had forgotten I was pregnant, and when I reminded her, that job evaporated; I knew it would. I was realistic enough to know that in this economy, no one is going to keep a job open for you while you're on maternity leave. Anyway, I temped until the end of my pregnancy. And that was fine; it was a stopgap.

When I started to look for work again after the birth of my baby, I deliberately looked for law: the most money and the best benefits. That's what I was going for and I did fairly well. I was looking for forty-two thousand dollars a year, they gave me thirty-eight thousand and a great benefits plan and I said, "Well, that's something." However, the first three months on this job were hell on earth. I started work on Monday, on Thursday my daughter, Sarah, had a major asthma episode and I had to be off work. This didn't go down well at all because this is a firm where they almost punch the clock. Plus at this same time, I was trying to find full-time daycare for Sarah because without a job, I couldn't put her in a daycare centre, but without a daycare, I couldn't stay in my job. It was

terrifying. All the things I managed to get through when I was pregnant — the job loss, Michael leaving — were not as hard as finding a daycare in this city. I must have looked at sixteen daycares, and I have great sympathy for any woman going back to work, particularly single parents, who have to find daycare, because it's tough.

So at the moment, work is not about what I want to do, it's about what I have to do. I have changed so much in the past two years, I barely recognize myself. I am much more patient. I put up with slights that I wouldn't have put up with before, including being reduced to tears by one of the most misogynous, violent people that I have ever met in any law firm going. Actually, the point of view of all the staff at this firm is very much "don't rock the boat!" Management definitely knows that they can control people more. People are afraid of losing their jobs because there isn't stuff out there. You can't just walk from one job to the next. In the 1980s I would not have thought twice about walking out of a job because there was always another one the next morning and because I had a good reputation and a good network for freelance work. I was never out of work. Now it would be a whole other story, particularly now that I have Sarah.

I try to not let things bother me like they used to. Even when I find things that happen in the office really irritating, I try to tolerate it now, whereas before I never would. I used to be heavily involved in office politics and constantly going to the rescue of someone who I thought had been wronged — that was my thing. They always said they liked my work but I had a big mouth. Whereas now I really don't care what goes on in the office. I will try to help someone if I can, but there's a real limit to it.

Like this woman who started two or three weeks ago. The guy she was working with reduced her to tears; she wasn't used to the culture of a law firm. I went out to lunch with her and

said, "You've got to understand this is the way it is. There's no point in ranting and raving about it. If you go and see personnel, chances are you'll be let go." That's happened to a couple of our staff recently. I mean, that's the way it is. When I was telling her this, I had just finished working for this one horrible guy. He had this tick and when you saw it, you knew something was coming. He'd be walking across the room and he'd do this with his head and you knew he was going to explode. One day I had to correct a fax for him, and he was making me so nervous that I made another mistake while I was correcting it. And he said to me, "At this rate I might as well send the thing by fucking carrier pigeon!" He got me to the point where I literally couldn't think. He had me so frightened, I ended up in tears.

But the thing is, I put up with that and I just wouldn't have in the past. But it's a tradeoff. I do what I have to do to bring the money home. I think that I do good quality work. I certainly don't work as hard as I used to, and I don't put the hours in. I will not do overtime; it's not a possibility for me. It's something that creates a lot of problems at work because they've called and said, "Can you stay late tonight?" And I've said no. They know I can't, but you're supposed to.

Doing a job well and with honesty is very important for me and always will be. It's always something that simply goes with me. It's the trust factor, you know. It's why now, at this new place, I have a hard time with having to punch my time-in-time-out when I'm away for appointments. I have always been trusted in the past to make up the time I missed. As long as I got my work done, it was OK. So for this firm now to say, "We are keeping track of you!" well, it just doesn't sit well. I am a trustworthy person to an extreme. I keep track of what I do in a day, and if I'm late in the morning, I take it off my lunch hour. That's a value that I take with me no matter where I go or what I do, and I think it's an important one. I

think you could give me anything to do no matter how confidential or how much discretion was required and be sure that it was going to be done.

And I work hard. I make a point of learning as many skills as I can. We've already had two upgrades of WordPerfect, and we have another one coming already. And that in itself is a whole learning process. We are no longer the "Take a letter, Miss Smith" secretaries of the past. The demands now are more like, "Create this database. Send this e-mail on the Internet. Look on the Internet for this. Pull up case law on Lawnet." There are all kinds of different skills that you never would have dreamed of having in the past. And they're very technical; the expertise in law is very significant. It's very different. Just look at voice mail and how much it's changed our lives. There's an awful lot more to it than typing nowadays, and they're very specific about what software they want and typing speeds they want and stuff like that.

We have a training department at work, but you really have to train yourself. You might get one half-hour on this and forty-five minutes on that. My whole training on the computer consisted of one day, as it is for everybody else, and that's the extent of your training. In many places, you do not get any training at all. Either you come with it or you self-train. It's a lamentable situation on the part of a lot of firms; they don't want to spend the money, but they want the results. They expect people to go out and do evening courses on their own and pay for it, which I think is unreasonable. It used to be that firms would pay for work-related courses, but most of them won't anymore. That's too bad because for every work-related course a person takes, there's another skill that you can use. But it's all in the interest of cost-cutting.

One of the interesting things I noticed at work recently is a lot of people are coming to me with technical questions about the computer. We have a whole systems department,

but I guess I'm more approachable and they've seen that I have the skills and I know what's going on. I think I'm a bit like a sponge and soak up and absorb any information that comes my way and it stays with me; I'm fortunate that way. But I don't want people to interrupt me that often, because a floater, which is what I am, has her time very heavily scheduled. I'm assigned to whoever needs me at any particular time and, if that job doesn't require a lot of typing, I might also have to answer someone's phone, or help with other people's overload. They expect you to be busy all the time. Most people who are not floaters work in dedicated positions, but if their lawyer is out, they are automatically assigned somewhere else. You are not allowed downtime. That is the big change, and I sometimes resent that because occasionally when you've been working really hard, you need some time to take a breath and do your filing. It means you have to keep up all the time and if you can't, you're doing that catch-up work on overtime.

I regret not being able to use and get paid for the law clerk training that I have. For the most part, my skills have always been disguised as secretarial work, and that's too bad because I'm capable of much more. I'm also not allowed to call myself a clerk while I'm working as a secretary, so I'm losing out. I've tried to persuade them differently this year, but if you're going to work as a clerk, you have to work overtime and I couldn't do it. That's why I took secretarial, because then I could put my foot down and say "No!" to overtime. That was one of my compromises when I took this job.

I think most people are compromising a lot more. It certainly is much more difficult to find work now. I think people are less likely to be doing what they want; they have to do what they can get work in. The job market is just so much more confusing than it used to be; there are so many more factors that we have to consider. We can't look at our position as being long-term or stable any longer; that's just not a given.

It isn't you who necessarily decides where you'll work or when your job ends — the employer decides that. There's also a great deal more competition. The kids are coming out of school with more computer skills than some of the older workers, and they'll work for less. That makes them in demand. It's really tough on people who are in their late thirties and upward, and a lot of women are reluctant or afraid to retrain at that age, which is a mistake.

I actually can see myself staying at this job for a while. Before, I never felt any sense of permanence or felt any sort of commitment, but now I'm much more constrained about how much movement I can make in my life in all areas. It's important I stay where I am. I have to plan for — I don't know the way to put it — for my own personal satisfaction later. Right now my priority is to make some money and try to save towards a house and to try to work more part-time when Sarah starts school.

I think this time has been good for me in terms of slowing me down and making me look at what I value in my life. I can't move as fast as I used to. I can't spark off and say "Screw you, I'm leaving." So you know in some ways, it's good not to be that firebrand, not to be upset about things people say. I used to be up at nights grinding my teeth, having stomachaches, angry at the world because of the bad things they were doing to people, their lack of righteousness. So now I'm trying not to get so upset about work. I could kill myself on their behalf and no one will remember ten years from now. The things that I do in my daughter's life now will matter in ten years. That's what's important.

Restructuring the Office –
Remodelling the Worker

ᕋ

An optimistic employee around here
is someone who brings her lunch.[1]

The scientific technological revolution of our time which
is not confined to electronic processes but also affects
organizational changes in the structure of corporations,
has fundamentally altered the forms of work, skill and
occupation. The whole notion of tradition, and
identity of persons with their work has been
radically changed.[2]

BY THE 1990S, as the global economy began to take shape, employers played their part in it by revolutionizing their workplaces to fit the leaner and meaner model now in style. With the potential for increased workloads made possible by the computer, they quickly turned their attention to figuring out how their operation costs could be reduced through the efficiency of using fewer employees doing more jobs and producing more work. Technology alone was not the answer. As one business consultant commented, "The challenge in the 1990s is no longer to change processes through technology, but rather to change people and thereby corporate culture and values to gain a competitive edge."[3] There are few, if any, studies that show that the word processor cuts the cost of producing a letter or report; the success stories are about companies who first changed the social relationships within the office and then introduced the technology.[4] What this means is that the relationship that employees have had

with their jobs and workplaces have to be changed — private secretaries become members of a team or pools, tellers in banks become first salespeople then operators in call centres, temporary workers turn into the just-in-time contingent workforce. The "identity" of these employees with their work and their work environment is turned topsy-turvy.

This restructuring of our workplaces comes out of an ever more pervasive environment of global capitalism. There is no way we can separate one from the other. It is beyond the scope of this book to give a discussion of the history, economic policies and ramifications of global capitalism, however a *very* simplified look is justified.[5] Since the late 1970s, national and international policies have been aimed at opening up the global market to capitalism. By then, the internal consumer market had reached its limit. With mass production and mass advertising, the people in industrial countries had seen the "commodification" of their everyday life by international corporate capitalism: "[T]he corporation comes to determine broadly the main cultural parameters and to define and structure humane needs so that they correspond with society as marketplace."[6] But one consumer market could only buy so many cars or bottles of mouthwash. The shift in the mode of production to one based on microelectronic and computer technology presented the ideal tools needed to expand global markets and production.

To create a fertile political climate receptive to this movement, neo-liberal economic and political policies were introduced around the world.

> [N]eo liberal policies are the *hallmark of the transition between two eras.* They are the policy changes that will "harmonize" the world of national capitals and nation-states, creating a global system of internationalized capital and supranational institutions. Such global organization represents the coming demise of long established social and political institutions of the industrial nation-states.[7]

Throughout the world, public policy became economically oriented; it was redesigned to create a climate that would make the free

movement of trade possible. Trade agreements — such as the General Agreement on Tariffs and Trade (GATT), now consolidated as the World Trade Organization (WTO), the Free Trade Agreement (FTA) between Canada and the United States, and the North American Free Trade Agreement (NAFTA) between Canada, the United States and Mexico — were designed in order "to create a single market, develop institutions to enhance capital mobility, and ensure the rights of corporations within the region."[8] As a result of these trade agreements, individual nation-states relinquished (in the name of free trade) much of the control they once held over the regulation of corporations. Free trade policy, it was surmised, would make national economies stronger and more able to compete. If there is competition, there is job creation and thus, through the trickle-down of wealth, workers will be better off.

But what is really happening is that the loosening of trade laws and deregulation of industry has given corporations the upper hand in the policy decisions of nations. Decisions made in the name of neo-liberal economics have left public institutions short of cash, owing to government decisions to reduce corporate and personal taxation. Hence, there is little or no money to provide services for its citizenry and to pay for public employees. In the same spirit, labour and environmental protection laws are attacked. For employees everywhere, this has meant the weakening or total elimination of laws that protected their health, safety and security. The loss of the sovereignty of the nation-state has also taken away the traditional structure for labour reform. And, even with this pro-corporation environment that nation-states provide, corporations can still freely close shop in one country (say, Canada) and move to another (say, Mexico) in search of ever-lower production costs. Local and national governments have no power to stop them. Once major corporations close up and leave the community or the country, they leave the workers and their communities behind, sinking.[9]

By the 1990s, globalism appeared as a "normal" fact of all of our lives — no matter where we live.[10] Small children from different parts of the world shout at us in an advertisement for the Internet, "Are you ready?"[11] It is more of a case of "ready or not here it comes!"

For us women working in offices in whatever sector of the economy — public, financial institutions, law, insurance — the opening of the global marketplace has meant a dramatic change in our workplaces. As our personal lives have been changed by the dictates of a global economy — including what kind of bookstore we can shop in, where we can get a cup of coffee and how we bank — our work lives have been even more directly restructured to fit the global image.

As Flexible as a "Gumby" [12]

If there were one characteristic that most epitomizes this global economy, it would have to be *flexibility*. The Concise Oxford English Dictionary defines "flexible" as: "1. able to be bent without breaking; 2. easily led; manageable; doable; 3. adaptable, versatile; variable (work flexible hours)."[13] These are all traits that globalism requires of all its players if they are to survive. Corporations and nation-states bend and adapt their worlds and rules to the dictates of a volatile market economy. The global labour force grows and subsides on the whims of some unseen force. And individual employees see their jobs, skills and work structures transformed before their eyes. In the best of all situations, this flexible world would also create open and changeable workplaces that would benefit those employees as well as the corporation — too often that side of flexiblity is not respected.

For those of us working in offices, flexibility plays itself out in many different guises — both positive and negative. But whether a good thing or bad, it helps if we are contortionists like Gumby, who are able to bend and stretch our skills and lives around our work. Our skills must now encompass all the new kinds of work incorporated into our jobs. An advertisement for a receptionist/publications officer at a local university called for the usual receptionist duties — answering the phones, greeting visitors — but the person would also be required to process manuscripts for publication, fill orders, maintain accounts and a database, develop promotional material and process the large mailings. She was also expected to be the administrative assistant to the centre's administrator. This one job required an extreme amount of flexibility in skills and in time management. For

all of this, the university was willing to pay $24,180, or $12.60 an hour — hardly enough to live on.[14]

This kind of versatility is becoming the expectation rather than the exception in job descriptions. All of us in whatever office job we have held had to have a certain amount of flexibility around our work. What is different now, is the extreme range of skills we are expected to have, as the above example illustrates, and the flexibility we must demonstrate in our time management just to be able to do all of this in a workday (as discussed in the last chapter with regard to overtime).

The positive side of this flexibility is that it does make it possible for us to learn new things — as my friend Suzi says, the "same old, same old is so boring"[15]; after many years working at the same job, she wants to have new things to do. Judith, who really knows the meaning of flexibility as a temporary worker, also finds this plunge into new jobs challenging and exciting. She talks of her experiences working as a temp — both in banks and government — where she was hired as an administrative assistant, but her actual job ended up being much more. New to the job and not permanent staff, she was in charge of setting up new departments, which required ordering equipment and computer technology, among other things — once the department was up and running, she lost her job (the other side of flexibility). She, like all of us, had to be flexible and quick in not only applying her "old" skills of typing, but in learning new skills — in her case, organization, purchasing and human resources. She feels she came out of the experience with an appreciation of her ability to organize offices.

However, the downside of this flexibility in responsibilities is that this intensification of our work carries with it the implication that we will do whatever is thrown our way regardless of whether it is in our job description, whether we were hired to do it or whether we are being compensated for it. It eliminates any kind of protection we have against this kind of abuse of our positions in the workplace. Carried to the extreme, this flexibility makes the office just another kind of sweatshop geared to get as much as possible out of the people who work there. When those people are dedicated to and responsible

for doing the best they can in a workplace, it compromises them and takes advantage of their sense of work values.

For instance, Stephanie and Loretta were both hired as tellers in the banks where they worked. Little by little, as the global financial market opened up, they began not only to have to serve their customers, but also to *sell* to their customers — VISAs, retirement packages, mortgages. They had to learn the skills of a salesperson, which eventually became more valuable to their managers than their skills as customer service representatives. They had no choice in the matter; it was just added to their responsibilities. It was the part of their jobs that both of them admitted they hated and which eventually led them both to leave banking.

But even if we're enthusiastic about taking on more responsibilities, like Judith and Suzi, or apprehensive and angry about it, like Stephanie and Loretta, it is very likely that we will not be compensated for the additional work. As in the case of the receptionist/ publications officer above, employers are not necessarily paying for all of these new skills that we are bringing with us or learning on the job. In a poll done by the International Association of Administrative Professionals, 94.7% of their respondents reported that their responsibilities increased in several areas including accounting, supervising and more administrative work. This additional work would have meant that these women had to learn to be more flexible not only in their skills, but also in how they planned their days. But the same poll showed that only 39.3% of these respondents said they were compensated for the increase in responsibilities.[16] We are, in effect, giving our labour power away — and once we start to do that, we are in trouble.[17] But in the volatile atmosphere of most workplaces today, those women who do have full-time jobs don't feel secure enough to complain about the intensification of their responsibilities or the pressure to work overtime. There is always the possibility that they will be the victim of the next downsizing or fired for not being a team player. We certainly do not want to be labelled as inflexible in this global marketplace.

Flexibility also means when, where and how often we work. This is, perhaps, the most threatening application of the word because the

concept of "flexible hours" diminishes the concept of an eight-hour day and a five-day workweek. The structured workweek is what provides us with stable incomes — and in many cases, even a regular three-day workweek is sufficient. But flexibility is undermining, or has undermined, this structure and has introduced the element of insecurity into our lives. Our work lives are no longer determined by our own needs or expectations. Restructuring has placed our fate in the hands of human resource experts who are designing more efficient ways for business to use our labour so to better meet the demands of this globally competitive world.[18] These "corporate technicians" hired to "explore and exploit worker motivation" have created a variety of work situations that guarantee for management greater scheduling and staffing flexibility,[19] and that offer companies another means to improve their bottom lines on the backs of their employees.[20] Nevertheless, many of these schemes have been touted as being worker-friendly. They are supposedly designed to give the employee more flexibility and freedom to work when and where it would be most convenient for her. Flexibility, we are told, is a win-win situation.

A flexible work schedule can make it easier for women in the "struggle to juggle" work, family and life responsibilities.[21] It may provide a welcome leeway when dealing with issues like childcare, studies, caring for an aging parent or maybe just adjusting our work schedule to our natural schedule. However, these worker-friendly opportunities must fit in the schedule of management, not necessarily that of the employee. It is the same principle used for fast-food workers — the greatest number of employees must be there for the busiest hours. Flex time, which allows full-time employees to choose their starting and quitting times, must work within that framework set by management. In my own workplace, when our hours were increased, this meant that women with childcare responsibilities had to adjust their childcare to their new hours. The firm was willing to allow flexibility within a reasonable time frame (the women, of course, were paying for that extra hour of childcare that we were now working without an extra hour of pay). The problem that arises in this kind of flexible work schedule is that the expectation remains that the secretary or word processor be at her job for however long

she is needed. More often than not, quitting times are ignored — "Just one more letter or correction, please" — and the flexibility remains in the hands of management, and does little to benefit the employee.

Another proposition put forward by the "corporate technicians" is the concept of telecommuting — doing office work by computer at home. Telecommuting has been very popular for workers taking orders for fast-food joints. Now it is spreading into almost all sectors of the business world — both for professional and non-professional staff. There is a lot about telecommuting that appeals to many women. The idea of doing all or part of our scheduled hours of work from home seems too good to be true, and I think it is. Working from home, we can have the flexibility of scheduling our work when we want to do it; there's the added benefit of not incurring the expense and time commuting and dressing for "downtown." At the same time, we can more easily manage childcare and maybe do our other household chores more readily after our workday is done. In reality, what too often happens is telecommuters actually put in longer hours, making up lost work time that was used for household emergencies. There is also the fact that all of this equipment is sitting in your home, using your electricity and your space. And there is no imposed quitting time — you can't just turn off the computer and go home, you're already there. There is also the isolation and a lack of connection to any office culture or social group. As a friend of mine in Washington told me when she returned to the office after trying to work at home: "It's too lonely."[22]

Job sharing is another example of flexible hours. In this scenario, two employees voluntarily share the responsibilities (and pay) of one full-time position. This scheme is usually reserved for professional staff, but can involve women in support/administrative positions, as well. This is not an imposed condition or proposition — usually employees volunteer or ask to job share. However, most office workers — such as the women in this book — could not afford the cut in pay that sharing would require. The same would be true for the "voluntary reduced work time programs" where workers are able to trade in pay for hours off — not many of the office workers I know would

be able to do this. What most of them are looking for is more income, not less.[23]

There are positives and negatives to almost any type of flexible schedule in our workplaces. The big problem with flexibility is that too much of it can mean, as Norma points out, that you're not working enough hours to survive. Unfortunately, many of the corporate-imposed flexible work schemes introduced into workplaces today, are designed to have workers work too few hours for them to qualify for benefits, employment insurance or vacation and sick leave. These workers become, as one company calls its flexible workers, the "LOs" — Low Overheads.[24] Given the lopsided scale of work these days, these flexible propositions seem impractical and even dangerous for office workers. Either people are overworked or they are under-worked — that place in the middle that many of us may have enjoyed in the past seems to be nonexistent in today's workplace.

The true face of corporate-imposed flexibility is very apparent to women like Norma and Judith, Sam and Meg — who work tempo-rary jobs — and Louise, who works in a call centre. In their experi-ence, flexibility is ushering in a culture of insecure and dehumanizing work. Under the guise of flexibility, business is eliminating "good" full-time positions that provided security and benefits, and creating more lower paid, contract and part-time work, while boosting their profits. This imbalance is a symptom of global restructuring in the workplace.

THE PERSONAL FACE OF RESTRUCTURING

Restructuring, or any other kind of organizational change, is not an impersonal event. It is indeed about changing the culture of an orga-nization, and that means changing the environment we work in. Changes in workplace culture mean changes to "the value systems, policies, authority and decision infrastructures and 'historical tradi-tions' that affect how the members of an organization behave."[25] No matter how democratic it may appear to be, restructuring is about power and control. In most office settings, it means that management is changing things for management's benefit. Office

restructuring is not intended to make workers' lives better; it is to make them "better" workers — that is, more productive employees. In the literature on organizational change, which is written from a management perspective, restructuring is interpreted as an inevitable and positive step for any organization to take. Without change, it is surmised, the organization and its workers will become stagnant and unproductive. Change — such as more and more technology, outsourcing of departments, creating teams of workers — is progressive and will move the organization into the future.

However, what is not spoken about is what restructuring does to the personal, professional and economic well-being of women office workers. The most immediate effects that women often experience during a major restructuring are the feelings of ambiguity. We don't know what our new roles will be, and the roles we played within the old organization are suddenly no longer suitable for our workplace. While we may have occupied a position of respect and stature before, that position now becomes obsolete. This was certainly true for Stephanie and Loretta, who witnessed major restructuring in the banking industry, Zoë at the university, and Meg, Joan and myself in law firms. We were all shaken by the ambiguity of what our new roles would be and how the environment of our workplace would look. Our uncertainty stemmed, to a large extent, from the loss of control that we had over our work and, to a certain extent, over our very "destiny" within our workplaces.[26] If we no longer know what we are going to be doing, it is hard to feel in control of anything.

It is true that change in our lives — whether at home or at work — always creates a certain amount of fear and ambiguity, no matter what the reason for it is. Fear itself feeds into our sense of powerlessness and makes the experience of change a painful one. However, there are circumstances that make it even more difficult to meet the adjustments necessary to accept new roles that change demands. When restructuring is being planned and carried out in most of our workplaces, those of us who are going to be most directly affected by those changes usually receive very little information and knowledge about what's happening. We subsist on rumours and suppositions — all of which put our work routines and sense of security on very

shaky ground. To add to the problem, this powerlessness that we feel mainly because of our ignorance of the situation can only be alleviated by the very people — management — who created the uncertainty to begin with. They hold all the cards and we must be dependent upon them for any solution that might be forthcoming to alleviate our ambiguity and our fears. This kind of dependency encourages compliance on our part, so we often accept whatever changes have been put in place just to put some routine and normalcy back into our work lives. Compliance will at least create some order out of the chaos caused by the restructuring.[27] Unfortunately, our compliancy also secures an immense amount of power and control firmly in the hands of management.

The depersonalized approach to business begun in the 1990s creates the kind of environment where employees get lost in the restructuring process. This style of doing business does not allow for consideration of years of service or loyalty, home responsibilities or health. Decisions that directly affect our economic and personal well-being are made with no consideration of how it will affect the person involved. Recently, at the law firm in Washington where I worked, a new restructuring plan included the outsourcing of the one remaining word processing department. Along with newer employees who lost their jobs and were not "picked up" by the contractor, were two women who had worked at this firm for more than twenty years each. Initially, there was no thought of saving their jobs; it was only after an uproar from other staff and when some "older partners fussed enough" that jobs were found for them "somewhere" in the firm.[28] Everyone is vulnerable, no one's job is safe or guaranteed; this has to make you anxious every time a meeting is called. You could be the one this time to lose your job or have your hours reduced so much that you'll have to get a second job. Every individual employee's economic well-being is on the line every day in an environment where management couldn't care less about them.

This depersonalized approach to management of the workplace has been the result, in part, of a merger-mania in the 1980s and 1990s unprecedented in business history. Corporations merged in order to control a greater share of the global market, which in itself

caused a "massive restructuring of the patterns of ownership"[29] — fewer companies controlled larger chunks of the world market. This means that corporations with headquarters half a world away are often dictating policies that don't relate at all to the company they are reorganizing. This depersonalization of a corporation removes any personal or professional concern that the owners of a company may have once held for their employees. If job lay-offs or branch closures are necessary to ensure the highest possible market gain for the new shareholders, then so be it.

For the woman in an office being restructured, this situation means that there is no recourse or connection to those who are deciding her fate. Accompanying this depersonalization, human resource departments become more attuned to corporate rather than individual needs. Downsizing often means human resource is in place (as was my experience at the law firm) to oversee lay-offs, not to address pertinent concerns of the staff. The very people in management who are instructed to close branch plants (or local branches of a bank) are often losing their own jobs as a planned consequence of the downsizing they have just managed. From one day to the next, employees don't know whether they will have a job the following day or whether their company will even exist that long.[30]

Even for companies not consumed by hungry conglomerates, their management decisions are still determined by the need to stay competitive in a world economy that spans the globe, and not just the city or country where they are located. In many cases, restructuring decisions made by local companies are determined not only by their desire to maintain profit levels, but also by decisions made by their clients and customers. For instance, if a law firm, such as Joan's or Meg's employers, has a major client that announces one day that it will no longer pay for duplicating costs, or wants a ceiling put on attorney's hourly rates — a common occurrence in current corporate law — then the law firm must comply or risk losing that client. The firm will look elsewhere for ways to stay competitive. Too often that somewhere is found in its labour force.

The corporate restructuring policies that have been enacted as part of a global strategy too often spell disaster for employees —

especially for women — within those workplaces.[31] In the extreme cases, when companies just pick up and relocate elsewhere, their old employees in the North, where they are leaving, and their new employees in the South, where they are relocating, are affected. As women in Northern countries see their work marginalized into low-paying jobs and then no jobs at all as companies restructure or move, they move ever closer to the edge of poverty. The Southern women (women in Mexico, Latin America, South America, Africa, Asia) who pick up jobs in the free trade zones do so from the depths of poverty. Both groups of women suffer — those in the North by slipping in status and economic well-being and those in the South by not making enough in the factories to lift themselves out of the abject poverty they have been forced into.[32]

Even in situations where the restructuring is not as dramatic as a workplace moving to Mexico, the "feminization of poverty" is played out. In many of the business sectors discussed in this book — banking, insurance, law, public service — global strategy has meant a diminishing of opportunities and incomes for many women. Banking, for instance, at one time offered incredible growth potential for women workers. Women like Stephanie could start working as a clerk typist or a teller and know that there existed an internal ladder out of entry-level work and into middle-management opportunities. Insurance companies offered some of the same types of opportunities in typing pools or claims processing. However, global strategy dictated a flattening out of organizational hierarchy, eliminating most of those middle-management jobs that women could aspire to. Thus, not only did technology and downsizing eliminate the entry-level jobs, it wiped out many possibilities for advancement.

Women working in offices in public institutions also suffered from the trickle-down effect of decisions made in favour of a global marketplace. Zoë's example is telling: in 1995 the federal government in Ottawa cut the education payments to the provinces; the province of Ontario, in turn, cut its contributions to universities. Zoë's university administration then cut the budget for her faculty by approximately $300,000, which in turn realized this cut through the downsizing of the secretaries. As a result, Zoë was moved into a

secretarial pool; she no longer reports to the head of an academic department, but to an administrator in the Office of the Dean. What used to be personalized ties to the academic faculty that she served were replaced by ties to an impersonal bureaucracy monitoring her work production. In addition, the administration flattened out all secretarial positions to one uniform level and title. Those who were at higher grades are still paid at that level, but their "title" and grade have been lowered to reflect the new policy. As Zoë says, they are all now "nameless, interchangeable, and certainly voiceless."[33] What this means for women working there in the future is that as the higher paid, more senior secretaries leave, their positions can be filled by women at lower pay who will be expected to have the same skills and experience. This university, like other public institutions — especially unionized ones — has been in the past a place women could find secure, well-paid and interesting work. Those jobs are disappearing and being replaced by more routinized and less secure work.

The trickle-down effect of globalization pushes women further down the economic ladder. Every time a downsizing happens, it eliminates jobs — many of which are good jobs, and replaces them with what are now called McJobs — jobs that offer no security or benefits. The squeezing of more and more women out of good jobs makes for a more compliant workforce, who are willing to take on more work for the same or less money just to have at least some kind of a job. Jobs like call centre representatives become "desirable" in a market that offers fewer opportunities and more applicants. The whole process ends up pushing more women like Louise, Norma and Sam, who have been in nonstandard work situations, further down the ladder towards poverty. More and more of us are becoming, as Sam remarks, desperately needy in a world of wealth.

Restructuring is affecting our entire society, but where we feel the effects most profoundly is in the workplace. The merciless decision-making of corporations and public institutions shows little or no regard for the lives of the employees making their livings within those worlds. As a result, the "social contract" between employer and employee breaks down, and employees become nothing more than a part of the cost-reducing efforts. It is no wonder that office workers

feel a sense of betrayal when employers violate the "unwritten but important social contract" that exists between them. That old contract, the reciprocity that traded loyalty for job security, is too easily and quickly — perhaps even necessarily — dismissed.[34] It is not surprising that the restructuring experience shatters the trust of office workers for management and owners. Any loyalty or care that a company held for its employees is dismissed as a relic of another, more frivolous time. Women in the office, who are made redundant by these decisions, need to understand that the restructuring that is reshaping their lives is a phenomenon affecting the economy as a whole. Once we realize that, we can start to turn the powerlessness that we feel in its wake into some sense of control over our work situations.

SHIFTS IN WOMEN'S OFFICE CULTURE: LOSING THE PERSONAL NETWORK, LOSING THE TACIT KNOWLEDGE

Restructuring changes more than our jobs; it also changes our social world of work. As our offices are restructured in the name of productivity, there also occurs a restructuring of the sociability that naturally occurs within them.[35] Each of us office workers is or has been a part of an informal social group in our workplace. It is our shared sociability within this group that makes our workplaces livable. If you were to ask a dozen office workers, "What (if anything) makes a job 'good' for you?" more than half of them would answer "the people." These "people" are the ones we go to lunch with so we can complain or laugh about our bosses and our jobs; they are our co-workers we call on for help and to share information. It is through our social group that we keep abreast of office politics and trade personal news. Our association with a social group in the office helps us get our work done and gives us a margin of power in the otherwise powerlessness of our positions.

More often than not, our groups are made up of people who sit physically close to us or who work with us on particular tasks on a regular basis. When there are changes to our work environment,

either through a restructuring of our work assignments or through physical moves, those alterations influence our social group as strongly as they do our work environment. For example, when my law firm in Washington moved from buildings it had occupied for many years to a new one, the attorneys chose the locations of their individual offices. The women who worked for them were able to see the blueprints and ask questions, but they had no say in the final decision as to where their desks would be placed. Little consideration was given to the fact that some of the support staff had worked together on the same floor or in the same office for many years and had formed their own friendships, backup systems and information sources. These informal secretarial groups were as important as the formal network of the attorneys in getting the firm's business done, yet no weight or value was given to preserving this network.

But perhaps that ambivalence about this dislocation was intentional. There are some in the management world who contend that disrupting these informal groups is a necessary part of any restructuring plan. Informal groups always represent some sort of a threat, however subtle, to management's control. These groups themselves probably don't realize this "power" they have when they get together and talk about things, maybe even laugh at the latest management scheme. As a way to circumvent this worker cohesiveness, management often invites the most outspoken member of a group to take part in planning office changes. The employee, solely by her participation on a committee, becomes an "insider" and often more pro-management as a result. She now has a personal stake in the restructuring through her participation in the planning (no matter how minimal). She has, in a way, become a "pawn to the schemes" of management.[36] It is hard to resist an invitation into the inner sanctum of decision-making — even if you suspect the reasons behind it.[37] When you have gone unrecognized for so long, to have any kind of voice is enticing.

But just as physical restructuring can change the social network of the office place, so does the imposition of new technology and work processes. As work intensifies, office staff are required to plug themselves into a variety of jobs and work situations, as well as learn

the new technologies. This means having less time to maintain inter-personal relationships. Familiar and fun exchanges such as office jokes, chitchat, or football and hockey pools, let alone going out to lunch, become less frequent. When this happens, much of the social fabric is damaged and the feelings of loyalty and friendship that workers had for each other and for management are undermined.[38] More important, when these groups are disrupted and work ceases to be a shared experience, something more is lost — other skills such as listening or showing consideration for another's point of view. These are the "instruments of co-operation" that keep the social group cohesive and productive in the workplace. They can atrophy from disuse just like a muscle in the body. When that happens, future personal interactions become awkward and unco-operative.[39]

When our social groups are disbanded or challenged, the "infor-mal knowledge network" of our workplace is also disrupted in the process. Our informal knowledge is, in effect, all the things that we use to get our job done. It consists both of the visible, or "working knowledge," that we have and our invisible, "tacit knowledge." Working knowledge is all our skills that can be measured and moni-tored — keyboarding (formerly known as typing), filing, answering the telephone, copying documents, sending faxes. In addition, it is all the processes we have in our head about how an office runs itself — the filing system, forms, billing procedures, telephone protocol — it is our "expert knowledge" about our jobs. We learn it as a tool of our trade.

Tacit knowledge, on the other hand, is that invisible, unspoken knowledge that we have about how to do our work. It is what allows us to make decisions, prioritize our work, troubleshoot, serve clients and appease bosses — skills that demand an incredible amount of dexterity, because we must not only anticipate problems, but also solve them once they arise. We pick up tacit knowledge informally through our personal relationship with our work environment. It could come from memories of special events, talking with someone in the cafeteria, being familiar with the personal histories of fellow employees — it is the information learned from the shared experi-ence of work. Tacit knowledge is the stuff that intuition is based on;

it is what fills the gap between learned knowledge and actually getting the work done.[40]

Zoë's world at the university was not only restructured physically when she was moved from a private office to a pool of secretaries, but the move also totally ignored her personal knowledge network that she had created at her old position. It also disbanded her close association with the faculty and students that she had dealt with on a daily basis — none of whom had any way to protest her situation. She did, obviously, move her knowledge with her. But now her work intensified to such a degree that she couldn't keep up with the routine work, let alone develop the same kind of close relationship with other students and faculty using the tacit knowledge she had accrued over the years at the university. It was these informal contacts that had made her work interesting and challenging, and now they were gone.

The same was definitely true of Stephanie in the bank. Once the bank made the decision to make everyone a "salesperson," her relationship with her clients was changed. She had, through personal contact, learned the names and account numbers of her regular customers in order to establish a personal relationship with them to make them feel comfortable and welcome. Now the bank, in effect, was tapping into this knowledge base and having her use it for their new purposes — selling products. This new role also put pressure on and altered the strong working relationship that the employees had with each other. Competition replaced co-operation. This restructuring proved to be a very effective way to redirect and disperse the energy and power of that group of workers.

In both of these cases, it was essential for management to disband the old groups in order to introduce new work structures and objectives; otherwise, Zoë and Stephanie would never have acquiesced. As was said earlier, this disbanding of old office relationships is necessary if restructuring is going to be successful. Informal groups hold the collective historical memory of an organization. If the group has existed over a long period of time, members of that group, collectively or individually, possess information about the organization that is not written down anywhere. They can tell newcomers about practices, policies and politics — the invaluable stuff that helps

workers adapt and adjust. Social groups also form an organization's conscience. Therefore, when management wants to restructure its organization, it doesn't really want too many people around who talk about the "good old days" (even if they weren't so good). So it's to the benefit of management that these informal groups are at least disbanded, if not removed completely.

Perhaps this is why the workers who have been there the longest seem to be the first to go in almost any restructuring scheme that involves a downsizing of employees. They leave by various routes, either through retirement, a buy-out package or firing, or maybe just because they are not able to survive in the brave new workplace and its demand for a constant adaptation to new technology. This leaves a group of employees newer to the company to create a different informal network. For management, this is much more desirable; it is assumed that these workers have a better understanding of the game rules of the new workplace. Daphnie describes how she's adapted to this culture. In her twenties, she knows that she has to "talk the talk" and has educated herself in the best ways to survive in today's office. Judith, who is in her early thirties, used a different route to help her understand the new culture of organizational change in the banking industry and the role she is expected to play there. She understands that what she knew about working in banks in the past is no longer true in the present. Judith is also aware, as are many other temporary workers, that during a transitory period when all the people with the historical memory are gone, there is no one around to tell people how things are done or who to avoid. There's not even anyone to ask where to go for lunch! In the life of the temporary worker going in and out of company offices, this absence is noticeable and critical.

Yet women like Daphnie and Judith are learning new strategies to help them integrate into the office and to build, however temporary, effective working relationships. For them, the personal networks may be replaced by computer networks like e-mail, but technological networks don't vibrate with the same social interaction as human networks do. These technological networks may also exclude those who lack the technological skills or don't have access to e-mail. It

may contribute to the growth of a new culture, but one that is much more controlled and limited.

But no matter what it looks like, it is hard to think about creating a new work culture when you are spending all of your time and energy surviving and adjusting to the restructured world that you find yourself in or moving off to as a temp. Indeed, how can you start creating something new when you're really not quite sure what it is you are facing? The short-term impact of any organizational change is confusion among the workers about who they are and where they belong. This uncertainty can, and usually does, make workers less efficient and effective in getting the job done, which in turn causes morale to sink to lower and lower levels during this period.[41] It can also make us question our own sense of value about ourselves within that workplace. When employers rearrange our work lives they are, in effect, telling us that what we have been doing in the past isn't of much value in this new world. It is, therefore, no surprise that we start doubting our own skills and worth. We too easily fall into the world of I'm "just" a secretary or bank teller or receptionist or temp. As we are shuffled around like furniture, not only are our visible, technical skills being tested and strained, but so are our tacit ones.

"Office work is intellectual work in the sense that it is a continuous exercise in problem-solving, searching out and creating information in order to bring the general rules and procedures to bear in each particular set of circumstances."[42] To do this work, we need to pull more out of ourselves than just our technical skills. Stephanie used her people skills and imagination in dealing with her customers; Loretta used her thoroughness and logic each time she, not her boss, corrected a discrepancy in one of the claims. Tacit skills are expected of us, but seldom acknowledged for what they are and the value that they bring to any work. When these skills are swept out the door as unnecessary parts of the new workplace, so is a piece of ourselves. It is this kind of emotional commitment that employers have come to expect from us, but seldom include in evaluations or with promotion and pay increases. And when management no longer pays for or respects this knowledge and integrity, it will largely disappear, and both management and us will be poorer for it.

If employees have become as interchangeable and disposable as old machinery, then so too are the individual and unique skills that each of us carries into the workplace. We are caught in this transitory period in our work where all the skills that we value the most are the least recognized and rewarded. Additionally, we are caught in the vicious circle where we don't have the time to do our work to the level that we respect and with the care that we normally would give to it. Our visible work that we are judged on and compensated for suffers because we're not putting our "selves" into it — we can't, there's no time. And if there is no time for that, there is little or no time for socializing and creating and maintaining an office culture where we can survive and grow.

Yet, we women have a valuable attribute that can contribute to caring for ourselves during the transitory time and to rebuilding a more caring work culture. Women are always expected to freely throw their emotional skills into any environment in which they find themselves. Women know that they bring body, mind and heart to accomplish work tasks.[43] The role of office workers often involves many of the same emotional demands as that of the housewife; and the largely male management traditionally has come to expect these "feminine" qualities in their office staff. We are expected to smooth out difficult situations, put on a good face for the clients, create a clean and pleasant work space (but not too personal), stay late if needed, make our bosses look good and sometimes even baby-sit or get coffee. We occupy a space in our office world between being the child and being the mother; the child when we are not given the credit for the work we do, and the mother for being able to take care of all those emotional needs of any organization. But why should that be? Too often, or perhaps just from habit, we fall into these roles from our own doing. When we say things like, "Well, I was going down to get my coffee anyway ..." or, "I really don't mind taking care of his kids," we are accepting that it is all right for these skills to go unpaid in our office, as they are in our homes. This does not place us in a strong position in relationship to the powers that be. But if we have the ability to care for others, why can't we use the emotional and intellectual skills to care for ourselves?

Stephanie

ॳ

FROM SERVICE TO SELLING
IN THE BANK

*Because when you work for a company with all
your enthusiasm, with everything that
you have to give and then, all of the sudden,
you have to go, it can cause a lot of resentment,
a lot of anger, a lot of questions
that you didn't get answered.*

Stephanie is a young woman in her late twenties, whose small physical stature conceals a huge supply of enthusiasm and passion for life. As a teenager, she immigrated to Canada from Ecuador with her family, who still form her support system for decision-making. She is the mother of two children.

I started working in offices when I left high school, actually before. I had a co-op placement at school in a bank; this was back in 1986. I would go to high school in the morning, where I took word processing and accounting; then in the afternoons, I was doing this co-op at the bank. I was running around a lot. We got thirty dollars for travel expenses, which was pretty good. At the beginning, it was boring — I don't want to use the word boring, but it was. The only thing they had me doing was filing. After I finished the filing, they

decided to train me on actual cash. For a few days, I just watched the head teller — how she served the client, how she handled the cash and what sort of questions she asked. Then she put me on her cash and then I was dealing with the clients with her cash. Then, within a week, they gave me my own cash. What helped me a lot then was that I had a second language, which was Spanish, and the area where I was getting trained had a lot of Spanish people. So I was able to help them with my English and Spanish, as well as with Portuguese. I was able to communicate with the customers, so they liked it pretty much.

But, of course, the day came when my placement finished. The manager said, "I'd like to see you in the office." I thought, "Well, this is goodbye, thank you very much." So I went in, and he said he had good news and bad news for me, and I told him it's always good to start with the bad news first. The bad news was that he didn't have a full-time job to offer me; the good news was that he didn't want me to go. So he gave me a sort of part-time and a sort of full-time job. They call it floating — floaters help every other branch that needs you — one week I'd be here, the next week I'd be in Etobicoke for two or three days; I would move around to different branches.

It worked out to be full-time even though I didn't count as full-time, although they did put me on benefits and everything right after I got hired. I was putting in a lot of hours — putting them together here and there. Sometimes I used to work on Saturdays, as well. I was busy all the time. Even though they called it floating, I never stopped. In a way, it was a very good opportunity to meet other people and see how they worked. It was a challenge, too. I remember I said to myself, "I will do this and I will enjoy it!" And I did.

After about a year, I decided to start a family and I got pregnant. I stayed home for about a year, and one day I said to

myself, "No, this is it, I really have to go back to work." I called this lady at this branch where I had made all these connections and where I knew all the co-workers. I said, "This is Stephanie, do you remember me, I worked in your branch?" And right away, when she heard my voice, she said, "Oh, the little Stephanie!" (They used to call me "little Stephanie.") I told her, "Well, it's time for me to go back to work. Do you have an opening or can you think of any other branch that needs somebody?" And she goes, "Well, as a matter of fact, we need a teller here. You need to speak to the manager; hold on, he's right here." She had told him how I work and all that. So it went very quickly. He asked me when I could start and I said, "Whenever you want me to start." And then he says, "OK, how about if you start Monday morning? Be here at nine o'clock." I was in heaven. I couldn't believe this. I got this job; it only took one phone call!

There was this Italian lady who lived beside me and we started to be back-yard friends, talking while hanging up clothes and gardening and things like that. She had always told me that whenever I needed a babysitter, she could do it. So on the Friday, I knocked on her door and said, "Now I really need you. How about if you babysit?" She was right next door so it was very handy and my son loved to be with her. So that's how I got childcare.

I started working on Monday morning. I was a teller, and within six months, the head teller was leaving because she was retiring, and they posted the job. My manager and the assistant manager came up to me and asked me if I would like to take that job. I didn't think I was ready because the head teller holds all the money, like all the treasury. I was so used to working with such a small cash, maybe fifteen thousand dollars. I told them that I thought it would be too much for me. I remember the manager said to me, "Stephanie, you can do it." It took me a good day or so to think it over because it was a big step. I would get a raise, and also it's a way to get ahead in your career in banking, if you want to think into the future. It's like a ladder; you keep going up, up, up. So I said, "OK, fine, I'll take it." That was all within six

months of starting back at the bank! Since I was the head teller, I was sort of supervisor, as well, to the other tellers. It also gave me the opportunity to see what other training I could get — not specifically outside the branch, but within the branch. I thought if I put my mind to it and if someone was willing to train me, I could learn so much more.

So what I did was when I wasn't busy or even if I was just standing waiting for a client, I would be all ears and keep my eyes open to the other side of the counter where the customer service was, to see what they do. They call it the side counter or "up front"; that's where they deal with all the drafts and GICs and RRSPs and all that wonderful stuff. When it wasn't that busy, I would go over and offer to help. They were surprised that I already knew how to do a lot of things. I told them, "Well, I've been watching!" After they saw what I could do and that I was willing to learn — and learn quickly — they decided to train me. So for six months I was doing the side counter and I was still the head teller. I was able to do it fine.

Then I saw a job posting for customer service and I said, "OK, I'm going to apply for it." It was in a different branch and I did go for the interview. I knew them, as well, because I worked with them before as a floater. They decided to give me the job. So I was in heaven again! But I was also sad at the same time because I was leaving my co-workers, who helped me a lot. They kept saying, "Don't leave, we'll train you because your next step will be assistant manager." But that's as far as I wanted to go in banking. I did not want to be a manager or an assistant manager. It's just the title itself, it doesn't scare me but ... how can I put it? I didn't want the power to manage people. I have my skills with people; I'm friendly with everyone. I always felt that if I had that sort of job title, I would lose that, I don't know how to put it, that interaction with others. They'd say, "Oh, here comes the manager!" You know what I mean? I like to be friendly and open with everybody.

This was at a time in banking when there was a demand for a lot of customer service and a lot of tellers. They still believed in face-to-face customer service, not so much in answering machines or the bank machine and all that — no, we had to interact with clients. I'm very friendly, so I was able to interact with a lot of clients; I was able to remember names, sometimes I even remembered their account numbers. I guess that's what made my job easier, that I was very open with everybody, with clients and everything. It was great!

I became the customer service/administrator. I was working for the manager and the assistant manager. I was sort of in the middle; I would be doing stuff for both of them, helping my own clients and working at my own desk doing things on the computer, dealing with cash, administration, general ledgers, debits, credits, transfers, basically everything. I also was sort of the branch technical expert, not because I studied this stuff, it's just that I love a challenge and could figure out how to fix the machines. So the job was really a combination of everything and that's what I loved about it. I stayed in that branch for seven or eight years.

I worked in banking for a total of eleven years. Oh god, did I see changes during that time! Those of us who worked there a long time would be so accustomed to doing stuff in one way, and then, all of the sudden, it was not done like that anymore. Then there started to be machines that could do the job, so we would have to be learning new things constantly. What is that called? Lifelong learning! So while I was there, I kept on taking these courses, but not outside of banking. I took some courses within the bank that they offered. I finished up to level four or five on courses to improve my customer service skills so that I would know the products and how to sell them better.

By the end, things were really different. I wasn't able to be so interactive with the clients; it was more like trying to get

their money all the time. So it was mostly selling at the end. As a customer service representative, I was the first to make an impression on the client, the first contact and the first person they're going to trust. So if I was talking to a client, just to be sort of friendly, at the same time, I was supposed to get as much information as I could from them about what their plans were for the future. Like they say, "Oh, I'm getting married and we're planning to put together for a house." I would say, "Oh, you're planning to get married — do you know we have loans? You're trying to put some money away for a house — do you know that we have a home owner's plan?" So that's how I'd do my selling. Then I would take them to my desk, sit down and explain the products. At the beginning, it was only the managers who could actually sit down and do the actual sale, the "sign here" — you know, do the deal. But, at the end, if a representative was good at doing referrals and sales, then she might as well do the whole thing. So at the end, I had to do a lot of sales. The bank was even thinking about going door-to-door to sell their products.

So that's where it was heading. At my annual performance review, they would tell me, "You got to sell twenty Master-Card's from this month to this month; you need to sell a mortgage in order to get a good review; you need to have at least four or five referrals for mortgages." It was sell, sell, sell! I found it to be very, I won't say bad, but a very deteriorating situation with your co-workers because it was a competition among ourselves. For example, say I was talking to a client about a mortgage and then later on, another representative said, "No, she talked to me first!" And then in the end, the manager would say, "Discuss it among yourselves and then whoever decides to take it, it goes to that person." So, in a way, this didn't fit with my values. Why would I have to compete with my staff, with my co-workers? We were able to work for so many years so wonderfully, and then, all of the

sudden, it was a battle between us and then it got out of hand.

It was really stressful. It was too much, too much. Sometimes I would stay there until six or six-thirty and they did not pay overtime. Morale was just terrible. I would go home and I would be in so much stress that I wasn't able to sleep because my performance review was coming and I'd think, "What have I done? Oh my god, I only have two mortgages, I have three more to go. I have to get that sale!"

And then they started cutting staff — first it was a loans officer, then tellers, and then, little by little, customer service didn't exist anymore. They wanted to put me back on cash because customer service became a place for risers, who are employees who have taken their Canadian Securities course and so were able to sell mutual funds. I was not a riser so I couldn't keep my job, even though I was expected at the same time to train this other person to do my job. But to tell you the honest truth, it didn't appeal to me anymore.

So I said, "OK, fine, I'll stay with cash." Then I got my cash; I worked there for a little while. Then two branches closed around my area and those clients were coming to our branch. So it was very hectic. The other workers from the other branches were sort of scattered all over the place — three would go to this branch, two would go to that branch. Then we were overstaffed and, of course, let's face it, in a company, if I'm making twenty dollars an hour and then somebody else comes and they offer him twelve dollars, who are they going to keep? So that's what it came down to and then I got offered a severance package. I could either take the severance package and leave then, or leave whenever they asked me to, when I would have to leave without a severance package.

That put me under a lot of stress. Because to tell you the honest truth, I didn't see myself working anywhere else because that's the only thing I had known how to do for the

last eleven years. That was my life. That was the only thing I could do with my eyes closed. But I said, "No, I can't wait until they say 'Stephanie, you're fired!'" because I knew they would be looking for whatever little mistake I made to let me go. So before it came to that, I thought, "OK, it's time for me to go." I didn't tell them that at first. I said I would think about it. I remember that day. I just went to my desk and I got out my personal stuff; I went downstairs and said to myself, "I'm not coming back. I'm just getting whatever they offer me because it's either that or nothing." So I would rather take something instead of nothing for all the years that I had worked.

I left that branch so depressed and saw everything as being just too much for me. Toronto was too big; the world was too big for me because I had nothing to offer. My skills were doomed because the only skill I had was within banking. I was so disappointed, as well. Because when you work for a company with all your enthusiasm, with everything that you have to give and then, all of the sudden, you have to go, it can cause a lot of resentment, a lot of anger, a lot of questions that you didn't get answered. What am I going to do? How am I going to feed my kids? What am I going to eat? Am I going to be on the street? What can I offer to anybody? I went through a very tough time.

And my self-esteem went very low. I can understand now when people do lose their jobs why they go through these depressions. Well, I went through all of that. I went to my doctor because I was under so much stress. I was on antidepressant pills; I was on sleeping pills; I was on awakening pills; I was on pills for my nerves. I was taking pills nonstop! After banking, there was no other life for me. Then the severance package came in. I hadn't been anywhere for the three months of my treatment for my depression, so the doctor said, "Stephanie, you need to get out from here!" So I

went back to Mommy in Ecuador with my kids. Mind you, my mom wanted to keep me but I said, "No, Mommy, I have to go and see what I can do for myself. I'm not a loser. I have to go and do something. I know there's something out there for me." So I came back and reality struck again: rent, food, clothes! What was I going to do?

I applied for employment insurance. I had never been unemployed; this was the first time. I have to tell you, and this sounds a little weird, but even now I have this feeling that there I was, not able to give what I had at a job, but I could apply to get money from the government when all I'm doing is just being at home. It didn't make sense in my head.

I thought about going back to another bank, but then decided that with all of the competition between banks, it would probably be just the same thing there, too. And I had had it with them! Then I thought I could probably be a receptionist, but I didn't have the right skills, really. My computer skills were limited because in banking, I only used the banking software. I never used the WordPerfect I had learned in high school. So there I was, I had worked with computers for eleven years, but only on that one system; now there were all these other things that I didn't even know what they were.

So I started doing this research about going back to school. I found this program that was a government-funded computer-training course. It was like another opening for me. I've got to tell you, I've always believed that doors close, but they have to open sometimes and that class opened a door for me. I thought that this was another opportunity and I was going to just give it the best that I could. They also offered a co-op placement. I did a co-op for four weeks with a big company who had the attitude that, "Oh, she's just a co-op — have her file!" So I started doing filing and it was like a never-ending story. Everyday, filing, filing, filing. So I said, "OK, you want me to stick to filing. I'm going to do it first of all for

myself, so that when I leave, I'm going to have it all done." And I did it all!

When I finished my co-op, my counsellor told me about this job where they needed somebody in reception, but it was only for a month. I said, "OK, I'm going for a job interview." I wanted to practise my interview skills; I got the job. I started Monday morning as receptionist. I didn't get much training. They just said, "This is the script you're going to use on the phone." They gave me about an hour to read the stuff, then I was left on my own.

After three weeks, I knew my time was running out, so I started to look for another job. But then my manager asked me to stay and gave me a choice: either stay on reception or move into administration. I decided to move on. So I started doing the administration and basically I was doing a little bit of everything again. I guess that's typical of clerical. You are hired to do one thing and then, all of a sudden, you have to do this little thing here and there. Right now, I love what I'm doing. When I'm doing a job that I enjoy doing, it is not a task, it's not just to get it done. It's mostly, I don't want to say personal, but it's mostly an achievement within myself that I'm going to get this thing done. And when I work in an office like this, I can never say, "This is boring," because there is always stuff to do.

Zoë

RESTRUCTURING 101:
LEARNING NEW THINGS
AT THE UNIVERSITY

I wonder how I am going to handle
the stress and the workload
in the coming years until I retire.

Zoë was raised on a farm in Quebec, but moved
to Toronto when she was a very young woman. At
fifty-two, she lives alone, except for her little dog,
and says that she loves her life. Her two children
are adults and on their own. She now has time in
her life to reclaim joys that she "may have let go
or put aside for a while" — such as reading and
going to French theatre. She admits to being cyni-
cal about her job, yet she enjoys it in many ways.

I got into office work as a second choice, and I didn't really
know what I was getting myself into. I wanted to go to
university and do different things, but my parents stopped
that. They said the boys should go to school and I should stay
home. What they meant was I would get married and have
someone to look after me. I grew up in Quebec, on a farm,
and this was their traditional background talking.

Anyway, I saw pictures of women working in an office
and I said, "Oh, that looks good." I saw some schools, too; I

had a brochure about a school in Quebec City and I said, "Yeah, I could go to a school like that and I could become an office worker," and that's how I did it. I went to Quebec City and did a Grade Twelve commercial special; I learned shorthand and typing, and within a year, I was ready to go and work in an office. And I did — it was in an insurance company. I was barely seventeen, so I was very happy to be able to go to work. I made twenty-eight dollars a week! So I've been working for almost thirty-five years. I'm now fifty-two and I stopped maybe three or four years when the children were home. Other than that, I've been working all along.

Well, after the insurance company, I went to work in a bank and that was a substantial increase in salary at that time. I always wanted to learn English and I didn't want to stay there — I wanted to see the world then! So I asked for a transfer to a bank in Toronto. I remember they called and they spoke some English to me and I managed to answer them. I came here all excited. I was nineteen. I was quite young. It was a trying time in a way because I was alone in a totally different culture. But I managed and it really was very exciting to be on my own. The hardest thing, I remember, was when I started to work in an office here, and of course I had to answer the phone in English, and I was unfamiliar with English names. This was very difficult, and to this day, I don't like the phone. I have a phobia about the phone!

After that, I went to another company that manufactured agriculture and construction equipment. By that time, I was married and then I had Stephanie, my first born, and I stayed home a few months. When I decided to return to work, I was just looking for something to do part-time. I looked in the newspaper and saw that they needed a bilingual secretary here at the university. And so I just phoned and was interviewed, met the man I was going to work for and that's how I got into it. That was in the fall of 1978. I remember the date very

distinctly because they had the staff strike that year. I was on the seventh floor here and I remember everybody left on strike just as I was starting to work and I was left alone here. It was so spooky!

So I did work part-time for a while. Eventually I went into a sessional job, which was ten months of the year. This meant that I could stay home with my kids during the summer months, which was ideal. Also, when I started the sessional job, right away I was unionized, which was good. But then I left my husband, so I needed to have something more permanent. At the time, there was a poet who was the master of a college who needed a bilingual secretary. So I met him and that worked out. I worked for him for five, six years. Then I wanted to move on to another position. There was a job as a secretary in the international student's office; I would be working for the former president of the university. I had the seniority, but was not given the job. I found out why — my boss had not given me as good a reference as I thought. I questioned him about it and he said that he had wanted to keep me there with him because he was working on a big conference, an international conference, and I was helping him. I was qualified in French, you see, and it was a problem at the time to find really qualified people. So I went to the union and there was a grievance, and I got the job right away. I was very nervous, in any case, to go from that job to the other one because after the grievance, I didn't feel wanted. But that is one instance when the union certainly has saved me and was there for me.

So, gradually over the years, I went from one job to the other within the university. It seemed to have been easier then, certainly that's the feeling that I had, that it was easier. There were more jobs advertised and it seemed to be easy to go from one to the other. It doesn't seem to be the case anymore. There seem to be a lot more applicants; they seem to

ask for a lot more qualifications. So that's my feeling, that it's more difficult to move around. In fact, you are stuck, I believe, especially if you get to a certain level, because there are a lack of openings for the higher levels. And I also think that your age probably holds you back.

And then, well, the technology makes all the difference. I remember at my first permanent job at the university, when I was the secretary to the poet, I didn't belong to a particular faculty or anything, so I was more or less on my own. One day I walked in and I found a computer on my desk. I had never seen one. I had no idea what it was or how to use it. So I worked at it on my own, with a little bit of frustration! That's how I was introduced to computer technology. And I must say, for a while, I had the same feeling about computers as I had with the telephone!

I gradually learned how to use it and as long as I had the word processing skills more or less, then that was all that was required of me on the job. I think at some point the administration got the message from the membership of the union that we needed to have some training. But I find that technology moves so quickly that you can hardly keep up. We constantly have people coming from the computer lab or whatever and upgrading this or changing that and they don't have the time to explain to us what it is that they're installing. It's there, so we have to use it. If they ask me how I feel about it, I tell them! I do! Sometimes I come across a piece of equipment or software and I say, "I don't like it," and I don't use it if I have the choice for a while. And then I come around to it; I'm forced to, really.

I wish at some point I could have stopped and understood, really understood, what's behind all of this technology. Sometimes I would get stuck, something would go wrong, I would push the wrong key and I'd get stuck. I have no idea how to fix it. It is very frustrating. Well, what I would like is

to start over again. If I had had that basic understanding and training in the technology and kept up with it or whatever, it seems to me it would be much easier now. But all the training and software came to me in pieces and I still don't understand it. The computer itself is great, although I find that it breaks down too much. It's not as reliable as it should be. I don't have a computer at home, so I cannot practise on my own. And I've always been so busy since I am here that I cannot take the time to fool around with things, which I would love to do.

Technology has made my job easier and more difficult at the same time. It has made it easier because it's so quick to change things, to redo things, to get things printed; but at the same time, it has brought, I think, a level of frustration to my working life that I hadn't expected. And you know that this is not going to stop, because more and more of it is coming. I've been wondering the last couple of years how I will react to this technology as I age and my brain doesn't react as well and I don't retain as much as I do now.

I wonder how my life in an office is going to be. It hasn't been pleasant the last few years because of the restructuring, not so much the technology, because you can handle that. But it's the restructuring that I have encountered here in this job that isn't so easy to handle. When it started, we knew there was going to be about fifteen people let go, but we didn't know who was going to get let go. So this was the first concern. I remember I was going on holidays and I was going to miss a meeting or something, so I went to the dean and I said, "I'm going on holidays and I'd like to know if I'm going to have a job or not when I get back." And he said, "No, you're safe." So that was the first thing — you would wonder whether you still had a job. Then you found out who was let go. I felt bad that some people were let go that had more seniority than others; there didn't seem to be any rhyme or reason. To some of them, they said, "OK, we're going to keep

you because you have more seniority or this and that." Then there were some instances when a person had more seniority than somebody else and she was let go. So I certainly felt guilty about that person.

After the restructuring, they piled even more responsibilities on me and they kept saying that yes, they would provide me support, they would help. It never came through. Before the restructuring, I was working in the French Studies and Modern Languages Department. I knew what I was doing; I was busy, but I could manage the load. And then one day to the next, I had to take over another department with very little support. So that in itself is scary. And then they piled up two departments together. There used to be two people in those two jobs — now you had one. Of course, they may have had time to slow down and take it easy, but not now. There are some periods here when it is so stressful.

Well, the union didn't seem to be able to do anything. There was a redeployment pool, so they were able to get jobs for the people who were let go. But, I mean, when it came to the restructuring, unless they were helping people who had to take over so much, they were not much help. I don't know how to explain it, but I think I've been disappointed by the union. Over the years, they would send us questionnaires and I would say, "Give me flexible hours, this is important to me." And then it seems that those issues really didn't appear when it was time to negotiate a new contract. So yeah, I felt disappointed.

The biggest adjustment we have had to make after restructuring is that, instead of having our own separate office, we're now all together in a central pool. So all those personalities are coming together. I feel that I'm rather quiet and I have to adjust to another voice. It gives you less time, I guess, to be friendly with students, with the professors, even with each other. It has made us more short-tempered with

each other. It hasn't been nice; it hasn't been nice at all. And you feel that management is just dying for one of you to leave so they can replace you with a younger person. They've even said that. I've heard that.

Some of my co-workers still had a very good sense of esteem about themselves. They were getting old, but they thought they knew better than the young ones how to do this and that. I was trying to be realistic at the time and I kind of disagreed with them. They've come around, actually, to my way of thinking. I can understand that there is a drawback to a worker who is older as opposed to a younger one. There are some trade-offs, disadvantages and advantages. But I know that I am very aware that management downstairs is just waiting to get rid of us. We were even downgraded in titles to "faculty secretaries." I'm still getting paid the same, but I do more than I did before and I'm just as efficient.

But we are so easily replaceable. It is hard to keep a nice view of your job. Sometimes you tend to say, "Oh, I'm 'just' an office worker." Although you know that the job you do can involve a lot of responsibilities. You can take a certain pride in what you're doing, but you're just in that whole bunch of office workers. And I don't think management has any respect for us. I don't think so. They look at your job, not at who you are. You can't help knowing that.

It has been difficult and I wonder how I am going to handle the stress and the workload in the coming years until I retire. Certainly I have to worry about that; it has affected my health. I was off last year suffering from major depression and the doctor then thought that I would have to be off for at least a whole year. It wasn't only the job, but it was a combination, I think, of different things. But I think my job was the most responsible in a way for my being sick.

I was telling someone recently that this was not something I expected to happen to me at this point in my life. First of all

because I come from a very traditional background, so when I got married, I expected, I suppose, to be able to count on my husband and everything. So I never expected to find myself in the position that I'm in today. It has been a big adjustment for me to accept this. And to know that at this point in my life, I'm not going to do anything else, that it's too late for me. And I could have gone somewhere else. But now it's not worth it for me because I have the seniority here. I mean little things are so important to me — the holidays, having lunch at one o'clock! I don't want to start over with two or three weeks' holiday again. But also there's the bigger disappointment that I know I'm not going to make anything else with my life; this is what I'm going to be. So I get frustrated because I don't dare to go somewhere else.

I see many young women who get into jobs here and they seem to feel lucky they got a job in the first place. It makes me think that maybe now it's changing and you are lucky to get a job. They're very satisfied with the benefits and the free tuition and to get into an environment that is kind of exciting compared to maybe working in a bank. And I think if someone is ambitious and does work towards a degree, there are possibilities to get ahead. I don't seem to have that ambition or to have the confidence in myself to go after some jobs here. There are some great possibilities here and if you're young, you can still make it. But there may still be exciting places to work on campus; something might yet come up for me. You never know which way life can turn.

Good Jobs, Bad Jobs
Flex Jobs, No Jobs

❧

CHEAP LABOUR

When they say fiscal restraint, they mean cheap labour.
When they decide on deficit financing they still mean cheap labour.
When they talk about productivity they mean cheap labour.
When they discourse on monetary reform, free trade, balance of
payments, responsible management, wrestling inflation to the
ground, revitalizing the economy, international competitiveness,
optimum production, sound investment climate, maintenance of
appreciable growth rates, they mean cheap labour.

— Helen Potrebenko, *Life, Love and Unions*[1]

IN A RECENT STUDY of the Canadian labour market, researchers found that instead of moving beyond the "jobless growth" of the last number of years, we have instead moved towards a job-poor growth featuring a "deficit of sustaining employment opportunities."[2] In other words, there just aren't enough good jobs to go around anymore. There seems to be a movement towards an "hourglass labour market" — at the high end are the secure and well-paid jobs of professionals and high-tech positions, and at the low end are the poorly paid, vulnerable service jobs. The jobs in the middle that many office workers were already in or could move into — like middle management — have evaporated with the levelling out of

corporate and government hierarchies. This is particularly disturbing for women who, together with young people in general, are ending up too often at the bottom half of that hourglass.[3]

This pattern in the types of jobs being created — "sustainable" good jobs being replaced by "vulnerable" bad jobs — ensures a precarious job market for all employees, including women office workers. As the authors of a study on the job-poor recovery in Canada comment, "Economic and social well-being are not ... just a matter of possessing a job. They are also and centrally about job quality, about the kinds of jobs people are able to get and hold on to."[4] According to their criteria, sustainable employment is much more than a fat paycheque. For one thing, it offers workers an opportunity for full participation in the labour market — not a just-in-time, flexible type of arrangement. It would provide enough security so that a person could relax a bit and count on having that job for a long enough period to be able to plan for the future. Furthermore, it would be employment that would appreciate over time and where career ladders and earning advancements were built into the structure. And, finally, sustainable employment would pay you enough to support yourself and your family.

This kind of sustainable employment sounds a lot like what many of us have always thought of as "good" office work. My job at the law firm certainly fit this criteria, as did Stephanie's when she first started working at the bank. However, the whittling away of our jobs from within have changed them enough so that now these once sustainable, good jobs resemble more and more the vulnerable, not-so-good jobs on the other side of the scale. We are slipping towards the bottom half of that hourglass. Gone from most of our work is any sense of being a vital employee in our workplace — we have become interchangeable parts to be plugged into whatever slot needs us. For instance, at my old law firm, secretaries that had enjoyed a certain amount of autonomy in their positions are now being lumped into teams and referred to as "Team Mates" — 50% of their evaluations would now come from Human Resources rather than individual attorneys.[5] Although they still remain "core" employees in the sense of their participation in the labour market, they have

become as faceless and "tradable" as any team player.

Likewise, as the global marketplace has crept into our workplace, security, which is what kept many of us in jobs we really disliked, is also a thing of the past. As one of my nephews who works in management said in rejecting my ideas as outmoded: There is no place for job security in the global marketplace. Even those of us who have worked at the same jobs for years, like Stephanie's eleven years at the bank, are not safe from downsizings and layoffs. And career ladders or merit raises for jobs well done are becoming almost nonexistent in today's offices — unless you work at the high-tech end of things like Daphnie. Even Zoë, who is protected by a collective agreement, has experienced the diminishing quality of her job, but at least as her work intensified, her union could insist that she get paid for the additional work.[6] We are caught in this transitory period where we have no choice but to accept a modified version of our once "good" jobs. As Zoë says about her own situation, "Certainly … our working conditions are not awful. Worse jobs there are. But how we ended up in this role under these conditions is … a reflection of society and of what goes on in that society."[7] And what is going on is the redefining of what constitutes good work. Not only is the current economic climate creating a vulnerable job stock for those seeking work, it is also destroying many of the good, sustaining jobs that we have had.[8]

We have good reason, though, to "grin and bear" whatever comes our way in our current workplaces — we already know that thousands of jobs have disappeared in the clerical field. But whereas in the past those lost positions have been concentrated in the "back office" jobs of word processing pools, file clerks and telephone operators, now they are moving into the front office, as well.[9] In a follow-up to the analysis of clerical occupations in the Toronto area that she did with Pat Bird in 1997, Alice deWolff compared the 1990 and 1995 census for the Toronto area to see what was happening to clerical jobs.[10] Among other things, her findings showed a "considerable job loss among more senior office workers." For instance, in the general secretary category, 19,339 jobs were lost — that represented a 30% job loss for that category alone. In addition, 2,315 legal secretary jobs disappeared — translating into a 22.1% job loss. For

the most part, these were full-time, full-year jobs that were gone. What was interesting, if not surprising, was that at the same time, there was an increase in the number of customer service clerks, partly due to corporate restructuring of services into call centres. deWolff is quick to point out that this didn't necessarily equate to an increase in "quality" jobs — "part-time customer service jobs more than doubled, while the income of both full time and part time earners fell." In fact, her analysis showed that right across the clerical board, part-time, lower-paid employment was on the increase.[11]

In Canada as a whole, gains in paid employment during the 1990s have come almost exclusively from a net increase in part-time work as the number of full-time employees declined.[12] What this implies is that the bulk of new jobs being created "are *not* stable, secure or sustaining."[13] In the United States during the same period, 20% of all net employment growth was part-time.[14] However, what we don't know is the nature of the 80% of full-time jobs that were created.

THE MANY FACES OF THE CONTINGENT/NONSTANDARD WORKFORCE

I saw an advertisement on a job board recently for a "temporary, permanent part-time secretary" — I wondered at the time if all those precarious short-term words would add up to one core full-time job.[15] Most likely, it did not. The word "contingent" implies "something whose occurrence depends on chance or uncertain conditions."[16] In today's employment scene, it comes in many guises, some of which are camouflaged as full-time work. We all know the obvious cases[17]: someone working full-time on a year-to-year contract; the temporary secretary in your office or the word processor working for a contractor after her department has been outsourced; the cashier working shifts at the supermarket and the teenager serving up fries in the fast-food joint. They are now joined by the customer service representative working shifts and being monitored as she answers your call. Who knows, maybe even the boss you're working for has been leased!

Whether hired through an agency or directly by the company, the advantages of a flexible workforce to management are obvious — it can be "swelled or deflated like an accordion at a moment's notice."[18] Employees become more easily "disposable" if they are not part of the permanent, core staff.[19] And, there is the added advantage, that the high cost of paying benefits — such as healthcare, pensions, sick leaves and vacations, workers' compensation and employment insurance, which can range from 30 to 40 % of the payroll cost — is eliminated.[20] Also eliminated is the expectation of an increase in pay as the traditional reward for an increase in experience, not to mention loyalty.

It is not surprising then that many other work environments have followed the factory model of the flexible, "just-in-time" workforce to cut overhead costs. In manufacturing, the purpose of this model was to deliver parts to factories only when they were needed on the production line and thus eliminate inventory costs. However, there was another agenda — "[T]o create a JIT workforce of part-time, temporary, 'contingent' workers whose shifts and workweeks ... were tailored to the exact production needs of the assembly plant."[21] The same principle can be adapted to offices where the number of high-paid, full-time core employees can be trimmed back and part-time employees hired during particularly busy times. At the law firm where I worked, full-time legal secretary positions are being left vacant and filled by temporary employees. As Suzi says, "There are at least ten secretarial openings that have been vacant for months. The firm just brings in temps. Anymore it's impossible to tell who works here and who doesn't."[22] Perhaps this is only a short-term management strategy while they wait to see the results of the teaming up of their core, full-time secretaries. This way, they can add or subtract from their employee roles without the high cost of severance pay or buyout packages. But it creates a vulnerable situation for all involved — core employees see what were core positions being staffed by temps, and the temps who know that they are filling core positions are aware that their future is unknown and out of their control.

Judith was in much the same position as those temporary secretaries in the Washington law firm. She accepted long-term

assignments in banking and government offices to help set up new departments; she was part of the new teams. However, once the departments were up and rolling, she wasn't offered a permanent job, even if there was one. The bank could use her knowledge and experience and when the job was finished, let her go without any fear of having to pay her a high severance package. She is part of this available, ever-growing flexible labour market that gives business a pool of skilled, part-time workers who can be hired at less than the hourly wage of full-time employees with no benefits and no long-term security.[23] And while such long-term contracts as Judith's — worked out between employer and employee — are perhaps the best that the part-time world can offer, they still hold the same insecurities as all the other nonstandard/contingent jobs.

A young woman I met at Times Change provides another example. The accounting department of an insurance company hired her on a four-month contract. She was a fully-qualified bookkeeper, but earned far less for this job than her experience would have demanded in a full-time core position. But precisely because of her experience and her abilities, she did her job so efficiently that she completed the work in just two weeks. The company was so pleased they told her they would not need her services anymore. This employer used her as they would use any other commodity — to meet a need. When that need was satisfied and they had their work done, they could just let her go; she, on the other hand, was once again unemployed. In the just-in-time workplace, her shelf life was over.

Even a nonprofit sector depends on a contingency workforce. After leaving the bank, Stephanie found herself in a contract job at an employment counselling organization. Her employer receives funding from a government agency for one-year periods. There is no guarantee that the funding will be renewed from one year to the next. Therefore, her position, as well as those of her co-workers, depends on how "the political winds are blowing" at funding-renewal time. It is an insecure position to be in, especially as a single mother. While she does take on increased responsibility and duties in her job, the enthusiasm that she feels is tinged by the fact that her job could end on March 31 of any given year.

Not just individual jobs, but whole departments within an organization can be declared inessential and are then outsourced — removing them from the company's "organizational structure," but keeping the physical work of it within the company office space. When the operations are "sold" to an outside contractor, the employees are, in effect, fired by their original employers and then "hired" by the contractor, who then sends them back to their original "owners" to do their old jobs. The company wins all around by retaining the expertise of these seasoned employees at lower rates of pay without incurring the expense of paying benefits. The employees, on the other hand, seldom earn the salary or benefits nor have the security that they had enjoyed from their original arrangement.[24] Their situation is precariously dependent on the wiles of both "employers" (much like temporary workers). If the contractor is outbid and loses the contract, the workers are out of a job without anything due them from either their new contractor or their original employer.[25]

The just-in-time model even allows businesses not to pay any salaries at all by choosing to use volunteers to tackle the backlog. I don't think anyone would argue the value of volunteer work when its labour benefits a nonprofit organization or cause. But why contribute free labour to a for-profit organization/corporation? I know that Daphnie sees volunteer work as a job search tool; it is her foot in the door and a reason to get out of bed and dressed in the morning. She sees it as a way of learning skills and networking. In some cases, however, candidates who have applied for jobs are encouraged to volunteer first and are given the impression that a job may result from it. But that isn't always the case. A friend of Meg's told her that she worked in a bank with other "volunteers" for six months without pay, thinking that a job was at the end of the "training."[26] No one was hired.

Of all the nonstandard forms of work, this is the one we should be most wary of, especially when volunteer labour is being built into the downsizing strategies of our employers. We should be careful about giving our labour away freely. It is, after all, "the only commodity most of us have to trade on."[27] It is particularly important that women understand this lesson. Too much of our work

has too often gone unpaid. If we decide to give our labour away, we are, in effect, saying that our skills are worth nothing. If we believe this, so too will our employers who can then use it as a bargaining tool against us to negotiate lower wages and benefits; if we don't want to accept a low wage for what the employer could get for "free," then too bad. Volunteer labour also weakens the bargaining position for the already anxious core and other nonstandard employees.[28]

There always has been part-time work in the office. However, in the past, temporary workers were hired to "fill in when the permanent employees weren't at work."[29] The temporary staff was used to complement the work of core employees — not to take the place of them. The purpose of being a temp was to have some flexibility in scheduling your work life to reflect your home life, and for some to pick up extra cash or fill in between full-time jobs. Some women have always chosen to work on a temporary basis. Sam has made her living at it for thirty years and Norma was able to move into a new city and survive on the salary she was able to make temping. Temporary work has saved many of us, including me, from destitution when we were in between full-time core jobs. It was our "choice," not our only alternative.

What's happening now is different. The contingent workforce is becoming even more of a permanent part of the employment scene. Labour is becoming a disposable and competitive tool in the global marketplace.[30] This depletes the supply of those sustainable, secure positions and puts many of us on a volatile and precarious track of employment. Before long, nonstandard work will start to be the norm rather than the exception — it took less than two decades for the automatic teller to replace the person![31] And, as the above indicates, this trend towards more and more unsustainable jobs being created is a serious one about which we should be concerned.

But there are many who doubt the seriousness of this — the economy is booming, so shouldn't that mean that everyone within it is doing well? Part of the problem is that it is difficult to get an accurate count of the numbers of people who are working involuntarily in nonstandard work situations — who are caught in

the slippage from sustainable core jobs to unsustainable nonstandard jobs. By its very nature, the size of a contingent workforce fluctuates up and down, depending on the needs of the economy — and as noted above, many contingent jobs look like full-time jobs because they are long-term, and are counted as such. So it is hard to pin down a number — especially for categories like leased or subcontracted workers. But, if we can't determine the exact numbers of employees working nonstandard jobs, what we can count is the incredible growth of the temporary staffing industry in North America — those numbers alone indicate that the nonstandard, contingent workforce is alive and well.

THE BOOMING BUSINESS OF NONSTANDARD EMPLOYMENT

Back in 1969 when I worked for Kelly Services in New York, they were certainly already the name brand in temporary services. But at that time, there weren't a lot of temporary agencies and the ones who were in operation were mainly providing temporary office and labour services. Thirty years later, the temporary staffing industry is one of the fastest growing industries in North America. Kelly Services reported in their third quarter earnings in October of 1999, sales of (US) $1.092 billion with net earnings of (US) $25 million. They ranked 374 on the Fortune 500 listing for 2000 — well above such companies as Mutual of Omaha Insurance (379) and Barnes and Noble (443).[32]

This is big business — all made possible by an increasing demand for a more flexible workforce. There is an incredible increase in not only the number of temporary staffing agencies, but in the volume of the employees that they hire. From 1982 to 1992, the number of people employed by temporary-help agencies tripled.[33] Since then, the average daily employment in temporary-help agencies has risen steadily — from 1.35 million in 1992 to 2.94 million in 1998.[34] Today, Kelly Services alone, employs 750,000 employees annually; their competitor, Manpower Temporary Services, is now the largest employer in the United States, with over 800,000

employees.[35] Even though these numbers represent a small percentage of the overall labour market, they do indicate a rapidly increasing contingent workforce — an employment pattern that by most indicators, is likely to accelerate.[36]

Part of this amazing growth can be explained by the incredible diversification of the services offered by staffing agencies. They have become "clearinghouse[s] for buyers and sellers of skills."[37] As companies downsize their core employees and decrease the size of their "brick and mortar" structures, the temp industry is moving in and offering them a wide array of business services. As always, they provide temporary employees; but now they span every field from traditional office staff to lawyers and engineers, health specialists and scientists. In addition, they have added services that reflect the changing nature of business in this global marketplace. For instance, if a company wants to outsource the mailroom or records management centre or any other department, the staffing agency will move in to manage it. A company can even decide that it doesn't want to have anything more to do with the bothersome chores of administering their human resources, and the agency will lease them full-time employees and thus assume responsibility for taking care of things like payroll and workers' compensation. It is not hard to see why this industry has been growing so quickly. Nonstandard work has always been their business — their eagerness to expand to meet the market is a good indication of the prevalent trend towards a more flexible workforce. If we needed any further proof, temporary workers in Canada and the US can now celebrate National Temporary Help Week every autumn![38] It is not hard to imagine, as has been predicted, that sometime in the future a day will come when "no one will ever again be employed by the people for whom they perform services."[39]

THE TEMP AGENCY

For the time being at least, office workers still continue to be the largest contributors to the current success of the staffing industry — total wages paid to the office/clerical sector more than doubled from

1990 to 1998.[40] That does not, of course, indicate that the pay doubled for individual temps, but rather that the number of employees increased. And that means a significant number of women are depending upon these flexible and unstable working arrangements for their economic well-being — many of them doing so involuntarily.[41] All of these women share one thing in common: they are in a volatile and precarious employment environment that is controlled not only by the market demand for their skills, but also by the efficiency and good will of the agencies they are registered with.

A good many of us who have done office work during our lives have used the services of a temp agency at some time or another. My own experiences were never particularly fulfilling or rewarding — except for the time I worked through a small agency in Washington, DC, who gave their employees a week's paid vacation after six months of work, and presented each of us with a T-shirt that read (front and back), "Life is a temporary assignment. Make it work!" I always was a bit uneasy about the control the agencies had over my work life, but I was much younger then and the economic times were very different. In today's marketplace, our biggest challenge to getting a job is often keeping our name at the top of an agency's list. A Toronto-based friend of mine was looking for a temporary position in the late 1990s. She went to one agency where they advertised "that all ... employment and career expectations are met with the highest level of personalized customer service."[42] At her interview, she was totally overwhelmed by the piles and piles of applicants' files that were stacked high on every available surface of the counsellor's cubicle. The counsellor sitting amidst the piles tried to pleasantly reassure her that something would come up, but as my friend said to me, "I knew then I didn't have a chance in hell."[43] The temp is at the mercy of whoever is in charge of her file — if they can find it — and generally this is a staff person overwhelmed and attempting to fill her own quota.

But, from the temp's perspective, the counsellor is the person who too often stands between her and the rent payment and food budget. Sam, who had successfully survived by doing temporary work for most of her adult life, suddenly found herself beholden to a

young woman who would or would not return calls or find suitable, better paying work. The relationship put Sam in a vulnerable and condescending position — one that she could not walk away from easily. Norma registered with at least three agencies at a time — knowing that it was her responsibility each day to check in with her counsellors to see if there was work for her.

Job seekers today have to be very proactive in their job search. They must become "portfolio workers," bringing an ever more diverse set of skills, experience and knowledge with them to the agency.[44] It takes an enormous amount of energy — both physical and mental — just to ensure that your name does not sink to the bottom of the availability list. And all of your efforts don't even guarantee you employment, because the agencies control who gets called, how frequently and for which types of jobs.

As those piles and piles of files in my friend's story indicate, there is just more competition for the jobs that are available. As employers restructure their workforce, they dump their skilled, full-time core staff into the pool of contingent workers, adding to the already substantial group of temporary workers making the rounds of agencies, job boards and employment services. These newcomers are in competition with the long-time temps like Sam, Norma and Judith for the well-paid, long-term contract jobs that may, if they're lucky, lead to full-time sustainable work. If these downwardly mobile newcomers are young and well-trained in the new technologies, they move to the top of the pile of any agency recruiter. Employers who created the situation in the first place benefit again by being able to pick and choose among the trained temporary employees they have just laid off the next time they need extra help.

Temporary work — especially if it is involuntary — is not sustainable work for the women compelled to take it on. On average, these women work fewer hours at lower hourly rates than their full-time counterparts — sometimes by as much as $5 to $8 per hour.[45] By paying less, the value of the worker's labour is also diminished by the employer, be it the employment agency or the company using the services. Unfortunately for the workers, their living expenses aren't reduced proportionately to the number of hours they're able to work

each week.[46] Also, where once temporary work was predictable as a source of income, today it is chancy at best, nonexistent at worst. Many temporary workers, especially if they are single and over forty, no longer feel they have choices about where and when they will work.[47] In the past, Sam had steady enough temporary work to be able to take weeks off to take courses or a vacation; today, she agonizes when Friday arrives with no assignment in place for Monday. Norma sticks close to her phone because she is afraid that if she leaves town for a vacation, she'll fall to the bottom of the list while she is gone.

There is another kind of insecurity that these workers face. When temporary workers make their way into offices, as Judith and Norma found out, core workers often just don't have the time or the inclination to help them or even to welcome them. The presence of temporary workers most likely will be read as a danger signal, especially for office staff who have experienced any kind of downsizing. Often, a temporary or contract position represents a good job gone; it might also be a sign that further cost-cutting strategies are in motion that might terminate other full-time positions.[48] This cold reception denies the temporary staff access to an office culture in which to do networking or even find friendship.

Contingent/nonstandard employees are also isolated from their own particular reference group, namely, other temporary workers. So it is impossible to find out about jobs, good agencies or effective and helpful counsellors through networks. This means that an individual woman has to negotiate working conditions and salary concerns on her own without the support of co-workers or even personnel/HR departments. A friend of mine in California, Lorraine, was working a four-month contract in what was supposed to be a "temp-to-perm" job. During her tenure, she took on additional responsibilities and repeatedly asked to get feedback from her manager about her performance. But, as she wrote me, "as a temp, there was not a system of performance evaluation or training ... The only specific thing my manager said regarding my performance was that he had no complaints."[49] She also contacted the agency on-site supervisor who promised to call the manager about the performance evaluation —

she never did it. So Lorraine took a more assertive approach and talked to the vice-president of this newly configured department, who encouraged her to try to pursue this position. When she approached the manager with this information, she was told that she really wasn't "cut out" for that job, and anyway, the manager wanted to look at more "senior personnel" to fill it. Lorraine was left unemployed again. As Lorraine learned, lack of support and networks leave women in the office even more vulnerable in the unfriendly economy. In such precarious positions, women may not question their rights because their courage to do so may border on foolhardiness. In today's job market, nonstandard contingent workers constantly walk the precarious line between a job — any job — and unemployment.

WORK IN THE NEW E-ECONOMY

When looking at the nonstandard jobs being created in this "new economy" of the global marketplace, perhaps there is not a better example than that of a call-centre representative. The call centre industry — not unlike the temporary staffing industry — is one of the fastest growing businesses, at an estimated annual rate of over 20%.[50] "Help supply services employment [where call-centre employees are counted] grew from 0.6% of the total private economy in 1982 to 2.7% in 1998 — a rate of growth surpassing even computer and data processing employment."[51] In Canada, it is estimated that over 300,000 people are working in the more than 6,000 call centres in operation, generating over $50 billion in sales (the US call centres generate $500 billion in sales annually).[52] It is not hard to believe that this is one of the most dynamic markets today — call centres are everywhere. In our day-to-day lives, we encounter call centres in almost anything we try to do — whether ordering airline tickets, getting our computer fixed or calling the local university. The person answering the phone can be anywhere.

For employees, call centres have become the new electronic "back office" where some jobs are becoming the "information age equivalent of flipping hamburgers."[53] However, there are others who believe that these jobs are the entry into the new economy for those who

have been forced out of the old. In Canada, colleges and business schools across the country have developed diploma-granting programs to teach the skills necessary to be a call-centre operator — or the "voice of e-commerce," as one educator put it.[54] One Ontario college offers courses that include everything from Telesales, Quality Customer Service and Interpersonal Dynamics, to Geography for Telemarketing.[55] The costs for these courses range anywhere from $1,000 to $3,000, depending on the school. At the end of the training, which can take one year or two, you might be lucky enough to land one of the "upper-end" agent jobs paying $13 an hour.

The proliferation of call centres is due partly to businesses consolidating their services into one centre. This has been especially true in the banking industry. Stephanie and Loretta and their other co-workers have seen the numbers of tellers plummet as bank branches have closed and tellers have moved into call centres. Here they become "sales and service specialists," but instead of working face-to-face with customers — or in "real time," as the jargon goes[56] — they now connect with customers by telephone in a room with five hundred or so other workers. These "sales and service specialists," as they are now called, are electronically plugged into a world where they are monitored and where quotas outweigh customer service in their evaluations. As technology eliminated one job, it created another — one where personal supervision and contact is replaced by electronic monitoring.[57] And since most call centres can operate on a 24-hour basis, they do. So operators may be required to change shifts every couple of weeks with at least one of those shifts being at night. In this brave new world, a co-op student like Stephanie can no longer move from being an entry-level teller to being offered the job of assistant manager within eleven years. When present, the ladder out of a call centre is steeper, with longer spaces between the rungs.[58]

In fact, there seems to be a "reverse career ladder" in place. Middle-management jobs, such as loan officers in banks, have also become "back office" positions. I met a young woman who had a master's degree in science. She had worked for many years as a loan officer at a bank. Recently, she and all of her co-workers were placed in a central call centre. There she not only took care of her loan

clients, she was responsible to answer questions about and sell many of the bank's other services. She was adamant at first that she was not a call-centre representative. But her view changed somewhat when her manager announced that there would now be quotas and that her calls would be monitored to ensure quality standards.[59]

I find it hard to imagine that call centres will produce the same kind of quality, sustainable employment for women that the "old economy" provided in places like banks, insurance companies and universities. There may be some who see no difference in the job of a teller or loan officer or telephone operator, whether she is sitting in a call centre or behind a wicket. In fact, they may think of this as the challenge of the information technological age. Stephanie maintained a very personal relationship with her job, her customers and her co-workers. That is almost impossible to do in an environment where you have quotas, your calls are being timed and monitored and where your chances of dealing with the same person more than once are slim. Sure, jobs in telework can vary as much in quality and pay as in any other business — from Louise working minimum wage telemarketing jobs to the young loan officer in the bank. But what all of these jobs have in common is their insecurity. The call centre business is about improving "cost effectiveness and profitability." With all the "attractive tax incentives, site location benefits and training and education grants" that governments provide these companies, there is nothing keeping them from relocating if they get a better deal elsewhere.[60] They are never "permanent," and neither are the jobs within them. How do you plan a future around that kind of instability? Yet even given their unstable foundations, more and more women like Louise depend on these jobs for some form of income.

We will have to wait and see if office workers find their way into call centres, or, if not on the phone, maybe find themselves turning into "e-slaves" answering other people's electronic queries in the new economy.[61] Experts are already predicting that some administrative occupations will be "significantly reduced or restructured as workplaces develop integrated e-business systems."[62] It is all too new to have a really clear idea of where it is going. Obviously, those whose skills are no longer in demand, like word processors, may be the first

to consider these options as new career opportunities. Louise thought her chances of finding more secure work lay in the office. But with the glut in the marketplace, her skills were not enough for her to even gain an entry-level job into office work. So she has stayed in telework, where she has the experience. But even with experience, she can only get jobs at the low end of call-centre wages. Her work, like that of all her co-workers, is insecure and she has no control over when and where she will work or how long the call centre will use her. Lucky for her, she has many years of experience living on a diminished wage — a wage that would not see her through the month if she was not as frugal and careful as she is.

MAKING ENDS MEET

Nonstandard work — contract, temporary, part-time, shift work — is not good, sustainable work. By its very nature, it is flexible, insecure, void of any career ladders or advancements and, in most cases, pays less than its full-time equivalent. The reality is that this type of work makes many women, as Sam poignantly points out, "desperately needy." How do you take care of health emergencies, rent increases, kids' shoes or maybe even a day off, if there is no guarantee that you will have a job tomorrow or next week or next month? As one expert in the field noted, it is work that "dooms a great many people to a much lower standard of living than many of them enjoyed as core workers."[63] Not only do they make less salary, they have little or no health or long-term disability insurance, no fringe benefits and nothing to "buoy them in case of disaster." In fact, the precariousness of their situation makes it hard for them to get out of this work and into something more secure — even if it were available.[64] As Margaret Maruani writes in *Le Monde Diplomatique*:

> Part-time means crisis time. However, it continues to be described benignly as "reconciling family and working life," or in terms of a flexibility that women are said to want. Which women? On what terms? For what kind of wages? For what

hours? ... [O]ver the years, part-time working has become, de
facto, a form of under-employment reserved for women, creating
a process of hidden impoverishment. Hidden because every
mention of part-time working is muddied with talk of "choice"
and flexible or reduced working hours.[65]

In the US, out of the more than 2 million people who were working
for temporary agencies at the end of 1998, 80% said they were doing
it involuntarily — they just couldn't find full-time work.[66] As one
temp commented, "One person's 'flexibility' is my 'never-know-if-I'll-
be-eating-next-week' nightmare."[67] Needless to say, many of us
would like to have more free hours; however, we can't and don't want
them if we have to give up our secure, better paid, full-time jobs. For
single mothers like Joan and Stephanie, the luxury of flexible, part-
time work is a dream. The women here, except perhaps Meg, Lucia
and myself, want and need full-time jobs. Sam and Norma, who
chose temporary work as their career path, find that the current envi-
ronment has become too precarious even for their trimmed-down
lifestyles. Many women today feel they have fallen into a trap not of
their own making. This is why so many of us stay in full-time jobs
that aren't fulfilling, don't pay enough or that may even threaten our
health.

It is encouraging to hear that there have been efforts made to
protect the rights of the contingent/nonstandard workforce. For in-
stance, there are groups in the US who are developing standards for
temporary agencies intended to provide more respect for, and protec-
tion of, the rights of the worker. One California group has developed
a "Code of Conduct for Temporary Placement and Staffing
Agencies." This covers many of the issues that temporary workers
have historically faced when dealing with a temporary agency. The
Code addresses such concerns as a fair and respectful interview
process; getting information in writing about fees; available positions
and benefits; a standard for assigning work so that temporary workers
are given enough advance notice and details in writing about assign-
ments; not being penalized for turning down an assignment for
legitimate reasons; and, it points out that "Workers should earn a

living wage and have realistic access to benefits."[68] Unfortunately, the temporary staffing industry is not eager to adopt this code of conduct. Yet, the code may encourage enough employers to think about the issues concerning their applicants, and make enough temporary employees aware of their rights and give them the courage to stand up for those rights.

Another positive sign has been some recent court decisions in the United States and Canada that ruled in favour of the rights of temporary workers. In the Ninth Circuit Court of Appeals, a US judge ruled that perma-temps — people hired as contract workers who stay for years in the same position — had the same rights as full-time core employees and therefore were due the same benefits and pay.[69] Unions are also challenging these perma-temp contract positions that exist outside the bargaining unit.[70] In Toronto, a judge ruled that a contract employee was due a severance package from her former employer on the grounds that her employer had referred to her in performance reviews as a "full-time employee."[71] In another case, a woman was replaced on a temporary job that she had held for two years after she was absent a few times without permission. The agency sent a replacement and terminated her employment immediately, providing two weeks pay in lieu of notice. The employee sued the agency for wrongful dismissal. The judge ruled that "a temporary employee who knows his or her job will eventually end is still entitled to notice before he or she can be terminated, although the amount of notice required will be less than if the job were permanent."[72] In the US, there is also a coalition of labour unions, civic activists and advocates for minority rights who have formed a nationwide organization — the National Alliance for Fair Employment — to address the rights of the contingent nonstandard employee.[73]

But when all is said and done, the best policy that could be enacted for the economic well-being of women and all workers would be the creation of more good, sustainable jobs. If this is not realized — and realized soon — more and more women will find themselves on the slippery slope into poverty.[74] Judith and Louise hang onto their independence and their well-being by watching carefully where their money goes. They don't own cars, take trips and

never buy on credit. Norma immediately cuts out all the extras except cigarettes when her employment market dries up so that she doesn't end up broke with bills to pay. This all creates a living environment filled with an uncertainty that matches their work environment. This downward spiral of the deteriorating workplace and personal space is pushing many women office workers into a world of debilitating stress and general health breakdown.

Norma

ᶜᵕ

THE INS AND OUTS
OF TEMP WORK

Now, I'm flexible by choice,
but also by necessity.

Norma is a single woman in her early forties who
describes herself as a "partial realist." She grew up
in a large Irish family in Quebec; her father
worked first as a pilot and then as a mechanic.
Her mother was a substitute teacher who, at age
forty-nine, returned to school and became the
first person in her family to receive a university
degree. Norma graduated from school at age six-
teen and began her working career. She has
moved "four or five" times, back and forth, across
the country. Norma claims that the only thing she
has done consistently over the past twenty years is
smoke cigarettes. She has been living in Toronto
for the past ten years.

I've always been self-supporting. My first job was working in a
toy factory on an assembly line. I lasted three weeks. I hated
it! And that was my introduction to working for a living. It
was September, and they were getting stuff out for the Christ-
mas rush. They made little plastic teacups and tea sets; that's
the line I worked on. They were pink, yellow and blue. The
place was horrible. If you forgot to punch the clock in the

morning, didn't matter what time you got there, you were docked fifteen minutes. If you were late, you were docked fifteen-minute increments. And the most embarrassing thing was if you were in the washroom too long, they came to get you. But before they came to get you there was a PA system, and they told you to hurry up and get out. Oh, it was not good.

The second job I had was through an agency in Montreal. I worked at an insurance company. Didn't hate it as much as I hated the toy factory, but it was "working" and it took a long time to get used to that. I stayed there for a while. I also worked at a railroad in their microfilm department, micro-filming all their files.

Then when I was nineteen, I went out West and did a complete reversal and worked outside. I did everything but waitress during the time I was there. I figure I'm the only person alive who never waitressed in Banff. I did a lot of desk-clerking and worked at the shops in the ski areas. I did that work for ten years. The job was seasonal; I worked in the summer and the winter, with no work during the months between ski season and summer, and fall and ski season! So I survived, basically, by the seat of my pants. I enjoyed it for the most part and I was able to use a lot of energy I had.

I think also that's where I actually learned to work. Work to me is about self-sufficiency and independence, and I had that there. It's also about a regular paycheque, success and responsibility. As I'm getting older, it also means that if I work now, and work properly and earn the wage I deserve (famous last words), I can actually afford to retire at some point. Now that's a really new thought for me!

I came to Toronto in 1986. I figured, and it sounds weird, that since I was now in the city, I should adopt city rules — work inside! So I figured I should learn to type. I took more typing courses then you can shake a stick at, and failed every single one of them. Then, when computers came out, I got on a computer and flew. I really like computer technology. My

first job in Toronto was as a switchboard operator, and my last job was executive assistant to a vice-president of research. So in ten years, I've gotten right up the ladder, which feels really good. I've learned a lot and taken a lot on myself.

But I was fired from my last job as executive assistant, and being fired shakes your belief in what you can do and how well you do it. That experience also taught me to distrust my gut feeling, or maybe to trust it more. I remember thinking when I got that job, "Oh, this is permanent. It pays this much money. I'm an Executive Assistant!" I disregarded the personalities I would be working with, the work styles involved, the hours involved, the demands involved and I got blown away by all this big stuff. Why did I say yes to that job? I was working for a research scientist. And I'm not a scientist. I'm not an academic, by any stretch of the imagination. I don't have the work ethic that scientists have. They are very focused; their lives are their work. I work so I can live — I don't live to work. But I went along with it. He wanted an assistant who could be psychic, who could be in his mind and keep things rolling. Maybe after five years you know what's coming, you can plan for it, but there was no training process and there was no support.

Also, I was told point blank that I would not get a raise until I worked more overtime. Well, I've never been willing to live in my job the way the bosses do. And what he considered compensation for overtime every day was five thousand dollars a year. So I'd be making between thirty-five to forty thousand dollars a year to live at my job. It was not enough — sorry, I got a life. But you know, because I'm single and don't have kids, people assume, once they find that out, they think, "Oh well, you can work late." That isn't the way it works. But if you don't do it, they don't like it. So I was fired from that job. I don't think there was a real problem with me not performing the job, I think it was more personality and work style.

So other than that job, most of my work during the ten

years I've been in Toronto has been as a temp. I've worked in a lot of different offices. Right now, I'm registered with three agencies, although only one has used me. Agencies are so strange. They demand no loyalty, but if I work at a place and they decide to hire me, the agency gets a finder's fee. So they don't promise me work, they don't demand my loyalty, but they take my money! And they demand a lot of skills from their workers. At two of the three agencies I registered with, the testing was two-and-a half hours long. It was the usual three subjects — math, English and the computer test. Microsoft and WordPerfect are now standard. You know if you don't have both in a temp situation, you've cut your marketability in half.

Temp work is a job — a job is drudgery. I do it well. You go in, whatever crisis is going on, you fix it, you do the job, you get out. There's no social contact, there's very little consideration for work conditions; there are no benefits. And there's a different perspective when you're a temp — you're paid by the hour. If you don't work, you don't get paid. The only accolade I'll get is they might call me back.

However, temp work is nice to bypass the ruts in the road — but it doesn't really give you any skills. No, that's not true, because it does. You have to communicate; you have to be able to talk to the client who you're working for and to the boss back at the agency. So you've got to do a lot of, I don't know what that's called — telegraphing? And you've got to know when not to. You've got to be flexible; you've got to be fast. You don't want to be in a job where there's a temp sitting there who needs to be led by the hand; you've got to be independent. Temp work really does teach you that.

I remember in the late 1980s, things were going real good for temps. Business was up and they were hiring temps. And temps were making great wages. But at the same time, it was a little maddening. I can't tell you how many jobs I was sent out

on where I literally sat there from nine to five and was given nothing to do. I was there "just in case" something came up. More often than not that something came up at around four-thirty in the afternoon. Somebody would come up to me and say, "Oh, can you stay late?" But I would say, "No, you've had me here wasting my time all day, you're not going to take my night." I've always been very adamant about that; it has been an important edge for me in the workplace. Don't waste my time and expect me to give you more. It's never been considered a popular attitude, but back then there were enough jobs that I could get away with it.

It's not that I won't help out. If it's here to be done, I'll do it. I mean, no problem. Every job has those times, so if it's there to be done and you've got a deadline for nine o'clock tomorrow morning and we're only halfway through, of course I'm not going to walk away. But most of the time the assumption is that you have nothing else to do. Or they waste your time on stupid things and then, all of the sudden, "Oh, the project has to be finished." I try my best.

I was flexible in my work when I was living out West. Now, I'm flexible by choice, but also by necessity. I would love to get into a job and be there for five years, but it's not available. Whether it's the way that I see the world or the way the world is right now, permanent work means a year at a stretch. I like the flexibility, but I hate the downside of it. Because if you're too flexible, it means you're not working all the time and it's hard to stay ahead. Especially now when I'm making two to three dollars less an hour as a temp as I was making when I started.

And the marketplace has probably closed a little; employers know very well that they can pick and choose among employees. It's not as easy to get a job anymore. For every job advertised, it doesn't matter where it's advertised, there are at least a thousand people who are looking at it. In five months,

I've had four responses to two hundred résumés sent out. So obviously I've got to do some rethinking at looking at the career I'm in or the job search. I'm not sure if it just means I'm in the wrong place, or if I have unrealistic expectations about the marketplace, or, you know, maybe I should just go back and do something else. I'm not sure where I'd go. Last weekend in the paper, it said that when you send in a résumé make sure the résumé answers the needs of the employer. That means you have to rework your résumé every time you send it out. Unless you have a home computer, you can't do that. So you're automatically disadvantaged. So looking for work is a lot of hard work.

I may be going back to school. If I do, it will be at night in human resource management. I do have good people skills, and I do have good information skills; information and people, that seems to be the most logical place to go. But there's a real tug on me. I've gone back to school a couple of times and failed miserably and amassed a small mountain of debt that took me seven years to get out from under. And now I'm thinking about doing it again? It's not that I'm stupid, I'm lazy. You know, I'm forty-one. Do I want to spend ten hours a week outside of class time studying?

I didn't go to school for four years, twenty years ago. I worked and I learned the job; I learned how to work. There are still those who believe that a university degree is tantamount. It trains you for something different, but for a job, for the average job? Secretaries need a BA for what? "Well, I have my BA in philosophy, I'd like to type your letters!"

Office work is really not for me; I know that, but I am trained to do this. I spent ten years learning how to do this, and I do it well. But it's not where my heart is. I get very frustrated sitting at a desk. I think I've got more physical energy than that; I've got more emotional energy. The stuff that I really enjoy, like photography, is a great skill to have, but how

many photographers are there who aren't working? I know that I'm flexible enough to spend twenty hours a week doing this, and twenty hours a week doing that. It doesn't bother me to be working three or four jobs — one that pays the rent and the others that pay some money, but it's what I like to do. But self-employment is the scariest thing on the face of the earth. I want to be able to take vacations; I want to be able to take a day off without worrying. I don't want to worry that when I come back, there's no work. And that's the thing about being self-employed, you don't know when the work is going to come. Working temp is exactly the same.

Really. it all comes down to money. I like the idea of being self-supporting and being financially successful. I don't need a million dollars. My needs and my wants in the world are very simple. I know how to deal with being poor. I mean, the minute I'm out of a job, all the extras — except the cigarettes — get chopped. I know how to deal with unemployment; but right now I'm very edgy because the last time things were like this, the temp work dried up. And now that the employment insurance laws have changed, I don't know what I'd do.

But still, there are things I will do and things I won't do, and I won't live at my job. I work so I can afford to do other things. I don't know that I'm looking for a career. I just want some sort of job that will see me through the winter, keep a roof over my head, food on the table. I've been back and forth across the country four or five times and I don't want to move anymore. I'm working hard keeping myself anchored. The thing that's holding me now is that I don't know where else to go or how to get a strategy together: How do you decide to move? And where do you go? My history has been that I just go, and I don't want to do that anymore. It takes a lot out of you and it's almost impossible to network from scratch; and networking now is primary. It's also age — I don't have it in me anymore to start blind again.

Louise

☙

YOUR CALL IS BEING MONITORED AND SO ARE YOU: THE NEW WORLD OF CALL CENTRE WORK

> *You know,*
> *if I had been a bull terrier,*
> *I would have been OK.*

Louise is single, in her early forties. She has a quick humour and enthusiasm, especially when she talks about her real interests — music and the arts. She is realistic enough to know her chances of getting a job in that business are not very good. She confesses that her job future could be different: "If I had the gumption, I would be creating a job of some sort for myself."

I had a Grade Twelve education. I didn't complete my credits for Grade Thirteen, thinking that, well, maybe I'd go back someday. Instead, I decided to go to the community college. I was supposed to be taking journalism, but I was not applying myself all that well and decided to try working full-time. My sister had been working in a hotel reservation centre; it was an independent company that had contracts with three different hotel chains. After she left, she recommended me to someone there. This was 1980 and it seemed a lot easier to get a job. So I went there for an interview. I brought my résumé, which I had thrown together, and said I could speak French reasonably

well and that I had a good telephone manner. This guy didn't even look at my résumé; he said, "Well, if you're Barbara's sister, that's fine."

I was working solely for Ramada Hotels at this reservation centre. People called in on the 1-800 line and because I spoke French reasonably well, I took all the calls in French. At this time, we were still telexing the reservations to the hotels, so I had to bang away on this old telex machine when I wasn't on the phones. Sometimes I was called upon to be acting supervisor when the managers had to be away. I wasn't paid more; the managers considered it a privilege and a learning experience, and you were supposed to just love it. If you had been there for any length of time, you were expected to teach others how to do the job. It was pretty rudimentary. The name of the game was to control the conversation, keep it short, not waste too much time and not let people babble on about nothing. We did have some people who called on a regular basis just because they were lonely.

We were monitored once a month. The managers actually tape-recorded the call. They used an old cassette recorder that was plugged in. I actually had to do that to people when I was an acting supervisor. There was one supervisor who was very friendly, and he would tell us we were being monitored. He'd say, "I have to monitor you now, so be good, OK?"

There was still this hangover from the late 1970s, where things moved a lot more slowly. You didn't have automatic transmission and quick communication. The company was not yet into the 24-hour-day mentality; they only operated up to ten at night. After awhile, they expanded the hours until midnight. They weren't even open on Sundays when I first began, and they were only open limited hours on Sundays by the time I left. It was not a very demanding job in many ways, but it was stressful when it got busy.

I worked there for five years. I had to leave because my husband, who was making more money on his job than I was on mine, got transferred. This happened a lot during my marriage; I would get settled in a job, and he would get

transferred between London (Ontario) and Toronto. I would always be leaving jobs and looking for new work. During those years, I tried to move into clerical work, but jobs were not plentiful, especially if you didn't have a lot of experience. So I stayed in the phone business.

It wasn't until the 1990s that I got into telemarketing. By this time, I was single again. Telemarketing is completely different from a reservation centre, where you just receive the calls. In telemarketing, you actually have to make "cold calls" and make a presentation to somebody. I started with selling insurance that you could put on your credit card. It was just so awful, and it was a rude awakening compared with the genteel, polite and restrained atmosphere that I had experienced in the reservation centre. I mean, in telemarketing, the name of the game is dog-eat-dog, go for the jugular. It doesn't matter what you say, just get them to take the product. So what you say is, "This will only cost you twelve dollars a month! Just think of it, and you'll have coverage for accidents." If anyone asked us, "What does this really cover?" what could we say? The insurance wouldn't really cover anything. What usually happened was that if some poor soul tried to make a claim, if she or he had some other insurance to begin with, this stuff would be null and void. It was simply useless. You just felt like an axe murderer; it was awful.

This telecentre was an American-owned company. It was in an office building overlooking Bay and Bloor Streets. But it was really just a sweatshop. There were at least one hundred cubicles in there. They were paying people a base salary of seven dollars an hour, but if you made at least fifty sales, you got twenty-five cents an hour more; big deal. The managers would give us a pep talk before we started sometimes, but when there was a big issue like money brought up by the workers, the pep talk turned into a forty-five minute yelling match. People would be yelling and asking how were they going to feed their families? It was a truly shocking place. Not only that, people stole lunches, they stole coats from the cloakroom. I actually had a pair of suede gloves that

disappeared from my pocket. Stealing was one of those issues brought up at the pep rallies/meetings, but management wasn't interested. I remember one piercing comment from one worker who said, "If you would pay people properly, they wouldn't have to steal."

And they had ridiculous regulations about dress codes — men had to wear ties and women had to wear dresses and stockings. Some of the people who worked there were really gothic punk rockers or something who had to have some kind of job to pay the rent. They'd come in with these outlandish getups. When I first started working there, there were these two women who showed up every day dressed like Elvira. You know, with the long black gown and a choker and cleavage, the whole bit. Every day they showed up to work like that; so they were properly dressed because they were wearing dresses and stockings and they weren't wearing jeans! It was insane.

You had quotas and if you weren't keeping to your quotas, and you were someone the supervisors thought was useless, they'd just say, "Get out, go on!" But for people like me, who they didn't think was a total write-off, they'd give a second chance. They were always monitoring me. They were listening on their little remote phones, walking up and down the aisles. I could make a few sales, but I couldn't sustain this bright, perky mode for long. It became too hard to keep pushing myself. I was doing all right for the first few weeks, and then I got into this dangerous territory where I wasn't making the quotas. The supervisors tried to be all folksy, you know, make you want to confide in them. They'd say, "What's bothering you? We're so sympathetic but it's really important you make your quotas or we'll have to put you on probation." That didn't make any sense to me — you're not making your quotas, so you're suspended for three days? This was like high school. Anyway, around Christmas things slowed right down and they weren't too strict about quotas, but after Christmas they put me on three days' probation.

So I knew I'd have to get out of there soon. I was always networking with these other women. Some of the people there

were working two or more jobs. One woman told me about another telemarketing company where they were selling long-distance telephone services. I thought, what the heck? I looked them up and I took a job there.

It was 1994 when I went to this other company. It really was a fun atmosphere; it was wild and crazy. They were a new company and were just feeling their way around; they were trying to build up the business and trying to get clients. The people running the place just weren't that professional. They were just having fun and they were hiring their buddies. The supervisory team was friendly with everybody. We had regular breaks and they tried to be nice; sometimes they'd say, "Kentucky Fried Chicken for everybody — on the house!" But they really didn't know what they were doing at the beginning.

We had an automatic dialling system at both telemarketing places. The usual practice is to buy phone numbers. (There are other companies that get lists of people's names and phone numbers and sell them to telemarketing and other companies that call people.) The automated dialling system meant that by using a system of simple commands, you could log in and the computer would dial for you, and the person's name and phone number would pop up on the screen.

They started you at eight dollars an hour and they weren't giving large amounts for bonuses. The long-distance service was the main thing they were promoting, but they were doing other projects that didn't involve selling. You might try to get people to attend seminars, let's say. I was put on that project for a couple of days and I was paid more by the hour for that, so it was interesting. I did a lot of things at that company. They had me verifying sales, which paid ten dollars an hour instead of eight. That would mean that when someone made a sale, you'd have to come onto the phone at the end and verify that they had told the client everything and that the client really did want whatever service they were promoting. That would not be popular with certain workers because, if it turned out that the client didn't want the product after all, the

worker would blame you for losing the sale. There was this high turnover, too. Some of the workers had other jobs and only worked evenings; there were university and high-school students coming in after school and during the summer. They might work full-time for the summer; after they all went back to school, the place seemed like a ghost town.

So it was a lot of fun at first, but then they began to wise up and catch on to the techniques of all the cutthroat telemarketing companies. The supervisors started saying, "If you can't meet your quota, you're history!" Then the big client sort of pulled the rug out from under the company, saying, "Look, you guys are blowing a lot of dough on wages here and you haven't really made that many sales for us, so we're leaving." So after Christmas, the company didn't have as much work for anybody. They started giving the good jobs to certain employees; it was real favouritism. The rest of us worked on this one credit card protection project. If enough sales weren't made on this project, then they would bring groups of people into the boardroom and say, "All right you, you, you and you, you're not making enough sales, goodbye." That's what they did to me. I worked there from March through January/February of the following year — a long time — and then they let me go because I wasn't making my quotas. So that left me just with nothing, but I was living with my brother, so I was not destitute. You know, if I had been a real bull terrier, I would have been OK.

Then someone I knew who only worked there part-time decided to help me. He had his own business and said, "Do you know any word processing?" I said, "Well, I took a Word-Perfect course a few years ago." Then he said, "Well, you're going to learn." He basically taught me WordPerfect 5.1. People would come to him with documents, résumés, manuscripts, and all kinds of stuff. I ended up helping with a manuscript and started on résumés. He was not paying an hourly wage; he was paying me by the page.

I took a course at George Brown College in medical terminology and in WordPerfect for Windows 6.1. I did that and I was still always applying for jobs that I was interested in.

I was hoping I could get something that would combine something to do with healthcare and clerical work. It was just that the job market was so tough because we had had this recession. I have records of all the jobs I applied for. I wasn't even getting interviews or replies or anything. That was a very tough period. It was hard for a lot of people, and it didn't matter if you were highly educated sometimes. There just weren't that many jobs at that time.

I was interviewed and got a job at this one place that needed a "call-centre representative." I didn't know what kind of a place it was. It turned out they represented a company who had a system for tracking lost or stolen goods. Customers would register valuables with this company. If their bicycle or sport utility vehicle was stolen, they would call a 1-800 number. Guess who would be at the end of the phone? "Hello." But that was only a small part of my job.

In any call centre, you have to be able to handle customer complaints. The main thing is to identify the problem and see how you can take steps to rectify it, and to reassure the customer. At this centre, they gave us this course in customer excellence, which was designed by this guy who was the manager of the call centre. He had a lot of stuff worked out about what a good customer representative does. What you do is empathize with the customer. That's just the stuff that comes naturally if you have been on the phone for a long time. You listen to people, and if someone says, "I've been waiting six months," you answer, "That's a long wait, isn't it?" You're not saying anything that any reasonable person wouldn't say. You're in a much better position than when you're phoning people up and you're putting the screws to them. You're paid better and obviously you don't get bonuses. I'm much better suited to this. It's all a question of listening, of paying attention and making the person feel like something has been done, and trying to do it, too.

I was monitored on this job, too. The supervisors would tell you right away what areas they thought might need improvement and what they thought was good. But, in

general, it was not a good place to work. The wage was good, but it wasn't a good company to work for because of the difficulties that they were in. It was a bad situation and I had a bad feeling about it. And I was right; I was laid off along with everyone else who was hired at the same time.

I got my foot in the door at the company I'm working with now when they advertised they had temporary positions — taking orders for a hospital lottery, which they hold in the spring and the fall. I got into the fall lottery that began right before Labour Day and ran through October, or at least past Thanksgiving. When we finished, they were vague about when they would have work again.

They had you working strictly a nine-to-five schedule — full-time hours. I kept in touch with them because they had contracts for four lotteries. So starting right after the New Year, I had a four-month stint through to the end of April working nine to five every day. Now, there were times when it started to be less busy, then they sent you home early. So they were finally catching on: "Oh, maybe we shouldn't be scheduling everyone working the same hours and we shouldn't be scheduling full shifts." They have now changed the scheduling so that they put you on what they call tours — tours of duty, if you will. So temporary employees are now working shorter shifts, and it's not Monday to Friday, nine to five. They mailed me the list of the tours to choose from and they said it would go according to seniority. I retained my rank in seniority from working there before.

The company does three things: lotteries, TASCOM (Telephone Answering Service Communication) and something called PIE. Now I'm not sure what PIE stands for, but it includes a whole system of accounts like *TV Guide* or exercise kits, the sorts of things advertised late at night with a 1-800 number. It's a lot of variety and there's a lot of training, a lot to learn.

The manager has got me scheduled for working something like ten days in a row out of the next fourteen. They're not full shifts, but it's changing all the time. One day I'll work

ten a.m. until three-forty-five p.m.; I'll do that two days in row. Then I'll work from two-thirty p.m. to ten-thirty p.m. It's all becoming sort of a nightmare for me. Those who have been there the longest obviously are the ones who get the good shifts. When you start, you get all the junk. But it's a small place and they're flexible enough that if you want to change a shift, you usually can work things out with people, or if not, you just adjust to it, everyone in their own way. But really, I just realized, that it's good to have something that is "permanent."

So my wages will keep going up the longer I am there. I started at eight seventy-five an hour doing the lottery and now it's about nine twenty-five an hour. I know now I can live comfortably on a wage like that because I don't have dependents and I don't have debts; but if you did, you'd really be in trouble. I don't have a lot of expenses, I don't have a vehicle and I don't have a lot of unnecessary stuff. So I'm living pretty comfortably now, but it wasn't always the case. As long as I can pay a rent that's not too high, I'll be all right. I'll be OK if I hang in there. I just have to overcome my initial frustration that "Oh god, is this *it?* This is my life?" But I'm going to keep looking for something else.

Sick and Tired
from it All

*If all the US workers affected with MSIs [musculoskeletal injuries]
stood fingertip to fingertip, they could make a chain of injured
hands and backs) across America, all the way from
the East Coast to the West Coast.[1]*

*If one factor unites the unemployed,
the precariously employed, the fully employed,
and those who usually work longer hours
(the over-employed), it is stress.[2]*

THE MONUMENTAL CHANGES taking place in our work environments
today may, if we're not careful, cause stress, injury or illness — or
maybe all three. Think about how much is different in our workplace
and how fast it all came about: technological innovations, restructur-
ing, downsizing, long working hours or not enough hours, insecurity,
intensification of our work, diminishing of control and the destruc-
tion of our work cultures. That's a lot to deal with, and even if all of
these changes do not directly touch our particular job, they have the
nasty tendency to still affect how we feel. This is primarily true
because our work is not a task that we do in isolation — it is an inte-
grated system. It involves our physical work environment — the air
we breathe, the temperature, the light, the people we work with and
for, the actual desk that we sit at and the chair that we sit on, our job
security, the processes and procedures that we go through to get our

work done, even what's happening at home.[3] If even one of these elements is out of whack, it may affect our physical and our psychological health.

These changes in our work environments — not to mention our lives — have happened so quickly that the injuries and stress caused by them were "unanticipated" even by many experts concerned with the health and well-being of workers.[4] Compounding this is the current political and social hegemony that contends that what is good for business, is good for people. Unfortunately, all the while that health experts were catching up and politicians, business people and senior management in the public sector were ignoring this problem, workers were suffering injuries. While it is difficult to get exact numbers of how many people (especially office workers) are suffering from workplace injuries, there have been some telling reports of the enormity of this problem. The American Federation of Labor and Congress of Industrial Organizations (AFL-CIO) in their "Stop the Pain" campaign cites a 1996 Bureau of Labor Statistics study that says that "nearly 650,000 workers suffered serious workplace injuries caused by repetitive motion and overexertion."[5] The Occupational Safety and Health Administration (OSHA), which is responsible for drafting new ergonomic standards in the US, says that "more than 647,000 Americans suffer from injuries or illness due to work-related musculoskeletal disorders which account for more than 34 percent of all workdays lost to injuries or illnesses. The cost to employers is estimated as high as $20 billion a year in direct workers' compensation costs."[6] Statistics Canada estimated that nearly 2 million people — or 1 out of every 14 Canadians — "sustained repetitive strain injuries (RSIs) that were serious enough to hamper their usual activities," making it an "important health problem."[7] Nearly half of these injuries occurred at work or school. None of the head counts that have been done of injured workers capture *all* of the people who are suffering from the ever-growing shopping list of physical and psychological disorders present in the workplace today: repetitive strain injuries (RSIs), cumulative trauma disorders (CTDs), musculoskeletal injuries (MSIs), not to mention good old stress and

burnout. There are just too many silent sufferers — or unheard voices — to get an honest account of how many people are hurting.

We do know that women are suffering in disproportionately high numbers. The AFL-CIO reports that in 1996, women made up 46 percent of the overall workforce in the US, but they accounted for "63 percent of repetitive motion injuries (46,211 of 73,796 reported cases) and 69 percent of reported carpal tunnel syndrome cases (20,725 of 29,937)."[8] These numbers are not surprising when you think of the types of jobs in which women are concentrated: sewing and cutting, assembly work, food processing, cashiering, cleaning, and, of course, office work — jobs that require repetitive motion and staying in one place for an extended period of time. And there is, of course, the added "second shift" of domestic work that most women face everyday that doesn't give them a chance to rest their weary hands for the next day at work.

Workplace illnesses and injuries are becoming the major safety and health challenge that we face today.[9] A decade ago not many of us knew what the word ergonomics meant; today it drifts into our daily vocabulary with the same ease as "the Net." That, if nothing else, indicates the pervasiveness of our unsafe, unhealthy workplaces. Ergonomics is defined as

> a body of knowledge about human abilities, human limitations and human characteristics that are relevant to design. Ergonomic design is the application of this body of knowledge to the design of tools, machines, systems, tasks, jobs and environments for safe, comfortable and effective *human* use.[10]

In the globally competitive world of today, there are many who feel that rather than practising good ergonomics by adjusting jobs so that they fit the needs of the worker, employers are more likely to insist that the worker adapt to fit the job or its technology.[11]

OH MY ACHING HANDS ... AND BACK ... AND ARMS ... AND EYES

Offices may not hold the most ergonomic dangers, but they certainly have more than their share of problems. To begin with, most of us

are very likely to be sitting in a chair at a desk, neither of which is designed for our bodies. The standard height and width of work-stations, desks, chairs and tables was based on a set of measurements taken during the Second World War from a sampling of US army recruits — all men, of course. That makes our chairs and desks the ideal size if you happen to be a 5'10" (1.77 metres) male — which few of us in the "pink collar ghetto" are at this point.[12] So the design of our office furniture was bad enough for us when we were working at typing tables. It became worse when they took away the type-writers and plunked computers down in their place with little or no adjustments made to the furniture to ensure safe usage. Those of us who worked in offices were expected to do the research and figure out what was good for us — we had to adjust to the machinery rather than the other way around. I remember being asked what type of document holder I wanted, but I don't remember being told of any health or safety reasons for choosing one over the other — those were up to me to find out.

Computer technology, as we all know, presented a whole new and different set of workplace problems into our lives. The computer is not just a different looking typewriter, although a lot of office workers tried to use it that way at the beginning. For one thing, it has a more "intensive" keyboard that allows workers to type "faster and for longer uninterrupted stretches than ever before."[13] That may be well and good, but the computer isn't the one doing that typing — humans simply cannot maintain that kind of intensity for long with-out doing some damage to their bodies.[14] Unfortunately for many of us, there just isn't a choice — downsizing has decreased the number of workers, but not the work. Many of us have found our work intensified, which keeps us on the keyboard for longer periods of time, which then makes us even more susceptible to injury. Also, we're just not getting up and walking around as much; many of the tasks that took us away from the keyboard are now built into soft-ware packages, like sending faxes. The cost of the computer technol-ogy has to be justified — whether or not it makes our jobs better or worse, more complicated or easier, the machine gets top considera-tion. Penny Kome in *Wounded Workers* sums this up succinctly:

The more money employers spend on computers and technological equipment, the more the work gets rearranged to make tasks easier for the machinery — even if that means the work is harder for the human resources involved. Computers make good servants but poor masters. Yet, more and more workers find themselves serving machines. And when health problems develop, often the first solution offered is more technology.[15]

All of this also means that we're staring at a computer screen for long periods of time, which can give us headaches and cause eyestrain. I remember being in my office staring at my computer screen when all of a sudden my vision became fragmented like a Cubist painting — parts of the picture just weren't there. It turned out I was having an ocular migraine without the pain; it was brought on by a combination of too many hours staring at the computer screen and working under flickering fluorescent lights. I couldn't do anything about the computer, but I did turn off the overhead lights and used lamps. There are also suspicions that the "heat and electrostatic and electromagnetic fields" in the immediate vicinity of our computers may not be so good for our health, either.[16] But as bad as all of this may be for those of us working in banks, universities or law offices, it is even worse for women like Louise working in call centres. These kinds of computer-centred jobs seem designed for injury. The operator has little or no control over her work and her breaks; she stays in one place doing one thing for long periods of time. When you throw in quotas and monitoring, you're asking for injury.[17] Computer use has grown so quickly that there hasn't been time to do all the research necessary to determine how safe they are to use. Perhaps in the meantime computers should carry a warning: Prolonged Use May Be Hazardous To Your Health.

Not only are we sustaining these injuries from the tools we use, but we are also breathing in a whole set of other dangers by working in "sick buildings." The energy crisis of the 1970s resulted in the sealing off of building windows thus requiring all air to pass through a ventilation system, that, too often, is adjusted so that a minimum amount of "fresh air" actually passes through.[18] Since this became prevalent, there has been a "persistent epidemic of health complaints"

from the non-industrial work environments; that is, among other office buildings, university buildings, banks and call centres. These complaints range from allergic and infectious diseases (we all remember Legionnaire's disease) to headaches and eye irritation.[19] The World Health Organization estimates that up to 30% of buildings in the world have significant air problems.[20] At the National Institute for Occupational Safety and Health (NIOSH) in the US, which is responsible for conducting research and making recommendations regarding work-related illnesses and injury, the requests for research regarding the indoor work environment have increased from 2% in 1980 to up to 65% in recent years.[21] So when we don't feel good in our workplaces, it isn't just all in our heads.

It wasn't just closing the windows that caused all this — it was also what was added to our work environment. New technology was introduced into our workplaces without any forethought of the physical harm it could do to our hands and backs and eyes. Neither was any consideration given to the health hazards that might be connected to what it was doing to the air around us. As the same air is being circulated over and over again, it is passing on all of the toxic residue that our machines are spilling out. The toners used in photocopiers and printers, for example, spill pollution into our office environments. In my Washington office, the accounting department was located next to the duplicating centre. As the number of photocopiers and printers increased, both spaces became covered with a fine black powder from the toner. My office colleagues and I could only speculate on what was happening to the lungs of the people who worked directly with these machines.

"Sick building syndrome" can be acerbated by a combination of otherwise harmless factors acting upon each other in a not-so-harmless way. "Microbiological and chemical exposures" — many of which are not being detected by current testing procedures — like temperature, humidity, lighting and noise, even "social/psychological stressors," can combine with whatever is being emitted from our machines to make a real toxic soup.[22] "Sick building syndrome" can cause such syndromes as sore throats, rashes, fatigue, headaches, congestion or nausea in people.[23] So it is not surprising that many of

us feel better physically, as well as psychologically, as soon as we walk out the door to go home. Our office jobs were once considered relatively free from harm, our work environments clean. But now we face working all day in a toxic box on machines that could be harming us in ways we don't even suspect. And all of this has become an accepted part of our work.

"I'm Just Too Busy! I'm Just Too Stressed!"

Our health and well-being at work and home is being threatened by the vicious circle that many of us find ourselves in today. Changes in our work situation make us more stressed, which in turn makes us more prone to injuries, which give us pain and cause more stress and depression because we can't keep a job or do the one we have. We end up burnt-out and sick. This is a problem of epidemic proportions. In one study in the US, 40% of workers reported that their jobs were very or extremely stressful.[24] That stress doesn't just stay at the job — we carry it around with us all the time. When we are in stressful situations over which we have no control and which are not resolved, our whole life cycle can be affected. We may find ourselves not being able to sleep, getting too many headaches, or having shorter fuses on our tempers. If we're not careful, there is even evidence that work stress can cause cardiovascular disease and psychological disorders.[25] Sam rode the vicious circle of ill health, making her less productive at work, which then made her more stressed and eventually so depressed that she had a hard time keeping a job. Meg feels vulnerable and Loretta fights high blood pressure. These are all signs of burnout caused by stressful work situations.

In their book *The Truth About Burnout,* American psychologist Christine Maslach and Canadian psychologist Michael Leiter contend that there are basic themes expressed in each person's burnout at work:

An erosion of engagement with the job. What started out as important, meaningful fascinating work becomes unpleasant, unfulfilling and meaningless.

An erosion of emotions. The positive feelings of enthusiasm,

dedication, security, and enjoyment fade away and are replaced by anger, anxiety, and depression.

A problem of fit between the person and the job. Individuals see this imbalance as a personal crisis, but it is really the workplace that is in trouble.[26]

Their use of the word *erosion* is intentional. None of us started a job with the intention of being stressed out by it all — although those of us who didn't "choose" office work, but slipped into it, might have carried a little seed of burnout and anger about our predicament into those workplaces. But Stephanie loved her job; her depression and burnout came after the gradual peeling away of what was good until there was little that was good left.

In the current economic climate, more and more of us are experiencing this erosion of our work. Zoë certainly did at the university; Sam, Judith and Norma have seen their stock of temporary jobs depleted; Loretta saw it in the intensification of her work, and Joan, as a floater at the law firm. It is no wonder that problems at work score higher on the list of life stressors than even financial or family problems.[27] And at the top of those work problems has to be the pervasive insecurity that exists today. *The New York Times* reported that as a result of the massive changes taking place in our workplaces, there is "the most acute job insecurity since the Depression. And this in turn has produced an unrelenting angst that is shattering people's notion of work and self and the very promise of tomorrow."[28] At a joint meeting of the American Psychological Association (APA) and the NIOSH, it was stated that "[t]here can be little doubt that the psychological demands of work, and thus the risk of job stress, have grown in response to increasingly leaner and more flexible production and employment practices in industry."[29] Downsizing and the just-in-time workforce are finally starting to be recognized as detriments to the well-being of workers.

Such insecurity breeds conditions that lead to serious problems for workers. Maslach and Leiter list six "mismatches" between people and their jobs that cause burnout in the workplace: work overload, lack of control, insufficient reward, breakdown in community, absence of fairness and conflicting values.[30] Insecurity has workers

"working scared."[31] People are working longer hours at jobs that are not rewarding and not necessarily part of an upward climb on a career ladder.[32] Or, on the other end of that scale, they are not being given enough meaningful work — a sure sign that your job is in jeopardy. Both situations are equally stressful. Neither situation gives us any sort of control over our day-to-day lives, let alone our futures, nor do they necessarily bring with them the "material rewards of money, prestige, and security."[33] Maslach and Leiter's criteria for a psychologically healthy work environment sounds very much like the criteria of sustainable work discussed in the previous chapter.

Working without rewards and security takes away any of the joy or satisfaction that we may have felt in our jobs. Zoë missed the responsibility and independence of her former job; Loretta, the time to do her job well; Stephanie, the personal contact with her customers and co-workers. Those kinds of intrinsic rewards from our jobs made the difference between a good job and a bad job for many of us. Office work is, as Loretta says, pretty mundane most of the time; however, when we are at least able to perform at a significant level and capacity, and are rewarded for our contribution to the workplace, then even the mundane can take on significant meaning.

Insecurity undermines any sense of community that we may have within the workplace. "As organizations weaken their commitment to their people," Maslach and Leiter observe, "staff members have less of a basis for making commitments to one another."[34] I saw this happen in my own workplace after the restructuring. Once the administration and the lawyers showed us that they were more concerned with the bottom line than our goodwill and well-being, there was a weakening of the camaraderie the secretaries had shared with each other and the support that they were willing to give each other. As Joan's work situation became more stressful, she tried to emotionally remove herself from her workplace and her co-workers' concerns as much as she could. Judith, and all other temporary workers, suffer because of this deterioration of work communities — there is no longer anyone who is willing to answer questions or show them around. When organizations cease to value the individual worker, the worker will cease to be loyal to the organization — both of which

damage the quality of the work produced and the work environment. The "short-term survival-and-profit value system" that is prevalent in so many of our workplaces today, leaves little room for many of the work values that we carried with us into our workplaces[35] — a sad and stressful commentary on the future of our economic and personal security.

The unpredictability of our workload, the loss of workplace community, the devaluing of our work, the lack of control and having no sense of reward for our work, become even more intensely felt if you are over forty. Many of us in this book are there already — Meg, Zoë, Loretta, Sam, Norma, Joan and myself — and our numbers are growing. As was noted in a NIOSH report on the "Work Environment and Workforce": "The number of workers over 55 and older is expected to grow twice as fast as the total workforce for the next several years as the 'baby boomer' population matures and life expectancy increases."[36] We could hope that because of our sheer numbers, the plight of the older worker would improve, not deteriorate. Right now, however, that doesn't seem to be the case.

Age discrimination starts to "kick in" at age forty and steadily becomes more prominent as we near fifty.[37] This is true for those of us who are employed and those of us who are looking for a job. Just at the time when we should be able to sit back and relax on our skills and experience, we have to worry about being perceived as being too old, too set in our ways, too tired and too "technically obsolete" to keep employed.[38] We also cost too much if we've been around for any length of time, so that puts us at the top of any "hit list" that our downsizing employers have. We've seen it happen again and again — employers don't want us to take it personally (and bring an age discrimination suit). They assure everybody that new blood, that is, young blood, is good for the place; it brings in new ideas.[39] What's never mentioned is what happens to us when we lose those jobs or have them changed beyond recognition. For many of us older workers, we lose more than our economic well-being — we lose our self-esteem.[40] Sam understood this when she was sent on jobs below her skill level; Meg certainly felt more vulnerable in workplaces as she got older. All of this makes for very stressful conditions.

It can be discouraging, especially when we have to admit that no matter how willing we are to participate in the new economy, our older bodies sometimes aren't able to keep up with the demands of high-tech jobs. Just hearing Daphnie's story of her job search and her expectation and willingness to be "on-call" at all times to do the job, makes me weary. I remember when I turned forty, I was working as a legal secretary in an office where overtime and all-nighters were the norm. After one such all-nighter, where I had to stay until the brief went to duplicating at five a.m. and then be back by eight a.m. to make sure everything was ready to file, I found that I was still recuperating a week afterwards. I remember how stressed, edgy and comparatively inefficient I felt for that week. That didn't make me less skilled, but it did make me wiser to the limitations of my aging body. The prospect of having to work ten, eleven or twelve hour days as part of the normal routine should cause serious anxiety for anybody, not just older workers.

But what can we do? Unfortunately, for all of us, young and old, unemployment is a constant threat. Our future is not as secure as it might have once seemed. The worry and pain of this kind of insecurity eats away at the very core of our being. Working in an environment like this raises our level of anxiety to a point where it saps our "energy, creativity, and productivity."[41] For the women in this book, who worked in offices long before the reconstruction of the 1990s, no matter how demeaning their jobs, they could still identify in some way with their work. When we lose our jobs, we lose that identity and the meaningful roles they play in our society and in our families.[42] Arlie Hochschild contends that work is becoming a "haven" for women the same way that it has been for men for years — women today are just as likely as men to feel appreciated at work and unappreciated at home. So losing a job becomes a very serious personal concern. "Women fear losing their places at work, and having such a place has become a source of security, pride, and a powerful sense of being valued."[43] Perhaps this is why many unemployed women prefer to identify themselves as "self-employed"; it doesn't carry the heavy negative social meaning of "unemployed."[44] And, perhaps, "self-employed" helps preserve the

image of these former roles in which women have a positive sense of themselves.

It's as if we are caught in a vicious circle of powerlessness not of our own making. In such a situation we not only lose voice and control over our work, but we also lose control over regulating the stress this induces. The physical and psychological damage of all this anxiety and stress is pushing many of us into depression. We, and many of our doctors, are not recognizing the seriousness of this disease.[45] Our doctors sometimes misdiagnose depression because the symptoms can be mistaken for other ills; we deny it because we don't like to admit that we have a "mental" problem. This denial has been so prevalent that depression is dubbed an "invisible illness."[46] Yet depression is so widespread that it is difficult to ignore its existence. It has surpassed "diabetes, high blood pressure, weak hearts, bad backs and bad digestive systems combined" as a common complaint.[47] Depressed workers have a hard time building up enough energy and enthusiasm to survive in a world that does not respect or recognize their needs. After many months of fighting it, Sam fell into the vicious circle of feeling depressed about her situation, which then made her feel desperately needy, which in turn made her less efficient and less able to operate at her normal level of productivity. Her precarious economic situation didn't allow her the luxury of taking time off to look after her mental health.

Is this our future — working high-stress, insecure jobs for employers who are more concerned about productivity and their bottom line than about the health of us workers? If it is, how can we take control and overcome the stress and depression that we are experiencing?

SOUNDS LIKE A PERSONAL PROBLEM

The first thing we have to do is to take ourselves, our injuries and our stress seriously. Too often, we ignore the early — and late — signals that something is wrong. We *didn't* expect our jobs to be harmful to our health. After all, all we're doing is typing and answering the

phone. So when our bodies hurt, do we stop what we're doing? Do we go home and rest? No, we usually just keep working. We might rub our aching arms or take a couple of painkillers, but we don't consider it, or us, important enough to stop working.[48] How many times have we finished just one more page when our hands were aching, or kept working through our tears and anger when we had someone standing over our shoulder, like Joan's boss, waiting for us to finish a job? We have to stop this; we have to speak out about and demand recognition of our pain. And it has to be a strong enough voice so we stop being ignored by our employers. As Maslach and Leiter note about burnout:

> When burnout does set in, people tend to keep working, even if not as well as before, so there are no serious threats to general productivity. Viewed from this perspective, burnout is just a cop-out, the whining of wimps who can't handle serious work and can't admit to failure. The feeling is that there is really nothing to "do" about burnout. In other words, if it ain't broke, don't fix it.[49]

As women, we should know better. How many of us have been told that our illnesses or injuries were just "in our heads" or maybe caused by "the time of the month?"[50] It's always been such an easy dismissal of us. For many of us older workers, age is now used as a favourite explanation for everything from weight gains to tired muscles and depression. We are indeed made to feel like "whining wimps" when we complain, so why add that to our misery?

Our predicament isn't helped by the fact that emotional stress and many physical injuries are "invisible." We could be making it all up, you know, so our symptoms are often treated as "hypochondria, neurosis, and even malingering."[51] Who knows, we could have picked up that injury knitting, or playing tennis, maybe gardening on the weekend, or doing all that housework.[52] And our stress is a personal problem, right? Both Zoë and Joan became so stressed out by their work that their doctors insisted they take time away from the office. Their employers, like many others, most likely were not too happy about what has been called this "dreaded entitlement mentality" that overworked employees presume when they have

unscheduled absences from their work.[53] When workers complain about injury, there seems to always be a suspicion of fraud — yet statistics show that workers' fraud only constitutes about 2% of all workers' compensation fraud cases — well below that of employer and provider fraud. Workers just get more press.[54]

What can we do? It's easy to say stop working when you're hurting, but this is not always possible to do. I remember a co-worker giving me this piece of advice when we were both going through a particularly stressful time at work: Do the one thing that you have some control over — take care of your body. Penny Kome, in *Wounded Workers*, would agree. She encourages workers to take care of themselves in the early stages of injury, before they reach the "crash" stage when the pain is constant, painkillers don't work and hands and wrists don't function anymore.[55] Some of the things she and others suggest appear on most self-improvement lists:

- Warm-up and stretch before starting work.
- Take breaks: stretch at your desk every thirty minutes, and do a walk-about every two hours. If you're more tied down to your computer, take micro-breaks of thirty to sixty seconds every minute or two — just lay your hands in your lap, roll your shoulders and shut your eyes.
- Have someone who knows ergonomics evaluate your posture and movement.
- Trim long fingernails that might affect hand position on your keyboard.
- Get enough sleep — aching body parts need rest to heal.
- Do daily aerobic exercise to improve circulation — walk up those stairs!
- Take regular classes in gentle stretching, such as yoga.
- Drink lots of water.[56]
- Take a nap — some companies are even providing "napping stations."[57]

While all of this is wonderful advice and will indeed make us feel better, it will not correct the problem. These are not personal problems, they are organizational problems and it is there, at that level,

that change has to be made. It is our jobs that are making us sick, not us. We can become as healthy as anything, but if we walk back into a stressful environment or one that is ergonomically dangerous to our health, we will regress back to where we started. If you don't believe this, just remember all the times you went on vacation and felt wonderful only to have that euphoria erased within hours of returning to your workplace.

Actually, the focus has to be on *both* the individual and the organization if change is to be truly effective. It is, after all, our jobs that are the critical source of our stress. That is why NIOSH recommends a "comprehensive approach" — Organizational Change + Stress Management = A Healthy Workplace. They feel that stress won't be reduced until organizations take direct steps to discover what are the root causes of the problem and then follow through by putting procedures in place to change them — even if it means that work routines and productions schedules are affected.[58] Their recommendations for creating stress-free workplaces resonate with some of the same ideas that were mentioned earlier to correct "mismatches":

- Ensure that the workload is in line with workers' capabilities and resources.
- Design jobs to provide meaning, stimulation, and opportunities for workers to use their skills.
- Give workers opportunities to participate in decisions and actions affecting their jobs.
- Provide opportunities for social interaction among workers.
- Establish work schedules that are compatible with demands and responsibilities outside the job.[59]

Changing organizations into healthy, stress-free workplaces, takes more than talk and workshops; links must be discovered and maintained between the worker, the employer and the organization. As Maslach and Leiter note:

> It is not simply a matter of reducing the negatives in the workplace; it is also an attempt to increase the positives. Strategies for developing engagement with work are those that enhance energy, involvement, and efficacy ... It means investing in people ... The

organization has to be able to show the same kind of commitment to its employees — the respect and concern — that it asks of them.[60]

It is hard to imagine our employers taking these necessary steps. But these authors think that not to do so, is asking for serious problems. For one thing, the likelihood of burnout in our workplaces today is very high — we all know someone who is stressed out about something. And if organizations choose to ignore it, it becomes an enormously expensive problem for them. Companies are spending billions of dollars on workers' compensation, healthcare benefits, absenteeism, sick leave and the general deterioration of job quality due to workers' burnout or injury.[61] It makes good economic sense to take care of us and our health needs. We could hope that they would also do it because it makes good people-sense — but that doesn't seem to happen much anymore.

Sam

2

Getting Up in the Morning Is Getting Harder Every Day

My future is a day-to-day thing.
And at this stage of the game
I should have a little bit more
to show than this.

Sam is single, in her early fifties. She considers her age an asset to prospective employers, even if they don't. She describes herself as a "fighter" who has definitely been more a participant than a spectator of life. Sam returned to university as an adult student to earn a degree; she also holds an ESL teacher's certificate.

I've been working off and on for thirty years. I left high school early and just got working; that was just what you did. I had typing in high school, so initially I got a job at a credit company and stayed there until it was put out of business by a bank. Then I went to work at the bank and then Texaco — I bounced around an awful lot! I was young. I wasn't serious about employment or the concept of getting one job and staying with it. Oh, my wasted youth!

I think it was in the 1970s I did some computer courses and some word processing on my own because I realized the direction things were moving in and that I had to do that. I took Wang, which is gone by the way of the dinosaur. However, it did give me some literacy about computers. It was

enough that when my temp agency had a job to fill that needed those skills, they would send me out on it. That's how I started some contract work with the Ontario government. I had enough to sort of get in and say, "Yes, I know what I'm doing, a little bit." And I could type. They gave me more training there. Actually, a lot of training I've gotten has been on the job, through different contracts. I do pick things up quickly, so that's how I've done it. But, initially, I took the initiative and paid for the training myself because I could see that I needed it.

I had good labour skills and I'm bright enough that I could pick things up in an office. So I could manage and I could extend myself if they allowed it, but I guess I still wasn't clued in on what the whole work ethic was. By the time I did, things were really changing, with recessions and people not hiring full-time.

In the 1980s, I started back to school to get my undergraduate degree. At that time, working temporary through agencies was beneficial because I would do summer courses and I could take a few weeks off. I would budget for it. Tuition wasn't so high; they still had the grant periods, so I could afford to do that. I could put money aside, and take a three- or six-week course in the summer to get my degree that much sooner and I wouldn't suffer financially. And I would still be able to have a holiday! But that's just from the mid to the late 1980s. Everything has changed dramatically in just this past decade.

I've worked really long-term in some places, but it has been, generally speaking, on a contract basis. I rarely had benefits or anything of that nature, but I was always able to keep working. Well, it would be up and down sometimes. At first, I would always be loyal to whatever agency I was with. I had to sign these contracts saying that I wouldn't work for anyone else. But even the agencies began to realize at a certain point

that wasn't feasible, that as a temp I had to be registered with other agencies and that they couldn't hold me because I had to keep busy. If they couldn't guarantee me work, what loyalty did I owe them? That was their job, to find me work and if they couldn't, why should I stay with them?

It was in the late 1980s, early 1990s when things changed. It used to be I could pick and choose assignments pretty much. Then it got to be really desperate, like, "Find me anything!" I would take things that would be more junior than I usually took. My hourly rate dropped dramatically — I would say it dropped two to three dollars an hour over the past five years. So I think with the economic climate that we're in — with the contracting out, with the companies not hiring because they don't want to part with benefits, and with temp workers like myself not being able to get hired — the agencies are gouging everybody and scooping the benefits and keeping the temp workers on a very short rein. I'm getting very frustrated, very fed up. It's impacting on my health, and on my living arrangement. My future is a day-to-day thing. And at this stage of the game, I should have a little bit more to show than this.

So it's not a pleasure to go to work. The jobs come week-by-week now. Occasionally I'll get long-term things, but you know it's very arbitrary, and they can let you go just like that in the middle of your assignment. I have no security. I've had to fight for everything I get and when an assignment is over, I want to be able to pick and choose. This woman at the agency, we have a good rapport, but she should be looking for better things for me. That's her job to send me out on things that are more challenging, at a better rate of pay. I've been upgrading my skills; I'm learning this, I'm doing that. I'm proving myself in places. But it's as if she's got me by the short and curlies when it comes to that. She knows that come Friday afternoon and I've got nothing lined up for Monday,

I'll take anything. Then she gives me this false sort of flattery, compliments about my skills. She patronizes me and she's just a young woman. She's getting on my nerves. But it's my only connection and it leaves me sort of desperately needy. It's really an awful feeling at this stage of my life that I have to feel desperately needy when I'm an asset. Generally, when I go any place, I get nothing but praise, they think I'm terrific. But she doesn't seem to be aware of this — I'm just getting the runaround.

Presently, I'm registered with two agencies. Well, actually I'm registered with a number of them, but these two are the ones I'm in most contact with, and one has kept me the most busy the past year and a half. Before that, I was at the University of Toronto for about five years. They have their own temp agency and they hire their own contract people. It operated the same pretty much as other agencies where you're recruited and you test with them. When people at the university need somebody for a week or long-term or something on grant, they would hire through this agency. They would pay the agency and then the agency would pay me. But the jobs started to dry up because people with grants were starting to hire people directly so they wouldn't have to pay the agency fee. I thought for a while I might be able to get a full-time job at the university through my temp work. But again, it's difficult with their restructuring to try to get hired on a full-time basis. Sometimes it's the luck of the draw.

It was quite an eye opener when I came back into the agency world. The university was a community unto itself. I learned a lot there, but I wasn't really growing in ways that would get me back into what you call the private sector. So I had to increase my skills and learn a little bit more about business and different types of business, not just the academic. But now I feel that I'm just back in this vicious circle again of going from one dead-end thing to another. I keep updating

my résumé. I keep answering other agencies' ads, but I just feel like I'm beating my brains out. Maybe it's because there's so many of us out there. They're just grinding us through like a meat grinder and they're not looking at the individual, the skills and the needs.

If I was hired, I would be an asset. It's getting to the point that I don't know how to market myself — it's self-esteem, marketing and accessing the hidden market. I'm just sort of learning what that's all about. I think I need to take control of the situation myself and not believe that the agencies are really acting in my best interest, because I don't believe that they are. Not when I look at the disparity at what my wage is now and what it used to be, and what they're still charging the client. Somebody's making the bucks on me, yet my wage isn't livable anymore. It used to be comfortable and livable. Obviously, I could pay for my education; I could take a trip. I could take time off! So something is very, very wrong.

And it wasn't necessarily just the agency. The thing is, if the market is there, the clients can dictate what they're going to pay for the same skills. Used to be, if they asked for certain skills, they would pay sixteen, seventeen dollars an hour. Now they'd only be prepared to pay thirteen or fourteen dollars an hour for the same job. So they want more for less; that's also what's going on and they're able to get it. And the agency, maybe because the client won't pay as much, the agency's taking that much more. So the worker is the one who's getting done in.

For example, on this current assignment, I get paid fourteen dollars and fifty cents. For doing this same kind of job five years ago, I would have been making at least sixteen dollars. And the fourteen-fifty is actually high right now! Generally, it's twelve-fifty to fourteen dollars. It is very, very depressing. And I need more computer skills, more admin skills for less money. I used to be able to go out on strictly

word processing — nothing very challenging, no fancy reports and things like that — for sixteen dollars an hour. Now, I have to go out and be a jack of all trades and maybe get thirteen-fifty. It is that big a disparity. It's very significant. I think it's very reflective of the market and what they perceive your skills to be. And I'm paid strictly by the hour. If I have a doctor's appointment or anything like that, it's not covered. And there's no sick pay. I get paid for the time I put in. There's no security in that.

In a lot of places, they treat you like you don't exist. Then your agency treats you like that. You're just out in the field unless something comes to their attention, you know, you make a faux pas or something. Then, they're all over you. I think, "Hey, you don't know from one week to the next who I am, what my needs are, what I'm doing, if I'm doing a good job or not. You only hear about this!" I'm getting more annoyed each day. I'm the low person on the totem pole for having concerns: first off, the client is always right. Then you're working for the agency, so they're right. Any concern I might have is very low. And yet I'm the one who's out there generating the cash. But I'm being made to feel needy and desperate.

But it's the unsettling business of being in between things and not knowing where you're going to be and trying to get on with the rest of your life and do other things, that really gets to me. It seems like my focus is always going from one assignment to the other and making sure I have work lined up for the next week. This is very draining on my lifestyle, energy, focus, everything.

I'm fifty now and I think my age should be a positive factor. I have maturity and experience to bring to a job. I think that's important, too. But I feel so depressed sometimes, so maybe that comes through. It's a battle to try to be up all the time. Well, I'm sorry, but nobody's up every day. And

people who are in jobs long-term, they have some bad days, but if you're working temp, it's almost as if you're not allowed to have a bad day. You're there for such a short time, you always have to be up and on the ball. Well, that doesn't work and that's ridiculous to even expect people to be like that.

I think office work has been devalued what with all the restructuring, cutbacks, letting people go, early packages, asking people to do twice as much for less, not appreciating what they really are accomplishing or how important their support staff (a cute little euphemism) are to the smooth running of most businesses. I just think that our labour, our input has been devalued financially and emotionally in all those regards. We've definitely lost our status.

All the value really has been put on technological skills. I've sort of been dragged into technology reluctantly, at the best of times. I can manage, but I'm certainly not competitive with these young people out there. And if you don't have current technological skills, you sink or swim. However, there are other skills that are not necessarily technological that are as important — wisdom, people-skills, maturity — and that you place a different type of value on. I think these have been devalued. People aren't giving these the same consideration. We're not automatons, you know. That's the way we're being treated. I think the clients are losing, too, but they don't realize it. They're sort of blind to the fact that they're not getting loyal people; they're not getting the quality of work that they would like because they're not inspiring anybody to give that calibre of performance.

What would be good for me would be a real job. Where I know they want me, where I have benefits and security. That would be good for me. A six-month contract is just, well, six months. I'm just six months further down the road and I'm still no further ahead. I have to start really feeling like I'm making some progress and that they're not just getting

everything from me and I'm not getting anything in return. Because then I don't have all that "enthusiasm." It's time to turn things around. I'm not necessarily going to go into those financial institutions where the young kids are going in and making their careers. But I'm sure there's a job out there for someone of my age and experience. Maybe not one of the designer jobs, but a job where there may be security, and I could be comfortable and they would be comfortable with me. I think that it's now just a matter of doing the real resourcing and connecting. I've got to just keep believing that that's going to happen. So it's sort of a day-by-day thing, you know. Every day I try to envision that it will happen, but it's tough.

Five or ten years ago, when I was doing my schooling and everything, there were up and down times, and sometimes there were lean times, but on the whole, I didn't feel that sense of desperation that I've been feeling the last couple of years or so. That sense of being between a rock and a hard place, of being at everyone's mercy, of having no control whatsoever over the situation, of not getting ahead, of all the stress and the insecurity. That's really been a fairly recent phenomenon. I think it's really widespread, not just with temps, but for people who have been in positions for a while. I don't know about these people who say the economy is improving! Where? Because I sure don't see it in the rank and file. I don't see that anybody's getting ahead or having more options. I don't think there are any options; you take what you can get.

I think office work is something I sort of fell into over the years and that's the way it is. Even now, with all my education, I wonder what else can I be doing? I just have to keep working day-to-day to earn my keep. And you know, some days when I wake up and it's bleak, and I'm going into a place where I'm not being appreciated just because I have to, it's very difficult to believe anything's going to change. It's a

day-to-day thing and I have to keep saying a silent little prayer. I made myself a little bookmark; I just carry it with me:

> God grant me the serenity to accept
> The things that cannot be changed
> The courage to change the things
> That can be changed
> And the wisdom to realize
> The difference.

I need to know those things, to internalize them and to believe that I can keep on going.

Meg

BEING OLDER
THAN THE BOSSES

But these days,
I sort of feel vulnerable.

Meg is fifty-seven and lives with her partner in a big, comfortable house in downtown Toronto. She is the mother of two adult children and grandmother to two small grandchildren, all of whom live "too far away." Meg says of herself: "I have a million interests. I sew, I paint a little bit, I write a little bit, I cook." She spent much of her adult life in the United States where she worked in paid work while being a single mother. When her children completed high school, she returned to Canada.

My first job was when I was fourteen. I went to work in my dad's dry cleaning plant in the summers, waiting on customers and going through pockets (yuck). I continued that through high school, then I went into nurse's training because my father said, "You have to be a nurse or teacher, and that's it!" No, a teacher wasn't even part of it. So I went into nurse's training, and after about three months, I just knew that wasn't for me. I just couldn't stand to see all that suffering. I had met someone right before I went into nurse's training so I left and married him and moved to the States. I worked in his office for a little while, just until I got pregnant.

Then my husband decided to go back to school, so we moved to Detroit (we were in St. Louis). Since he was going to school, I was going to have to work full-time. I got the newspaper out and said: "Oh, there's a job — I can get a job as a secretary for the *Detroit News!*" There were jobs everywhere, this was 1965; it seemed like anytime you applied for a job, you got a job. I couldn't type well enough to work as a secretary, so I got a job in the advertising department, scheduling the ads and dealing with advertising agencies and that kind of thing. I loved that job, just loved it. And I loved being in a newspaper. Six months later, the supervisor of the department left and they promoted me. I did a really good job. I was there for two and a half years and then there was a strike, which was so demoralizing. Although I wasn't out on strike because I was a supervisor, it was terrible that my friends were laid off and I just didn't feel right about working. So I left there. I had been working four days a week and by then we had enough money so I didn't have to work. But I still wanted to do something. So I went to work at General Motors. My boss was very nice, the people I worked with were nice, it was a beautiful office — but I sort of liked the grunginess of the newspaper office. I stayed at GM about two years, I guess. Then my husband was making a lot of money and my kids were home, so I quit.

We moved to Pittsburgh for my husband's job and I was unhappy being home alone and away from friends. I called the United Press International, and the Associated Press offices, since I'd loved the newspaper business so much. It just happened that the people at AP needed somebody part-time, which was perfect for me. I was able to work from ten to three, four days a week. I loved it there, just loved it. I was there about two years.

Then I was divorced and one of the conditions of the divorce was that I had to have a full-time job to support myself, the kids, everything. I worked for two months at Westinghouse. That was sort of fun but it wasn't what I really liked. I knew the man who was the bureau chief of UPI in

Detroit, and he asked me if I wanted a job in the Pittsburgh office as a secretary. I went there and liked it a lot more. Then there was a strike, but I didn't go out because I worked with management. The fact was that I had two kids, no husband and no support, and you know, it never occurred to me to not work. I did have to cross the picket line every morning to go to work.

During the strike they moved me from the office into the newsroom. I was working from six in the morning until ten or eleven at night writing radio copy without having any idea what I was doing. They just said to me, "Here's the style book." I did an OK job. They told me I could have a try at the next opening in the newsroom, if I wanted to. I started thinking, "Why should these people in the newsroom want me there? I was given the opportunity because they were suffering?" Well, let me tell you, they were so wonderful. They never held it against me that I worked while they were on strike. They helped me learn the job, which was mainly writing news stories and going out on stories and press conferences and stuff like that. I never liked the press part of it. I was very intimidated. In fact, I was scared to death. I didn't know what I was doing. But I loved being in the newsroom.

This was in the late 1970s, I was making thirteen thousand dollars a year to work around the clock on shift work and Sundays and holidays and weekends. That really got to me after awhile. I never knew whether I'd be home for Christmas or New Year's or Thanksgiving. After seven years of this, I was just burnt-out. My second child was just finishing high school and I thought, "What am I doing in Pittsburgh?" I had no reason, really, to stay. So I came back to Canada. I never gave up my Canadian citizenship. It was a good thing!

So by now we're in 1979. My sister was working for a company selling pagers and so she got me a job there. My territory was out around Brampton (in Ontario); there were just farms out there, so I felt like they were asking me to sell pagers to cows. I couldn't sell pagers. Actually, I couldn't sell anything. But I tried it for a few months. Then I found out

that my old boss from UPI in Pittsburgh was now head of United Press Canada. He asked me if I would come and work in the office here as a summer vacation relief person. So I did that and continued selling pagers. While I was there, they got a call one day from someone at the University of Toronto asking if they had anybody to recommend to work in their public relations office, so I started working there part-time. So for a short time, I was working three jobs — selling pagers, summer relief at UPI and part-time at the university! The first one I gave up, of course, was selling pagers.

Then in the fall, the UPI job ended and I started full-time at U of T. I was so accustomed to the crazy pace at UPI that the university work was just too slow. I didn't feel productive. I didn't feel like I was earning my money. But I really loved the atmosphere. It was very free and easy. But it just didn't feel right.

I was always looking for something else. Then a job listing came along in the department of fundraising at the university. So I went to work there doing writing and office work, some PR stuff. There was a society woman running the department and she took all the credit for everything. It wasn't an egalitarian place, you know. I was miserable there.

I started looking for a new job, but this time jobs were getting harder to find, the job market was tighter and I was older. So my choices were not great. I just took the first job I could get and do. It was called a "marketing co-ordinator" for an accounting firm. I was definitely not suited for this job. No one ever told me what the heck I was supposed to be doing. I realized soon after I was hired and put in a corner office with a view, that I was sort of a pawn in the marketing manager's bid to make his empire bigger. But the privileged position didn't last too long. When my boss went off to his mother's funeral, his boss shipped me into an inside office the size of a kitchen table. I had been there for six months when a friend from my U of T days, who was running a fundraising campaign at the Royal Ontario Museum, asked if I wanted to go work for him. I ran from that job. At the ROM, I had a

three-year contract; it was renewed twice. But then that particular campaign was finished and I was out of work.

By now it's the late 1980s. I remember thinking at the time, "What am I going to do with the rest of my life?" I had no job. I didn't want to work with rich people anymore. I didn't like fundraising. I had worked for a big corporation and didn't like that. I would have taken a job at a newspaper, but there weren't any. So I signed up with a temp agency to do secretarial work.

Eventually I got a job at a law firm whose motto was "The Sweatshop with the Difference." And they were proud of it! I didn't fit in there; I didn't like it there. I worked and the pay was good, and I just stayed. I stayed there for about two years. Then I went to another agency and got a job with what they called a "left wing" law firm. I liked it there; it was much better secretarial work. I was doing a little bit of law clerk work, keeping up with minute books and incorporations. I also handled the charitable registration numbers. That was interesting because I would have to write sort of a short story for Revenue Canada to make them believe that the group really did need a charitable number. So I could do a little bit of writing, which I liked. I kept thinking during this time that I should be trying to do more writing. That's what I had been doing at UPI. And I knew that the longer I was away from it, the less confident I was that I could do it. But I was working full-time and I didn't have the time or ambition to be writing at home at night. It bothered me.

Then I had an argument with my boss. He had left me something at the end of the day with a note that said, "Send this." So I sent it by courier. The next day when he came in, he screamed at me for wasting the firm's money; hadn't I ever heard about the fax machine? It was humiliating; I was so mad. This law firm was the kind of place where they encouraged you to talk back, but I just lost my temper. I just decided I couldn't work there. When I got home, I thought, "Here I am in the middle of some files and they won't know what's going on." So I called them and said I would come back for a

month and clean things up, so I did. Then, it was my fiftieth birthday, and I gave myself three months off to work at the Omega Institute in New York for the summer. It was great. When I came back, I just couldn't seem to make a break from temping and think about something else to do. In the back of my mind, I kept thinking, "I should be trying to do this writing." Instead, I worked in offices until one day I just felt that I couldn't work anymore. I think I had a little bit of a breakdown. So I collected unemployment insurance for a while until it ran out.

Then a friend told me about a place that needed somebody part-time. It was a community centre and they needed somebody in the office in the spring for a couple of months to sign up people for summer camps. So that's what I'm doing now along with some occasional work in a law firm where I had worked before.

I wouldn't work if I wasn't getting paid. Money is the only reason I work, although the benefits of a good place are worth far more than money. And it's the camaraderie and people who think the way I think, but that so rarely happens. I loved it at UPI because of the other people who were there. I felt related to them in some way. I've never felt that way anywhere else. Except at that one law firm there were people who I felt were like cousins to me.

But most of the law firms that I've been in, I never felt that I had anything in common with anybody else, and I think they felt that, too. I have found in the past few years that I've been so much older than everybody else and our life experiences were so different. They talked about their kids, and I wanted to talk about my grandkids. They weren't interested because to them a grandchild was so foreign an idea. They didn't realize how important my grandchildren are to me. I got to the point where I never talked about anything because no one was interested. I wonder where all the women my age are working? What are they doing? Because, in fact, I wasn't only older than the secretaries, I was also older than the lawyers.

And the work was so dry, too. It was just meaningless. You couldn't care less, especially in corporate law when you're working for other people's millions of dollars. And another thing I don't like about law firms: there are the lawyers and there are the secretaries, and the lawyers would spit on you if they could. At UPI I felt that we were a real team. We were all equal, even the bureau chief, who did get the weekends off — that was the one way he wasn't equal. I guess what I felt was that there were people around me that I trusted, who would sort of look out for me, as I was looking out for them. There's no way that I can put a finger on it, but just somehow that these were people I trusted, and if I told them something about myself, you know they would value it or hold it or whatever. But that doesn't happen very often in offices.

The work itself that I do has very little importance, really. I can do just about anything. Right now at the community centre, I'm folding papers and sticking them in envelopes and running them through the postage metre! Once in a while it might be nice to use my brain, but I didn't do that in law offices, either. I have this job until the end of May. After that I have no idea what I'll do — I don't have a clue. I'm not looking for anything right now. I was signed up with a temp agency, but they said things were pretty slow. They thought they would try to keep me working because I was somebody who they can count on. But I don't think there's as much work now. I found I've been extremely lucky at having a job when I need it. It's not necessarily been a job that I wanted, but I haven't been out of work until I chose to be out of work this past year. There was always something that came up. So I've been very fortunate that way.

When I go to a place to work, I take it very seriously and I do a really good job. I want to be respected. I don't want to pretend that I'm a lawyer if I'm in a law firm, but I want to be respected as a person. Nobody will ever not get their money's worth if they hire me. I really feel that that's important and that's what I have to give. That's how I get self-respect in a job, because sometimes it's very hard, but it's better if I at least

feel that I'm doing my best and they're getting their money's worth.

But on the other hand, if I'm supposed to work nine to five, don't come and hang around my desk every day at ten to five or five o'clock or five after five and ask me to stay, because that drives me crazy. I don't care if you want to pay me or not. I want to work and know there is a finite time. I don't know about law firms in the States, but here, they want you to stay. They'll pay you and it's supposed to be voluntary, but, boy oh boy, do they really hate it when you don't agree to stay. I got a job assessment just before I quit the last job. I was told that I was the best secretary this person had ever had, but he couldn't put up with my not being willing to work late. And when they say late, they don't want you to pick up and leave at seven o'clock, they need you to work until midnight. After that, I never felt the same. It was like they were saying, "We're doing you a favour, we're giving you a job." The other thing they let you know was how replaceable you were: "Honey, you don't like it, bye, there's the door, we got ten people waiting in line for your job!"

My partner is supporting me, basically. I can't live on three-days-a-week income from the community centre. I'm fifty-seven. I'd retire if I could, but I don't feel right about it. You know I feel I've got to contribute a little bit. I know if I wanted to go to school, he would support me, emotionally and monetarily. But there's nothing — why go to school unless you have some ideas? If I ever needed to work full-time again, if he were to lose his job or drop dead, I could maybe go back to a law firm. I would probably have to take a course somewhere along the way with the new equipment. Anything that came out in the last year and a half I don't know. But I've never had problems picking up new technology. It's always come. The work itself comes easy to me. I've never had problems learning how to do a job.

But these days, I sort of feel vulnerable. I feel now when I step into an office, god, they can do anything they want with me. Who's going to protect me? Nobody has ever beat me up

on a job, nobody's ever been abusive. A boss did chase me around the desk once, and I got out of there. I don't know, I just don't feel safe now. I can't explain why. It's like there's nobody looking out for me. And I don't understand why it is happening now.

Judith

ℒ

TAKING SMALL STEPS
INTO THE FUTURE

_I guess it was in the spring of 1993
when I left that full-time job
and walked into the temp world
and I haven't walked out since._

Judith is single and in her late thirties. She has a
pensiveness about her that lightens when she
smiles — which she does a lot. She grew up in
Montreal, where she began a university program
in economics and math in the late 1970s. She left
her studies because of medical problems and
moved to Toronto where she thought she could
"straighten out" her life and return to university.
She still makes Toronto her home.

I started to get work as a clerical worker to make money. I
needed money. I had no place to stay; I didn't have my univer-
sity degree and I'd used up all my savings. I was a very middle-
class person back then. I grew up in the suburbs, went to
school, worked hard. I did very well. I thought I'd get my
degree, study economics, be an economist. That all sounded
great — it was ideas. In my second year of university, every-
thing seemed to fall apart. I was studying economics and
math and I had A grades. I'd saved up a lot of money and I
was working about twenty-five hours a week as a lifeguard

when my epilepsy was diagnosed. So I had to drop out of school and six months later, my dad died. It was terrible. So instead of pursuing a university degree, I had to pursue a job.

I thought my way out was to go to Toronto for a year, straighten out my life and then go back to university. Toronto was booming compared with Montreal in the early 1980s. I knew I could just pick up a job, start working anywhere. I thought: "Oh yeah, I'll just work it out and then go back to university."

I had to learn to understand office work from the bottom up. I had learnt typing in high school and I had a sense of organization. That was all you really needed, it seemed, to get a job as an office worker at that time. I just took any job I could. I ran after the newspaper ads. I think I got one or two job offers through the agencies. My first job was for a securities company as a secretary. That lasted until I had my first seizure on the job and was fired. So I knew right then what was going to happen. The next job after that, the guy demoted me when I had a seizure. The doctor had taken me off the medicine for a year, so I started having seizures. It was like, if the seizures happened at work, I lost my job; if they happened at night or at home, I had the time to recover, which wasn't too bad. I was scared at not having a job. Either I lost jobs or it seemed I was just being promoted to train someone else to do my job and got kicked out on Friday. The doctor finally put me back on the medicine and that helped, but all during this time, I did not know my rights.

All of these jobs were basically jobs where you were the secretary to a person who wanted to dictate, give you letters, do typing, answer the phone calls — a very average sort of job. I was making in the low twenty thousand dollar range, up to a few years ago. At the time, I guess it was enough to live on. I had a junior bedroom apartment. I was always scared of being in debt, so I just didn't have any credit cards or anything. I made ends meet.

In the late 1980s, I had my first experience with computers. I worked for a small, independent insurance broker; he was just starting to get one or two computers in the office. It was that time just before computers became a business write-off. It turns out, in the 1990s, companies could write off computers, that's why they all bought them.

I learned how to use the computer on jobs through trial and error. I just kept working at it. Basically, it was still a typing job in a lot of cases. All you did was typing and memos, format. So all you did was get shown something once and it was fine. When I got into jobs where they used more sophisticated software, I bought books and made notes like crazy. I think the technology came easier to me because I was always very good in math, lousy in languages, maybe more like a man. And I found that after five to seven years, all the software was very similar. It really was. It's just a matter of how you start, how you do this, this, this. I think I had a very good handle on the typing and that was giving me the roots to how to do a letter. And you just take that into a software package.

By the time I worked for a communications company in 1990, every person had a computer on her desk. I remember that. I got that job through an agency. It was a full-time job and I stayed there for two years. I would have stayed longer, but the woman I worked for was a real nut cake who gave my home phone number out, so I was getting calls in the middle of the night from people looking for her. I complained about it and got let go from that job. So I started looking around again and I got a job within a few months in a new department at a major bank.

They were forming a new insurance department. At the beginning, it was only about forty people, but it was going to develop into a big company and then later move to the suburbs, which it did. Forming these new departments

seemed to be a trend in the early 1990s. The same thing happened when I worked at a rival bank. These banks would create a new department by keeping the people they liked and getting rid of other departments. That way they had the right people working for them. At the beginning, it would always be a small group of people and the bosses would be really nice to everyone, bring orange juice and cookies. But everyone knew that they were not being brought on board just to have a good time — at the end of three years, they were supposed to make a profit.

In both banks, I was sort of like the secretary, helping to set up the new department. The banks weren't hiring too many admin people at this time. They had very few secretaries. I worked full-time at the first bank doing just general secretarial work and helped with the logistics of setting up a new department. At the next bank, it was a temp job; I worked for the woman who was in charge of computers. She needed an assistant until her full-time person started. I was ordering computers, software, hardware and inventory for this new department. I had no experience in any of this, totally learning on the job. It was a great experience, though. I was ready for it; the timing was perfect. I stayed until they brought in the person who was supposed to do all of this. I ended up sticking around, helping her do the job. This is how I knew I was very good at setting up these new departments.

This was around the same time when the Free Trade Agreement with the United States was put into place. That marked the beginning of the end of unemployment insurance. Before, whether you quit or you were fired, you could still get UI. That all changed. It was all rewritten. I think that created a flood of unemployed people, because basically, a company could let you go for any reason. Before then, you really were entitled to UI for all the work you'd done. It didn't matter why you left. So I think that was the beginning of the big changes,

when it seemed that most jobs available were temp ones. I guess it was in the spring of 1993 when I left that full-time job and walked into the temp world and I haven't walked out since.

I worked in temp work out of necessity. At first, I was thinking it would just turn into a job. Then I started to see that this was all a bit of a lie from the agency. It usually never did become permanent. But then I started to see what was happening — everyone was laying people off, everyone was merging, everyone was pulling their hair out at their jobs — and I started to realize that I was somewhat better off doing temp than having a full-time job.

When the temp job at the second bank ended, I got a break and was offered to work as a temp for a different department. My name had come up to someone and the company said that since I would not be working for the same people I had before, they could hire me without the agency. I could bill my own rates and basically be self-employed. I worked three months for one department as their admin assistant until they hired someone or I helped set up new departments. There wasn't even a contract. I had no idea how long the job would be. I think if it had been through an agency, there would have been something more solid. It was supposed to be three months and it turned out to be eleven months. It was great. I think because I was self-employed, it taught me to feel good about just grabbing for whatever I could, learning whatever I could. It gave me back a good sense of "I'm in charge of my life," rather than at everyone's call. I started to realize I had a little more control.

During that time that I was working as a self-employed temp at the bank, I had the chance for a seven-month maternity replacement position. It sounded great; it was my wages or more, small office, again to set up from scratch. They were converting to computers and they were saying they were

depending on my computer knowledge to help them through. Then one of the VPs at the second bank that I had worked for told me one of her people was looking for a full-time secretary, would I be interested. A full-time job!

It was a tough decision to make, but it was a good job offer — downtown, good pay, a bit of computers, room to grow. I was told I'd be working for the VP of the technology division plus his staff. It turned out it was him, plus four guys who worked for him, plus five guys who worked on the project for him, plus two guys who worked on another project. I was supposed to take care of accounts payable, human resources, new employees' paperwork, his schedule and the typing. One of the guys who worked on the Y2K program wanted me to start working on that program, as well. It was outrageous. This was the job of an admin assistant? It just blew me away.

I see this happening like crazy. Whether you are self-employed or you work full-time, you don't know what the job will be within a year. Every job I've ever taken as a secretary has evolved into twice as much work. They don't pay more; they just say that's part of the job. They give as little description as possible when you start the job for that reason. A lot of places expect a secretary to do graphics, desktop publishing, Lotus spreadsheets — jobs that used to be paid for separately with a lot more money. Now they are just throwing it on the secretary.

But the worse thing about that job was that the office was right next to the call centre and I could hear everything. I couldn't hear myself think. I complained to my boss and he only said, "Well, we can work this out, let's move your chair around." My office was an open cubicle and he thought turning my chair around to face the wall was going to help the noise level. Of course, he had four walls and a door. I literally got a jaw problem because I was grinding my teeth to close

my ears. So I gave him my notice, trained the new girl and left.

Then I was stuck. I had no job; I had turned down some great offers, but they were all taken. I was burnt-out and my doctor said I was suffering jaw problems from grinding my teeth. I just was kind of blown away. But after a month, I went to the agencies and started looking for work. This agency put me in a government job. I was supposed to set up yet another new department. What they didn't tell me was that I'd be by myself without another secretary around. I had no one to turn to; so I just kept calling everyone. It was nuts. I had to learn everything on my own. At that time in the government, so many departments were being downsized that there were people sitting around, literally waiting for their pink slips. I think, in all honesty, that some of the women who were working there then who wouldn't help me were really just burnt-out.

This is another reason why I'm a little scared with all these mergers going on. The first thing they knock off is the people who can tell you how to do anything. So if they are knocked off, you, the temp, are screwed. Why should I be responsible for things if no one is going to tell me how to get it done? Yet, the employer expects you to do it. It's really absurd. It is really ridiculous that I, as a temp, should be so stressed out doing a nine-to-five job.

I don't know. I think the whole world of secretary/office admin is just about over. It's expected that everyone do their own stuff now. The only ones who get a secretary are the people that are very senior. That's a little scary to me because I don't know what else I can do. This was my means of survival for the last few years. I'm asking myself if I'm going to be like the person on the street if I can't get an office job? What am I going to do? It's like taking a huge career change. What else can I do? What can I do that would actually give me a regular

size paycheque or even around that? I see the ads for sales assistants, six, eight dollars an hour. How can you live off that? It's incredible. The experts say that the real opportunities are in computers. Do you know how much money it costs to take those certification courses? The average person, or let's say the low-income person, can't afford that. There's no way you can.

I don't know how to go out there and sell myself. I don't know how to say, "I'm interested in this other job. I can handle this." And then they say, "Well, what's your background in it? Do you have a degree?" I've always classified myself as a person who's done the admin work to survive but was capable of a little beyond that, but for personal and other reasons, I couldn't make the next jump. Now, I don't even know how to try.

The Office Workers' Future: Trying to Turn it Around

_It's true the term "secretary" is not viewed with respect,
especially by the people who work as such. Perhaps
this is where the change should start if we want
to be perceived in a better light.[1]_

Nothing Works Without Clerks![2]

THE CHALLENGE FACING US today is to put together a coherent plan of action that addresses the issues of self, occupation, community, political and economic voice, and power as they affect office workers. We have to find a way to create as sustainable a work environment as we can during this period of transition. Having a say in how the new work culture unfolds won't necessarily make our work more interesting, but it will make our world more livable. It isn't that we are rejecting the new workplace outright — we all acknowledge and accept that change is inevitable, and that computer technology and a global economy are here to stay. This is not the problem. The challenge is how to retain a sense of our selves, our values, our health and our dignity within this changing environment. Change shouldn't mean that we give up everything — the good and the bad – from the "old" economy in order to survive in the "new." What we have to do is decide what is too important to risk losing and how we can maintain that within our workplaces. This is not an easy task. It means that we have to re-examine and challenge some of the conventional wisdom

that others hold about our positions and that we office workers hold onto as part of our identity.

To begin, I think we have to realistically look at the role that we play in the work environment, whatever it may be: administrative assistant, teller, secretary, receptionist, call-centre operator. We don't have to like what we do, but we do have to come to appreciate it for what it is — namely, a vital component of the global economy. In other words, we have to believe the truth behind that bumper sticker noted above — nothing does work without clerks. Even though we, and our jobs, are most often ignored by our employers and treated as incidental to the running of our workplaces, *we* have to start believing that our work brings real value to the bottom line of our employers. Challenging the "I'm just a secretary" image and providing leadership within our workplaces are the first steps towards wearing the title with dignity and respect.

To achieve this goal, we must revalue the importance of community and our sense of belonging both inside and outside our workplace. We can start the search for solutions to our workplace problems on a very personal level, but we need others for feedback, support, professional inspiration and reality checks about our own experiences. Too often, our own workplace community becomes so jaded by the politics of the employer that it disintegrates. It becomes impossible to objectively look at the situation and our role. We must overcome this malaise to think of ourselves as the larger group called "office workers" and not just as isolated individual workers. Only when we can identify with that larger group and name things in common can we begin the process of revaluing and renaming our work. Only then will we have the necessary forum to speak as a group and talk about how the changes in our workplace are affecting us as a group.

History has shown us that it takes collective action to bring about any basic change — there is no reason to think that our situation should be any different. In today's climate, where not only our own workplaces are being transformed but where worldwide labour laws are being ravaged in order to suit the needs of a global marketplace, collectivity is especially important. If we are to maintain or gain economic well-being, we need a collective voice to speak for us

in negotiations with our employers, whether they be about daycare, pay raises, overtime or new technology.

To recover a sense of ourselves as office workers, we must acknowledge and act on the fact that our problems are not, as the new ethos would like us to believe, of our making, but are built into the system by our employers. No matter how much experience, education, skills and loyalty we may bring to the workplace, we are not rewarded with the status, mobility or security that existed before the current restructuring brought about by computerized technology and the globalization of the economy. There is nothing intrinsically wrong with our roles, it is what they — and by association, us — have come to represent in this new technological and economic world. The issue is how to reverse the deterioration of our workplace and restore the dignity and rewards of a sustainable work culture.

In Search of a Sustainable Workplace and Culture

There are many routes to take towards a stronger self-image, and from there, towards a more assertive voice in the workplace. We each have our own particular preferences about which route to take — what is important is that we begin the journey. I think the first thing we have to do is start talking to one another again about issues in our workplaces and the role we play in them. The more we connect with each other, the more strength we have to take next steps. In addition, we have to broaden our outlook so that we become as informed about global changes as our employers. Let's use some of that "life-long learning" to benefit our, and not just our employer's, economic well-being. Then let's team-up with organizations that support the needs and aims of office workers. In this section, I look at four of these organizations, which I have selected based largely on my familiarity with their work and because they address issues that affect women's working lives. I believe they offer us a more positive route to take towards strengthening a voice in our workplaces.[3]

SEARCH FOR SELF IN THE WORKPLACE:
TIMES CHANGE WOMEN'S EMPLOYMENT SERVICE [4]

The first time I walked into the office of the Times Change Women's Employment Service in Toronto, I was struck by two things: one, the people who worked there were laughing; and two, it was all women — clients and employees alike. After spending some time there as a volunteer while I did research for my master's thesis, I added another item to this observation: mutual respect. More than any organization I have ever been associated with, Times Change demonstrates a respect for women and for their work in everything it does. For the twenty-five years since its founding as a grassroots, feminist collective, it has, as its name indicates, devoted its work to women's self-respect in times of change and upheaval in their work lives. I joined Times Change as a volunteer and eventually became the president of the board. As I wrote on the occasion of their 25th Anniversary celebration, they show a "respect for the individual needs of each client who walks in the door; respect for the organization and what it stands for; respect for the collective process in decision-making; respect for the diversity of our community and how that diversity enriches our lives; and a respect for the value of the work that women do — paid and unpaid — in this world."[5]

Times Change does not directly search for jobs. Its role always has been, through workshops, counselling and resources, to develop women's knowledge of their relationship to the workplace in order to better prepare them to deal with it. As an office worker, I found that just being around this environment gave me a better understanding of my role and the confidence not to be ashamed of what I did. Here was an organization that was taking the workplace concerns of women seriously. Their clients ranged from women with PhDs to women who had left high school at an early age to new immigrants with no Canadian experience to highly paid professionals. Whether the women came for counselling or a workshop, or maybe just to check the job board, Times Change provided them with a supportive environment in which to work on their own issues. That is really the key to Times Change — confidence in each woman's ability to make

the change herself. Times Change doesn't work miracles — but it does give women a process to use that enables them to take responsibility for their own employment issues. Loretta said her experience at a Times Change career planning workshop was like an "awakening" for her. She heard other people put value on the work she had done over the years as a part-time worker and a full-time mother. She could then finally accept that, "Yes, I could do things and they are good to know how to do." Joan keeps her material pasted on the back of her bedroom door so that she is reminded that if the chance ever materializes, she and her dream are ready.

Times Change serves approximately 2,000 clients a year — a small percentage of women workers in the Toronto area. Office workers everywhere should be able to access this kind of guidance and support in mending our self-confidence and self-esteem by building our knowledge to deal with our changing workplaces. If we can find ways to assess our own skills and their worth to our employers, then maybe we'll be able to look at our roles and our lives differently. If we don't have a strong sense of our power and strengths to begin with, no matter how the collective voice is organized — whether through management representation or in an advocacy organization — we will not be heard. Not only does self-awareness feed our self-esteem, it also sharpens our awareness of the world around us. Self-awareness leads to social awareness, which encourages us to take the next step of participating in groups working on behalf of others in similar situations — in this case, office workers.

SEARCH FOR OCCUPATIONAL INTEGRITY: OFFICE WORKERS' CAREER CENTRE[6]

The Office Workers' Career Centre (OWCC) in Toronto was founded in 1997 to provide labour market information and counselling services for the growing number of unemployed and underemployed clerical workers in Toronto.[7] It is one of the first organizations in North America to dedicate itself solely to the issues and concerns of office workers. By its very existence, it is confirming that our jobs, and those of us working them, continue to be vital parts of the

economy. There are so few organizations specifically dedicated to our needs that to have such a centre at all is meaningful.

Unlike Times Change, which deals with employment issues for all women workers, the OWCC's focus is centred exclusively on office workers — male and female. In addition to workshops, counselling and computer services for its clients, it undertakes research projects to find out how office workers are faring in the shifting economy; for example, how many jobs are being lost and in which sectors, and what this means for the people who depend on the existence of these jobs. It also sponsors a series of speakers who address issues relating to the clerical occupation: loss of jobs, aging, new employment opportunities. In addition, in the resource centre that it shares with Times Change, it provides reports, journals and books covering a range of employment issues important to office workers — from training and education, to job search, career planning and legal matters. The OWCC gives us a credibiility that we too often do not have. Their resources help us as workers broaden our understanding of the bigger economic picture, which can help separate what is "a personal problem" from what is the result of external forces upon our workplace.

SEARCH FOR COMMUNITY: THE INTERNATIONAL ASSOCIATION OF ADMINISTRATIVE PROFESSIONALS

When my sister Julie and I were in our late teens and working at our first office jobs, a high-school friend asked us to join an organization of other secretaries. We did. The organization met each week in a room above the Clock Restaurant in Columbus, Ohio. There were lots of "rules and order" to follow, committees to join and presentations to listen to. My sister's memory served her much better than mine — I thought we had joined the National Secretaries' Association, which we had not. We, in fact, had joined Beta Sigma Phi, a friendship sorority.[8] In retrospect, my sister says she thinks we joined "because it was an opportunity to do something different and to meet new people, and probably an opportunity to meet guys."[9] But we were also "seeking community" and that still remains the best reason for any of us to get involved in such an organization.

The International Association of Administrative Professionals (IAAP) started its life in 1942 as the National Secretaries' Association. Its mission then and now was "to be the acknowledged, recognized leader of office professionals and to enhance their individual and collective value, image, competence, and influence."[10] It is the second part of that mission statement that I think is the most important for office workers. And that — enhancing "value, image, competence, and influence" — happens at its local chapters. It is at this level that the real community-building takes place for women members of the IAAP and where they receive two very important workplace tools. One, regular workshops provide the members with an opportunity to learn new skills (such as leadership, or maybe a new technology) they can then take back with them into the workplace. The local chapters also provide a "safe place" for women to test out these skills and ideas before they try them out on the job. Elaine Daniels, a Toronto secretary and long-time member of the IAAP, explains it this way:

> That is really the mandate in essence of the organization, to provide leadership skills so that as an office administration professional, [we] can become masters of what it is that [we] do or what it is that the workforce would like [us] to become. Everybody talks about taking initiative, being a leader, presentation skills, communication skills. Well, how do you learn all of that if you're not really given an opportunity? Every office, every day doesn't have those opportunities, but local chapters do.[11]

Two, the local chapter gives each of its members an expanded network of administrative workers to tap into for information, jobs and contacts; this is particularly important in chaotic economic times when jobs are constantly in flux.

While developing an internal sense of our community is essential, it is equally important to convince our employers to acknowledge and act on our organizational attempts to define our community. Changing our name to "administrative professionals" so far has done nothing to improve our situation. The IAAP believes that respect will come to this occupation through the recognition of the skills and training that office workers bring to their jobs. And so

it should. However, their worthy goals frequently encounter obstacles and frustrations in the workplace.

As early as 1951, the IAAP had put in place a "standard setting certification program," called the Certified Professional Secretary, that tests applicants' proficiency in three fields: finance and business law, office systems and administration, and management. Successful completion of the exam gives the person a CPS rating, an "internationally recognized standard of proficiency as a professional secretary."[12] While there may be some employers who recognize this certificate, it does not necessarily result in higher salaries, better positions or expanded career opportunities. A CPS rating may give women confidence and skills to face their work professionally, but it does not raise the occupation to the level of a profession. There were two women in my former law firm who were CPS certified. They were superior secretaries and wonderful co-workers. However, they were treated the same as all the rest of us who had high-school diplomas as our credentials. I don't know if they were paid more, since we never talked about salaries. I do know that they were inflicted with the same low status and disrespect of any other secretary. I seriously doubt whether the lawyers who hired them and for whom they worked had ever heard of the association or of its CPS certification, and probably didn't take it seriously if they had. It is difficult for status-conscious lawyers to take secretaries seriously as professionals. For that matter, very few of the secretaries knew of the organization. The IAAP's efforts reflect the plight of trying to negotiate community goals of advancement and respect within the workplace. Elaine Daniels, also CPS certified, concurs that nothing really changes with the title: "When it comes to pay scales and how it all equates, you're still viewed as office support, clerical support or whatever. And that's how you're gauged."[13]

Until office workers address the issues that put us in invisible and voiceless roles, we will not be given the respect or the pay we deserve, even with a "professional" title.[14] Recognition will come only with membership in an organization that persuades our employers to give us a voice in decisions that affect us, pay us fairly for the skills that we bring into the workplace and give us a sense of security in our job.

Meg said to me at one point that she didn't want to be treated like a lawyer in the law firm, but she did want to receive the same recognition and the status based on her contributions to the workplace that the lawyer received for hers. That is what it is all about. Nothing more, nothing less. We require recognition of our indispensable role as skilled workers. Daphnie demands this of her employers and makes sure that they know who they have working for them. However, for many of us who are qualified and intelligent women, that kind of self-assertion does not come easily — and it should not be necessary.[15]

SEARCH FOR POLITICAL AND ECONOMIC VOICE: 9 TO 5, NATIONAL ASSOCIATION OF WORKING WOMEN

The current 9to5, National Association of Working Women grew out of the consolidation of several women's grassroots groups which, during the 1970s, were dealing with the problems of women workers in the US. The women who run 9to5 believe that workers already have a voice. They contend that the value of an activist organization like theirs is that it "amplifies women's voices."[16] So much of their purpose is to take those voices and let them be heard politically, economically and publicly. Their organization seems to have bridged that gap between learning about yourself and your job, and transforming that into activism in the workplace.

9to5 keeps this voice strong in three ways. First, the staff concentrate on issues that workers themselves identify as hurdles to overcome if they are to "win greater opportunities at work and to remove barriers to self-sufficiency."[17] The 9to5 staff discover what these issues are through the women who call their "Job Survival Hotline" (1-800-522-0925), which links callers with trained counsellors who help them work through their job problem. The issues raised by these callers can range from racism and sexual harassment, to family leave and daycare issues, nonstandard work and low pay.[18] 9to5 researches and publicly and actively addresses these concerns. For example, they published the "9to5 Guide to Combating Sexual Harassment," which describes the problem and tries to provide practical solutions

to it. 9to5 also works with organizations to help them enact effective policies and procedures to prevent sexual harassment.[19] So not only do 9to5 staff counsel and advise the affected woman worker, they also address the systemic roots of the problems. As well, 9to5 joins alliances, particularly with unions, to enhance the reach and political power necessary to address these critical issues.

The second way 9to5 "amplifies voices" in the workplace is by offering their members leadership training. As Cindia Cameron, a 9to5 spokesperson, explains:

> The aim of this style of leadership development is both to provide clerical women with the skills and experience to control their own organizations, and also to use these leaders to convey to potential members that 9to5 is a group where people like themselves make decisions and make change.[20]

Through workshops and professional training, 9to5 gives women an opportunity to learn how to express their views, have them heard and, in many cases, have them acted upon — something that every one of us office workers could use. After the training, it is up to the individual woman how she chooses to use these skills – the important thing is that she is now informed and has tools to take with her back to her workplace.

The third way 9to5 keeps the voice alive is by inviting members to build an information and support network among women office workers.[21] Its bimonthly newsletter informs members of political and economic issues that are pertinent to their well-being and provides a forum for their own letters and questions. Members are invited to join the Activist Network, which acts as the "voice of 9to5" in communities, workplaces and local political arenas. Through all of these efforts, there is the strong conviction that change comes about when individuals take an active role and let their voices be heard.

Organizations like 9to5, Times Change, the OWCC and the IAAP can motivate, encourage and support us in our efforts to understand change and move forward. When we participate in these organizations, we've taken a positive step towards improving our situation — and it's better than coping alone.[22] These groups

educate, encourage and support us through the throes of change; they give us a stronger base from which to question decisions in our workplaces and offer constructive criticism and advice from which both we and our employers could benefit — like dealing with stress in a healthy and productive way.[23] It is from such organizational communities that real change begins to emerge.

SEARCH FOR POWER: LABOUR AND UNION ORGANIZATIONS

But while belonging to these organizations may inspire us and strengthen our sense of self, occupation, community and voice, we need a still stronger organizing force to confront the challenges currently facing us. In order not to become or remain "victims" of change, we have to have the "ability to control and influence changes that are taking place."[24] We may well have to look towards unions as a solution to this dilemma.

The word "union" often conjures up the same kind of negative reactions from women office workers that the word "feminism" does — "That's not for me!" But maybe it is time that those of us who have never had union protection re-evaluate the pros and cons of such membership. Office workers outside of the public sector do not have a history of political, civic or union participation, and public sector participation is relatively recent.[25] Individually we may possess strong beliefs, but seldom do we transfer our convictions to our workplace. Rarely do we challenge an issue that affects our occupation. It seems we don't accept our "common identity" as office workers nor do we have a "collective sense" about how we could achieve an outcome that would improve our working conditions. We may speak out as a woman, or as a mother, or as a conservative or liberal, but seldom as an office worker.

For many of us, there is an element of "fear" that exists. What would happen if we did challenge decisions made in our workplace, let alone organize to do so? Cindia Cameron, the 9 to 5 spokesperson who has explored the issue of organizing office workers, understands this only too well:

What many women really fear is stepping out of the mold —
taking a stand for yourself first, before boss or company loyalty.
Women are still brought up to put others before themselves. If
they do change their behavior ... it is often a threat to friends,
family, co-workers, and their own self-images. This is the real
fear.[26]

In our workplace culture, we have been and continue to be
praised for being the strength behind the scenes, not as visible front-
line staff. The relationship with our bosses places some of us in a
semi-management position where it is presumed that we are "natu-
rally" pro-management and our loyalty is to the company, putting us
beyond any union organizing efforts. Wearing the union label would
lower the status, however low it may already be, that we hold within
the office.[27] When we challenge that image, we challenge our own
identity within that environment.

This kind of thinking, this sense of loyalty to our bosses, can be
an obstacle for those unions trying to make contact with us. In order
to convince us that it is worth considering joining a union, organizers
may have to change their strategies, and we may have to reassess our
own images and roles as frontline information workers. In addition,
there has to be a strong enough reason to risk stepping away from
our traditional roles and our association with management — given
the large number of unionized public sector jobs in Canada, it seems
this is happening.[28] And, as the mill workers of the early Industrial
Revolution would tell us if they could, it is always better to face
change collectively than to be out there all alone. I think it is worth-
while here to give an example of a group of office workers in Toronto
who did decide to organize. Their story illustrates how office workers
and unions both have to re-examine their image in order to survive
in this global economy.

In 1996, the University of Toronto, in response to a major
provincial cut to university budgets, began a major restructuring. In a
very corporate way, the university proceeded to inflict pay cuts and
eliminate jobs or make them into contract positions. The group most
hard hit by this downsizing was the technical and administrative

workers — the only nonunionized staff at that time.[29] The staff association that represented most of these workers had no official bargaining power, so could do nothing to prevent any of these actions. Although there were other issues that fuelled the move to unionize, it was this overwhelming sense of powerlessness that these workers felt in the face of layoffs, wage cuts, restructuring and increased workloads that was the deciding factor. As one worker, who later became an organizer, put it, "The real issue was getting a place at the table. We learned that, without a union, the university could make changes by organizational fiat."[30]

In May of 1997, the staff association asked its members in a referendum whether they thought the association should certify; two-thirds voted yes. After much consideration, they chose to affiliate with the Steelworkers, both because they were the most responsive in their bid, and for their image of being "a tough union that people won't mess with."[31] Staff participated throughout the campaign as volunteer organizers. They were recruited through word of mouth, leaflets, meetings, a Web site, e-mail and newsletters. The end result was a successful campaign and the "cracking of the old culture of isolation, distrust and every-department-for-itself."[32] For their side, the Steelworkers had to accommodate the concerns of the white- and pink-collar workers who were demanding their attention — focusing on the issues that they brought to the table. The workers, in turn, had to recognize that becoming "People of Steel" and standing up for their own rights would not lower their status in the workplace. The slogan for the union drive pointedly illustrated that these office workers could still feel loyal to the university while taking care of themselves: "It's not anti-U of T to be pro-union."[33]

While this is a very simplified version of the work and time that went into this organizing drive, it does illustrate that there are other options to being the victim of change. These office workers were successful in their drive; however, they did start with a staff association and a large enough body of workers that made an organizing drive financially appealing to the union. What about all of us who work in small workplaces, who are not part of large organizations or

the public sector? Perhaps by taking a look at the most vulnerable positions among us — those of contingent workers — we can get an idea of what kinds of efforts might organize the rest of us.

Unions and labour organizations are finding creative new ways to protect the most vulnerable and fastest growing group of all workers today — the contingent workforce. This is particularly important for office workers as more and more of us slip out of full-time, permanent jobs and into the part-time, contract, temporary and "perma-temp" world.[34] There have been some creative projects undertaken in the United States to give voice and visibility to this group of "8 million-plus employees who move in and out of temp work every year [and who] get paid less than full-timers, lack health care and other benefits, and often fall through the cracks in labor and employment laws."[35] Most of these efforts have been able to get off the ground through coalitions of labour, community and government interests.

In California, for example, a group called Working Partnerships USA, is looking at the possibility of "a new kind of union aimed at clerical and technical employees" who are working in "nonstandard work arrangements" in the Silicon Valley. Working in collaboration with a local chapter of the Service Employees International Union (SEIU) and a community college, Working Partnerships has set up a pilot project to "provide skills certification, job rights training, and job placement for temporary workers seeking clerical employment." They will also administer "portable benefits" — health coverage that will follow a temporary employee from one assignment to the next — and provide ongoing job referrals to participants. They also maintain the "Temporary Worker HomeBase" Web site that provides a forum for temporary workers to share their experiences with others; it also acts as a clearinghouse on subjects pertinent to survival as a contingent worker. Resources include a directory of organizations, job placement and training opportunities, an overview of relevant law, and updates on unemployment insurance.[36]

9to5, Working Partnerships and the other members of the National Alliance for Fair Employment have launched a campaign to create a "Code of Conduct for Temporary Placement and Staffing Agencies" in order to ensure that certain standards are observed in

the industry that reflect the needs and rights of the contingent worker. The Code spells out acceptable conduct on agency procedures, from interviewing and assigning workers, to truthful advertising and the legal relationship between the agency and the worker.[37]

The challenge to unions and labour organizations, especially around nonstandard work, is enormous. These coalitions, such as Working Partnerships, and 9to5's relationship with the Working Women's Department of the AFL-CIO, open up private sector offices and temporary agencies where unions have not often travelled. Many unionists, activists and workers are aware that the image and reality of unions today must change with the workplace. In other words, today's union is not your "father's" union.[38]

For women caught in the web of contingent work, it is promising that coalitions like Working Partnerships are actively creating new organizational models that reflect our reality and improve our working situations. Alice deWolff points out that Working Partnerships is on the right track:

> They got it right in some way because what they're doing is exactly what people need — they're acting as an agent for you when you're looking for different bits and pieces of work ... they are the adjustment mechanism for most workers. The business of being that intermediary is very important ... and makes the transitions and the non-permanence part more easy to manage. There is somebody who's paying attention to what to do next.[39]

Some unions have also taken steps to make membership more accessible to nonunion workers. The Service Employees International Union (SEIU), for example, has an associate membership program for retirees, laid off members and others interested in union issues. This allows members to "take their union with them,"[40] and gives nonunion workers an opportunity to feel connected to a larger group that is concerned about work issues. More importantly, it gives them a chance to learn about unions and the "purchase power" of belonging to a large organization without the fear of employer retaliation.

For women in the office, organizations and unions give us something to tap into. Their concern about us and our workplace and their attempts to make workplace improvements can build our political confidence and make us a little less invisible in our own eyes and in the eyes of our employers. It is up to us to let these organizations know what it is we need. And it is up to us to recognize that their experience, support and networks can help us survive the biggest transition in the history of office workers.

Daphnie

2

FACING THE FUTURE
ON HER TERMS

*I always sort of
wound up on my feet.*

Daphnie is a high-energy, vivacious Black woman
in her twenties. She speaks several languages
learned as a child moving with her diplomat par-
ents. Her mother warned her early on that her
"permanently tanned" skin would make her "over-
qualified" for jobs. Her answer as a child was that
"nobody's going to tell me that!" That attitude has
stayed with her throughout her life.

I didn't have any clerical skills to speak of in a formal sense. I
don't even know how I managed to pick it up. One summer
in Grade Eight, I worked in the junior high-school office
answering the phone and doing clerical things. And I worked
as a ward clerk at a hospital that Mom worked at, where she
would have preferred that I stayed working, but I wanted to
go out and see the world. So I think it was just based on my
ability to pick up skills as I went along.

When I was about nineteen years old I worked for an
advertising agency. I took it as a summer job that wound up
rolling into a full-time job in the fall. It was an ad
agency/lawyers office — very interesting kind of people
working there. Instead of being a receptionist, I gravitated

to a "traffic controller." I basically handled a lot of the artwork that went in and out of the office and made sure that it got to its destination for printing and stuff like that. I wound up leaving that job and working for a communications company, basically a PR firm, and that was also really exciting. I was the office clerk, doing everybody's expenses. They had a real computer and a real photocopier!

But I was basically unsure of what I wanted to do. I went back to school full-time and got a degree. Then I realized that I still didn't know what I wanted to do. But I knew I had all these skills. I was a whiz at the computer; I was great with numbers. I always had glowing reviews during that period of time. I took on part-time temp work through an agency. That allowed me to sort of look for work or go to school and concentrate on things like that. I always sort of wound up on my feet.

So I took the skills I had and applied for jobs in companies that I wanted to learn about. It was sort of like, "OK, I don't know anything about publishing, I'll go work for a publishing company," and I'd send off my résumé. It was an excellent way to get into occupational arenas that I had some interest in. Clerical work was a good sort of ticket into a place. It was a ticket in, but not necessarily a ticket that I wanted to use to stay in any particular field.

That's how I wound up getting into the film business. I got the job based on my résumé and the cover letter. I stated that I had no experience in film and television, but I'm a hard worker and I'm dedicated. I'm quick on my feet and I will do what I can to help the production along. And that I saw it as not just an opportunity for me to provide a service, but they would basically be paying me to learn. I've found my way into all these different areas because employers can say, "OK, it's a good attitude. You've got a really good attitude."

Film was a great experience. I wound up being hired as an assistant unit manager, which is just another way of saying secretary. The pay was outrageously high; the hours were outrageously

long. From there, I progressed to being an associate producer of a show, which is the natural progression. It, too, was a big heady title, but I was still a secretary. I finally left because I got tired of the long hours and also because it's still such a male-dominated occupation. No matter how long I would have stayed there and no matter what my title was, the old guard would still have said, "Oh, you're just the secretary." I have a healthy understanding of who I am and what I want to do. And I've tried to take the attitude that I don't want people telling me that I'm "just" anything.

But for whatever reason, I never wound up feeling trapped in being a secretary, even though there were places like the film business where they tried. Whenever I was hired to be a secretary, the job always wound up being an assistant and therefore I basically ruled the roost. Anyplace where I didn't rule the roost, I left.

I say to people, "You don't have to be fake with people, but just treat people with respect, even if they treat you badly, just treat them with respect because one day they could be your boss." You're never "just" a secretary, nobody is ever "just" anything. If you choose to be a "just," then that's your choice. But if you go in with the attitude of "I'm not 'just' an assistant, I'm an ASSISTANT!" then you're basically saying you'll go the extra mile, you're not going to break any law during that extra mile, but you'll go the extra mile. Which means you're someone that they should realize they are very lucky to have.

I remember going for an interview not too long ago at an ad agency where they said, "We don't believe in admin support." In my head, I said, "What am I doing here?" Mind you, the job was to be executive assistant to the president, but in my mind, I guess I had been so heavily conditioned, I was saying, "I'm a secretary." But the first thing he said was, "We don't believe in admin support here. Everybody types their

own letters; everybody does their own work." They say that everywhere I go these days. And it's not true. I wind up doing the work. But I do find people come into a job with keyboarding skills and software knowledge and therefore their ability to work independently is a lot higher. But at the same time, they say they don't believe in admin support but somebody's running around doing that stuff. In some places, they claim that it's fiscally advantageous to them; the reality is you're paying these people how much money to run around to figure out what's wrong with the photocopier when they should be sketching or something. It's sort of a strange situation. The job I'm in now, I work for two vice-presidents, one director and one managing director at a company. But the reality is that the manager and the managing director basically work so independently that they, in my mind, constitute barely one person.

This is a company that is extraordinary, and I've worked in a lot of companies. It's an Internet company. They are owned by a conglomerate. They seem to have a future, a strong entrepreneurial spirit. Three years ago they only had an office of thirty people, now they have an office of five hundred. Everyone who works there is coming from an unconventional background. People who started off as assistants are now managers in a space of less than two years. And we're not talking about people who have been in jobs, like me. These are people who are right out of college. When I came for the interview, they told me of the tremendous growth potential. The same thing I always heard at every job. This is the first job where I've seen it to a scale as massive as this and it's strictly based on the industry alone. The sky's the limit!

This is the first time in years I've actually worked for a company where the benefits are one hundred percent across the board for everyone. Plus they'll pay for any educational courses you want to take. Of course, computer people they

hire can write their own tickets. The extras are all part of the negotiation because these people can pretty much walk anywhere. They're not quite that generous with the support staff.

I'm the assistant to a vice president and two managers who are basically VPs. (I subsequently learned that they were really intimidated by the fact that I was dressed in such a professional manner for my interview.) I'm doing everything from booking travel and hotels, to organizing the office, which I call housekeeping, to actually drafting up proposals and sending out requests for proposals. I know what the parameters of my job involve, but I also know we're all people working together really hard in an environment that's extremely fast-paced and things fall through the cracks. My job is to be the juggler and catch those things.

I was hired full-time. I don't know if they actually set out to hire me full-time, but they did. Most new employees are hired on contract. The company wants to see how people work out. I'm not really sure what the difference is between having a three-month probation and being on contract, other than, I guess your probationary period on contract is longer. I also see the company using it as a way to avoid paying benefits, but at the same time they're trying to weed out people. If they need the job filled right away, and they think they've found someone, they give them the job — if they perform above the call of duty!

I've had to learn a lot of technical jargon for this job so I could understand what my bosses were talking about. But I've always wanted to learn more on the job. I don't want to get bored. This company is great because I have exposure to all the different departments so if I'm not too busy, I can wander around and talk to people about what they do. I make my own hours, too. I carry my beeper around with me all the time so I can be anywhere and if something happens at work, I'm right on it. They're apparently not used to that sort of

situation happening. My bosses are always saying, "What time do you come in in the morning?" because I'll stay until seven at night. I'll stay to whatever time it takes me to get whatever needs done, done. That's always been my attitude and that's always been the way I work. I didn't realize that that's what puts me outside the realm of a lot of other workers. A lot of people are nine-to-five clock-watchers.

I know how lucky I am. I know that it is solely based on my personality that I wind up in these jobs, and that I keep the jobs that I keep. The experiences that I have and the promotions that I've received have to do with the way I do my job and the way I take on things that do not remotely fall into the realm of being a secretary. I decide that I'm going to take it on and I jump in there and I do it. And that happens in every job that I do. I look for the places that I can grab onto and help out, with the knowledge that I'm learning something.

But I'm also aware of how scared I was that I was never going to get work again. The search for this job was the longest job search I've been on. I was looking from July of last year to January. I was getting frantic; I was really really getting frightened because it had been so long. Normally it's bang, bang, bang, got a job. This was the first time I was really scared. At the same time, I was trying to keep my energy and attitude up. It's one thing to be supporting friends who are afraid that they are not going to get a job or that they're going to have to take a job that they're not going to be happy with. It's a totally different story when it finally happens to you for the first time. I mean, I have never been out of work in terms of seeking a job for this long. And yeah, in retrospect, I can say I know it had to happen because look at where I'm at now. But the reality was, I was freaked out and I thought I was finally going to have to take a job that I really didn't want.

I always tell my friends who've been laid off, "Here's what you're going to do, volunteer half-a-day at a company that you

want to work at. Write down ten companies right now this minute. Forget about the fact that you don't have the skills. Write ten of them down, if you can't write ten, write five." I think of places that I worked while I was looking for a job, volunteer capacity, where I wound up getting a job simply because the minute a job opening occurred, they shoved me into it. Sometimes it was not necessarily in a position that they knew was right for me, a good fit, but they wanted to keep me because of my attitude towards work and how well I interacted with other people at the company.

I said in my interview for this job that my job is to make my boss look good. And I see that if my boss looks good, I look good. My boss gets a promotion, I get a promotion. But at the same time, my boss doesn't get a promotion and I'm good at my job, I get hired away from that boss into someone's department who appreciates what I do. So I go in with the win-win attitude, which sounds like a total pep rally, but for whatever reason, it's worked.

Lucia

༄

LOOKING FOR A WAY BACK IN

*If I was to walk into an office right now,
it would be like going to a
foreign country.*

Lucia is in her early thirties. She's a first genera-
tion Italian-Canadian. Her parents came to
Canada in the late 1960s. Her father worked as a
construction worker; her mother, a seamstress.
From them she learned three lessons about work:
(1) you worked hard for your money; (2) if you're
going to do a job, do it as well as you can; and (3)
you had to respect the boss because the boss had
the power. Lucia has been a stay-at-home mom to
her two daughters for the past seven years. Her
lawyer husband works out of an office in the
basement of their home.

I started working at the age of fifteen in a restaurant
Saturday mornings, washing dishes and floors and sweeping.
My aunt got me the job and I hated every minute of it. My
other aunt got me this job at a real estate office and that was
three nights a week after school. I was very ignorant about
what work was about. I didn't have chores in the house and I
didn't know what was out there.

In Grade Eleven, I clipped a newspaper ad for Herzing
Business School. At that time I knew I was very good at
typing. I had good speed, and I enjoyed that. Then when
Grade Twelve came, I knew I didn't want to go to university,

so I called up Herzing and met with the recruiter. I went home and asked my mother what I should do; it was three thousand dollars tuition. She said, "Do whatever you want, but I can't help you financially." So right there and then I made a decision to do it. I knew I could support myself.

I enjoyed every single minute of that experience. It was one of the best learning experiences of my life. I graduated on a Friday and I started work on Monday. I worked at that law firm for five years, my first job ever. I thoroughly enjoyed it. It was just fabulous.

It was the appreciation, the validation I got from all the people. I had such positive response to my work. When I went to the law firm not only did I meet people from my own background, Italian, but women my own age. They were examples for me. I really admired their work, their dress, their way of presenting themselves. I had very few role models in my life so it was a real eye opener seeing how women wore makeup or dressed. And it was a nice size firm, it wasn't too big. People said good morning, and the lawyers talked to you. It was a learning experience on many levels: growing as an individual, growing in my profession, relating to women my age, earning an income, saving money. I really took pride in my work, because people would come to me and say, "Would you do this for me?" My confidence was fostered by these people. It really taught me a lot about being a professional, which they can't teach you in school. You either do the job well, or you don't, wherever your talents lie. Mine were in recognizing voices on the telephone so I could call the clients by name, I had a good typing speed and I was accurate. I proofread everything and I was efficient and organized. It was a great first experience!

I left it in 1984 or 1985. My boss at the time, the first lawyer I ever worked with, invited me to go to work in a computer company he was a part-owner of. I thought it was in the capacity of his secretary. Well, it turned out to be gofer, receptionist, manager, secretary, accountant, everything. Then

the company moved to Markham (east of Toronto) and I didn't drive; it was an hour-and-a-half commute by bus. We'd eat off the truck at lunchtime. It was not the best environment. I threatened to leave many times and he would lure me back because he came to rely on me desperately. He knew I was competent, trustworthy and efficient. When I finally left, he took it quite hard because we'd been together a long time. He was quite angry.

I went back to law, and wouldn't you know it, I went into a job at a law firm that lasted four months. I had a very inexperienced lawyer who was blaming me for his mistakes, and I wouldn't tolerate that so I quit. I went into another law firm and I was bored to tears; I just couldn't take it. I was quite depressed at this point because I thought I'd never find the working experience I had in that five years. And then, I answered an ad for an entertainment lawyer and I got the job. I stayed there for a year and a half.

I was working on a computer for the first time. My first day on the job, no one came to greet me. I was there at nine o'clock sharp and I sat down at my desk and someone handed me the manual for the word processor. It was like trying to hook up the VCR without a manual. It took me a long time to figure it out. The job was still a learning experience and it was good. Wouldn't you know it, I met my husband there. Then the whole entertainment department moved on and again my boss came to rely on me because I was efficient and trustworthy. I was loyal. I got his coffee, I didn't give him any crap, and I didn't talk back to him. I think my longevity in some of these places is because I didn't talk back; I didn't make waves and I didn't cause problems. I just did whatever they told me to do. Looking back, I was quite stupid. I was getting quite disenchanted with what I was seeing in this particular law firm. There was a hierarchy, there was a lack of cohesion with the secretaries. It was quite segregated.

Anyway, I left. I was unemployed for two months after that. I was answering ads, all day long that's what I'd do. I looked at the newspaper; I wrote letters, I made phone calls. I sent off my résumé and finally, after two months, I was getting quite despondent. "Why isn't anybody hiring me? Why can't I find anything interesting out there?" And finally, I answered an ad for an all-suite hotel company.

I took a cut in pay, I reduced my vacation time from four weeks to two and I didn't have benefits. So it was quite a step backwards for me. I had to learn a new computer system and their phone system wasn't the greatest. I ended up doing a lot of work that an office manager would have done. Everybody came to me for answers. It was quite stressful in that I got interrupted a lot. I was not as efficient as I could have been because my work kept mounting and I wasn't producing as the work kept mounting. I felt quite incompetent by then.

My husband got offered a job in Ottawa and wanted me to move with him. My boss was quite upset when I told him. By this time I was so stressed, my stomach was in knots half the time. I was working on my feet a lot. I was running around like a chicken with her head cut off. It was just unbelievable the stress I had at this point.

We moved to Ottawa and I became pregnant. I couldn't find a job. It was just like a turnaround: "Oh my god, I'm unemployable." And then things started changing. This was in 1990 and computers were more common and everything was becoming more technically advanced. I felt that I was falling further and further behind compared with other people. I remember my husband buying a computer. Well, he put me in front of the computer, and this is when WordPerfect was just coming out. He sat me down and he said, "Well, go ahead." So I looked at the screen, followed the tutor program, taught myself how to do it, through many mistakes, trial and error. And there I was, sitting at our kitchen on a

high stool and literally just being thrown into that hot water. I did it; it was very frustrating. But that's how I stayed in touch with the computer, because my husband needed me to do that and he would bring work home.

I made a conscious decision to be a stay-at-home mom. Little did I know what stresses that job had! It's been a growing and learning experience and I don't think I would have done it any differently. But it also made me lose a part of myself, a part of my identity because you forget what your own needs are. Because you're concentrating on your kids' needs and your family's, you lose any perspective on what your desires are. I can't think of what's fun anymore because right now, life is work, it really is. Being a parent is a lot of work; being a stay-at-home mom is a lot of work. I'm floundering right now. I haven't enjoyed being a stay-at-home mom for a long time. It's a decision I made for my kids' sake and maybe they've benefited and maybe they haven't. I don't know, but I do know that it's a lifestyle that I've become accustomed to. And given the kind of person I am, working and being a mom would have been too much for me.

I have heard a lot of people say that through volunteer work they got permanent jobs. I thought that would be a really great transition for me; working part-time, learning technically what I have to learn to get back in the workplace without having to pay a lot of money to get the courses. I'd be doing somebody a favour, basically, and I'd get something out of it in return. I think I'm going to have to go the route of the volunteer. I think it's a way of boosting my ego without having that paycheque hanging over me and having the judgement of being a paid worker and earning a salary that is below what I used to make. That's really what I want. I want to get the experience. It would be almost like going back to school without the ties of tuition. And if it doesn't work out, I won't

feel like I failed. It would be a way to restructure my life around a schedule that I'm not used to.

I know I'm not going to be earning the salary I earned when I left work. So right now, it's more important for me to get up to standard in the workforce. Volunteering would be a great way to do it. Also, it would be a good thing to do it to get out and meet new people and have the recognition I once had about my positive traits, whether I'm organized, efficient, fast, a good typist, an accurate typist, whatever. But then, if it didn't seem like work, then it would be a good thing, too.

I've been out of work for six years. I'm so far behind that it's going to be quite awkward going back to work. I thought, "Can I do it? Do I want to do it? Is it the right time? Is this going to be a real blow to my ego that I'm not like everybody else, that I'm so behind technically?" I don't know what's out there anymore. If I was to walk into an office right now, it would be like going to a foreign country. Jobs aren't out there like they once were. The fact that I don't have the skills to offer an employer would place me at the bottom of the list right now. I'd really have a tough time being rejected. It would have to be someone who would say, "Your background is great! We're willing to train you." But I don't know that there are people out there who would do that. They want the most skills at the cheapest cost.

Volunteer work would be the most logical route to go. I would say, "OK, this is what I have to do to become knowledgeable about how this company works." And, if it's a company I respect and I want to make contact with them, it's worth sticking with it and making the connections and proving myself and maybe be given more responsibility over time. So that's the way I look at it.

It's also been difficult not being a contributor to the financial aspect of raising a family. I think in the next couple of years I'm going to have to make some real changes. It's

going to be tough; it's going to be really tough. I hope I will look at it as an adventure, as opposed to something bad. Fear is prohibiting me from taking drastic steps. I want to take the little tiny steps, as opposed to making gigantic steps and doing a complete turnaround.

Epilogue

OF THE ELEVEN WOMEN whose stories appear here, I was able to contact nine of them, to find out what they are doing today (summer 2000).

Loretta has left the insurance company — the "job from hell," as she put it. For a year, she ran her own business providing care to the elderly. She loved it but work fell off during the summer months. Then a friend asked her if she wanted a job in film. She is now office manager of a company that supplies food and equipment for film shoots. She loves the chaos and demands of the job.

Joan is on long-term disability. The doctors are still trying to sort out exactly what causes her illness. They have narrowed it down to possibly environmental poisoning and/or chronic fatigue syndrome — both invisible illnesses. She spent months and months dealing with the law firm where she worked and with the government employment insurance in order to claim her rights under both systems. She has moved out of Toronto with her daughter and now lives close to her parents in a rural area of Ontario.

Stephanie still works at the nonprofit organization. A year ago, the union at the local community college that administers the funds for this organization brought a grievance against her workplace for using contract workers. Her position was one of those grieved. After much negotiation, the college agreed to bring Stephanie's and one other position under the collective agreement. Stephanie feels that it is good to be unionized; it has helped her gain some respect in the office. She has some "peace of mind" knowing that if she opens her mouth, she won't be on the street. "I have rights," she says. Her union membership also means that if the organization does not receive its government funding, she has the opportunity to move into a position at the college. For a single mother, that security is very important.

Zoë is still part of the secretarial pool at the university. Her years of service and union protection are strong incentives for her to stay put. She has reactivated her student file and plans to start classes again in the fall. She's going to start with an Introductory to Psychology course that will qualify her then to take a course she really wants — Animal Behaviour. Her little dog died this year — she's curious whether animals get depressed, too.

Louise is still working the call centre circuit — mostly for market research and public opinion polls. She works for two different companies, which are keeping her pretty busy. She, too, is considering going back to school — she says she always talks about taking courses, but this time she's going to do it. She is feeling secure enough now that she moved out of her brother's place and into her own apartment.

Sam has found a full-time job with benefits. She did get the job through her temporary work — but not through her temporary agency. On one of her assignments, she hit it off on a personal level with a supervisor. When that woman started working for a new company, she passed job postings on to Sam and recommended her for the position she holds now. For the first time in a long while, Sam feels a certain amount of security. She now has sick leave and other benefits that help alleviate some of her "desperately needy" fears of before.

Meg recently celebrated her 60th birthday which has her thinking even more about what she's doing with her life. She has left the community centre, but still works two days a week at an all-women law firm. She likes the flexibility that this gives her life, but not the work or the paycheque. Her partner has recently retired, which changes her life considerably. It may necessitate her working more days during the week — both for the money and for the solace.

Judith is still working temporary jobs through agencies. She is finding that the world of temporary work is becoming even more stressful than before. Jobs are scarcer while salaries are going down, and expectations of skills and responsibilities on the job are going up. Judith also feels that the core employees in offices are even more "snarly" towards the temp than they were before and employers just

want the work done. At one place, her employer actually locked her in so she wouldn't leave like all the other temps did!

Lucia, while waiting for her second child to go to school full-time, has been serving on the Board of Directors at Times Change. She volunteers at her children's schools and participates in fundraising efforts for the schools and Times Change. She discovered this year that her re-entry into the world of paid work will have to be postponed again — she is expecting her third child later this year.

I was not able to contact Daphnie, even as technically wired as she is; nor was I able to contact Norma, who may have moved once again across the country.

As for me, I have just finished writing this book and have to begin learning about marketing it so that the women whom I *want* to read it will have access to it. Then I must start job-hunting. I am looking forward to having some people-contact on a daily basis again. Hopefully, I will be able to use what I have learned while writing this book to acquire a job where I can make some difference in the world of work for women.

Notes

INTRODUCTION, 13–24

1. John Cassidy, "Who Killed the Middle Class?" *The New Yorker*, 16 October 1995, 114.

2. Graham S. Lowe, *Women in the Administrative Revolution: The Feminization of Clerical Work* (Toronto: University of Toronto Press, 1987), 146. Graham Lowe comments on this disparity and the minimal progress that was made during this same period, "Female clerks earned 53% of the average male clerical salary inching up to 58% by 1971."

3. Alice deWolff, speaking at the Annual General Meeting of the Office Workers' Career Centre, Toronto, ON, 27 October 1999.

4. Joan, interview by author, Toronto, ON, 15 March 1997.

5. Loretta, interview by author, Toronto, ON, 20 March 1997.

6. Lucia, interview by author, Toronto, ON, 6 March 1997.

7. Studs Terkel, *Working* (New York: Ballentine Books, 1972), xiii.

8. I had a similar discussion with a nephew of mine who works in a managerial position for a large Swedish company. They are in the midst of merging and consolidating production. He is in charge of closing down plants; his responsibilities include firing many of his co-workers and friends and convincing them that "security" is a ridiculous concept in this day and age. He is also aware that the same applies to him — when he finishes this job, he will have eliminated his own position. It's a lousy way to work.

9. David Noble, *Progress Without People* (Toronto: Between the Lines, 1995), xv.

10. Isabella Bakker, ed.,Introduction to *Rethinking Restructuring: Gender and Change in Canada* (Toronto: University of Toronto Press, 1996), 3.

11. This very popular expression originally appeared in *The Clarion* in 1913. Rosalie Maggio, *The Beacon Book of Quotations by Women* (Boston, MA: Beacon Press, 1992), 348.

12. Corrine Glesne and Alan Peshkin, *Becoming Qualitative Researchers: An Introduction* (White Plains, NY: Longman, 1992).

13. I am referring to Hillary Clinton, wife of US President Bill Clinton, and Hillary Weston, Lieutenant Governor of Ontario, Canada. Both women have a high profile and are often quoted on subjects in which they have little experience

14. Pat Bird and Alice deWolff, *Occupational Analysis: Clerical Occupations in Metropolitan Toronto*. Report to the Clerical Workers' Centre (Toronto: Clerical Workers' Centre, 1997), 2.

15. Bruce Little, "Layoffs Hit Nearly 18,000 in January," *The Globe and Mail,* 4 February 1999, B7.

16. Shulamit Reinharz, *Feminist Methods in Social Research* (New York: Oxford, 1992), 126.

MY STORY: LESSONS FROM LAW, 25–33

1. This story was told to me by a co-worker one evening when we were both working overtime for the fourth consecutive night. A storm was raging outside, banging the big plate glass windows in the office of the partner we were working for. As we watched the storm, Jackie said, "Remember the Huntsville Women!" She then put her coat on and went home. Subsequent research has not unveiled more on this story. So whether myth or reality, it's still a good warning.

CHAPTER ONE: BUT CAN SHE TYPE? BUT DOES IT MATTER? 35–51

1. "Inbasket," *Your Office: The Magazine for Canadian Small Business* (April 1999), 9.

2. Heather Menzies, *Whose Brave New World? The Information Highway and the New Economy* (Toronto: Between the Lines, 1996), 112.

3. Ursula Franklin, *The Real World of Technology* (Toronto: CBC Enterprises, 1990; reprint, Concord, ON: Anansi, 1992), 12.

4. Alice deWolff, interview by author, Toronto, ON, 10 January 2000.

5. Franklin, *The Real World of Technology,* 17–18.

6. Joan Greenbaum, *Windows on the Workplace: Computers, Jobs, and the Organization of Office Work in the Late Twentieth Century* (New York: Monthly Review Press, 1995), 38.

7. Harry Braverman, *Labor and Monopoly Capital: The Degradation of Work in the Twentieth Century* (New York: Monthly Review Press, 1974), 342.

8. See Greenbaum, *Windows on the Workplace,* for an extensive discussion on the front office/back office phenomenon. In particular, see 32–42.

9. William Russell Kelly founded the Russell Kelly Office Service in 1946 in Detroit, Michigan. It was the first time that businesses could hire temporary workers. Originally, the work was done in his home office since he had the up-to-date office equipment; later, the worker and the equipment went to the place of business, and finally, as businesses started to buy their own office equipment, he sent his workers into the workplaces. Kelly required his female employees to watch a film as part of their orientation — the film was intended to help them explain to their husbands or fathers why it was all right for a woman to be working. When she was ready to go out on an assignment, the woman would have to identify herself as, "I'm your Russell Kelly Office Service girl." This soon became shortened to, "I'm your Kelly Girl." And, thus, in 1957 the name was officially changed to Kelly Girl, which came to be a synonym for any kind of temporary help. Kelly Girl remained the name until 1966, when the company became Kelly Services. "Corporate information. Kelly/Adderley

Interview." *Kelly Services.* <http://www.kellyservices.com/corpinfo/history/interview.html>. 29 November 1999.

10. Today there is one centre and that has been contracted out. It is open from 8 a.m. to midnight five days a week and from 9 a.m. to 5:30 p.m. on Saturdays, closed Sundays. Suzi, e-mail to author, 6 March 2000.

11. Barbara Garson, *The Electronic Sweatshop: How Computers Are Transforming the Office of the Future into the Factory of the Past* (New York: Penguin Books, 1988), 172.

12. Michael Hammer and James Champy, *Reengineering the Corporation* (New York: Harper Business, 1993), 83.

13. Franklin, *The Real World of Technology,* 56.

14. For a thorough and interesting look into the world of fast food, see Ester Reiter, *Making Fast Food: From the Frying Pan into the Fryer* (Montreal: McGill-Queen's University Press, 1991); Ester Reiter, "Serving the McCustomer: Fast Food Is Not About Food," in Deborah Barndt, ed., *Women Working the NAFTA Food Chain: Women, Food and Globalization* (Toronto: Second Story Press, 1999; now available from Sumach Press, Toronto), 81–96.

15. Ann Eyerman, "Serving Up Service: Fast Food and Office Workers Doing It with a Smile," in Barndt, ed., *Women Working the NAFTA Food Chain: Women, Food and Globalization* , 162-174.

16. Suzi, e-mail to author, 8 September 1999.

17. Jennifer J. Laabs, "Eyeing Future HR Concerns," *Personnel Journal* (January 1996), 36.

18. In a comprehensive study of the clerical field in Toronto, Pat Bird and Alice deWolff found that any training and education needed to get a job or keep one was now primarily the responsibility of the employee and not the employer. Pat Bird and Alice deWolff, *Occupational Analysis: Clerical Occupations in Metropolitan Toronto* (Toronto Clerical Workers' Centre, 1997), 6.

19. This was not surprising. This same firm some years earlier had moved into a new office building. The builders were behind schedule, but delaying the entry into the building would have cost the firm considerable amounts in rent to the old landlords. They decided to move on the designated day as planned. Secretaries were expected to dress appropriately for their job. Therefore, as carpenters and ruglayers walked the hallways in hardhats and steel-tipped shoes, the secretaries wore their heels.

20. CBC Radio, "This Morning," 12 September 1999.

21. Suzi, e-mail to author, 5 October 1999.

22. On a recent visit to my former law firm, one of the paralegals told me this story. The firm had announced that a certain form was now accessible on the computer system and employees were told to use the computer version immediately. She went in to access it and it wasn't there. She called the Help Desk, who said it wasn't available yet; she would have to get it out of Supply. She went to

Supply and they said that it was only available electronically; they couldn't give one to her. What should have been a three-minute task using either method took her two days.

Zoë told me a similar story in one of our subsequent conversations. The Registrar's office was changing a certain rule regarding pass/fail grades (so it was an important piece of information). Information about this would be available on-line and office staff were advised where to access this. When that site did not provide the answers, Zoë e-mailed the two contact people. She did not receive a reply from either one — so she telephoned the Registrar's office and got voice mail from yet a third person. When I talked to her, it was a week or more after the initial contact had been made and she still did not have an answer.

23. Kathy Muller, "WageRage," *Our Times* (May/June 1999), 11.

24. Flavian DeLima, "Lifelong Learning Can Help Keep Skills Intact," *The Toronto Star*, 30 January 1999, H1.

25. Garson, *The Electronic Sweatshop*, 263.

CHAPTER TWO: RESTRUCTURING THE OFFICE, 67–87

1. Fieldnotes, 1997. Anonymous, informal discussion with author. I had met a woman who was trained in human resources, but who could not find a full-time job. In my talk with her, she said that at her last full-time job, she had felt so confident of her tenure there that she brought in a whole case of water for her office. She was fired just a few days later. As she packed up her desk and the water, one of her co-workers comforted her with this quote.

2. Stanley Aronowitz and William DiFazio, *The Jobless Future: Sci-Tech and the Dogma of Work* (Minneapolis: University of Minnesota Press, 1994), 15.

3. John P. Herzog, "People: The Critical Factor in Managing Change," *Journal of Systems Management* (March 1991), 11.

4. Barbara Garson, *The Electronic Sweatshop: How Computers Are Transforming the Office of the Future into the Factory of the Past* (New York: Penguin Books, 1988), 167.

5. Needless to say, there are many books that have been written on the phenomenon of global capitalism — both pro and con. I personally found Gary Teeple's *Globalization and the Decline of Social Reform* (New Jersey: Humanities Press International Inc., 1995; Toronto: Garamond Press, 1995), provided a clear and readable treatment of the history and economic repercussions of globalization.

6. Teeple, *Globalization*, 130.

7. Ibid., 2. Emphasis in original.

8. Marjorie Griffin Cohen, "New International Trade Agreements: Their Reactionary Role in Creating Markets and Retarding Social Welfare," in Isabella Bakker ed., *Rethinking Restructuring: Gender and Change in Canada* (Toronto: University of Toronto Press, 1996), 191.

9. Kofi Annan, Secretary-General of the United Nations, in a speech to business leaders, called for a "global compact of shared values and principles to put a human face on globalization." He does not disagree that globalization is a fact of life, but believes that we have underestimated the fragility of that life. The problem, as he sees it, is that "the spread of markets has outpaced the ability of societies and their political systems to adjust to them, let alone guide them." He proposes that workers' rights, as well as that of the environment, must be aggressively fought for in any global trade talks. "UN Head Challenges Business," *The Toronto Star*, 1 February 1999, A3.

10. Two years ago when I visited a small village in Spain where I have a house, the local *supermercado* had shelves filled with Kellogg's breakfast cereals — this in a country where eating cereal for breakfast is not part of the culture. However, now with advertising, especially on television, I'm sure it is fast becoming a "modern" thing to do — like going to McDonald's.

11. Television advertisement for Cisco Systems.

12. For anyone who doesn't remember him, Gumby was a green plastic toy that could be bent in almost any direction, then spring back to his original shape. A friend in Toronto told me that, during the 1980s, she remembers seeing subway ads for a temporary agency that used Gumby as their mascot representing the more flexible workforce. If you want to read more about Gumby or even order a Superflex Gumby, checkout the Web page <http://www.gumbyworld.com>.

13. R. E. Allen, ed., *The Concise Oxford English Dictionary*, 8th ed. (Oxford: Clarendon Press, 1973).

14. Susan Alexander, "Wanted: Receptionist PhD," *Herizons* (Fall 1998), 48.

15. Suzi, e-mail to author, 6 March 2000.

16. "Nine Out of Ten Administrative Professionals Report Increased Responsibilities." International Association of Administrative Professionals. <http://www.iaap-hq.org/news_9.html>. 2 Febuary 2000.

17. I remember one year getting a particularly small raise at the law firm; I went to the managing partner who I had worked with closely and told him that this was an insult to my skills and my contribution to the firm. He said, "You must know how much we value your work here." I reminded him that at that law firm, the only true sign of appreciation was dollars. No partner would have been content at compensation time with a "Good Job, Henry."

18. There is much in a name. In my own workplace when the "Personnel" Department changed to the "Human Resource" Department, there was some office joking that we workers were now a commodity, the same as any other natural resource, say the sea or forest, to be exploited for the benefit of our bosses. We were right.

19. Aronowitz and DiFazio, *The Jobless Future*, 34.

20. Beverly Geber, "The Flexible Work Force: Using Contingent Workers Wisely and Humanely," *Training* (December 1993), 30.

21. "Why Shorter Work Time?" *32 Hours: Action for Full Employment.* <http://www.web.net/32hours/whyshorter.htm>. 9 March 2000.

22. Although I'm not a telecommuter, I understand my friend's comment. For the last four years, all of my work has been "home" work — first for my master's degree, then working as a research assistant and finally writing this book. It *is* lonely work; I miss the stimulation and camaraderie of my "office mates."

23. Linda Thornburg, "Change Comes Slowly," *HR Magazine* (February 1994), 48.

24. Garson, *The Electronic Sweatshop,* 227.

25. Herzog, "People: The Critical Factor," 7–8.

26. Marie McKendall, "The Tyranny of Change: Organizational Development Revisited," *Journal of Business Ethics* (1993), 96.

27. Ibid., 97.

28 Suzi, e-mail to author, 7 March 2000.

29. Aronowitz and DiFazio, *The Jobless Future,* 8.

30. One president of a Canadian subsidiary of a US multinational found out his company had been sold out from under him when he read his morning newspaper. Michael Stern, "Employers Still Covet Loyal, Long-Term Workers," *The Toronto Star,* 13 February 1999, H1.

31. Pat Armstrong, "The Feminization of the Labour Force: Harmonizing Down in a Global Economy," in Bakker, ed., *Rethinking Restructuring,* 52–53.

32. In a stunning film, *From the Mountains to the Maquiladoras,* a group of women electronic workers from Tennessee visit their former employer's plant in Mexico. There they meet face-to-face with the women who "took their jobs." The film respectfully and movingly covers the visit to the plant and Matamoros, Mexico, where the women live. The Tennessee women (with the aid of a translator) talk to the Mexican women about their work and its low pay; visit the women in their homes and hold their babies while the Mexican women talk of the high cost of food and no indoor plumbing. The Tennessee women come away with a humanized picture of globalization and the poverty and hardships it brings to women everywhere. This film is available in many libraries or from the Tennessee Industrial Renewal Network, 1515 East Magnolia, Suite #403, Knoxville, Tennessee 37917.

33. Zoë, e-mail to author, 3 March 2000.

34 Brian O'Reilly, quoting Daniel Yankelovich, marketing and opinion researcher, "The New Deal: What Companies and Employees Owe One Another," *Fortune,* 13 June 1994, 44.

35. Anne Machung, "Word Processing: Forward for Business, Backward for Women," in Karen B. Sacks and Dorothy Remy, eds., *My Troubles Are Going to Have Trouble with Me: Everyday Trials and Triumphs of Women Workers* (New Brunswick, NJ: Rutgers University Press, 1984), 128.

36. McKendall, "The Tyranny of Change," 101.

37. There was a Personal Advisory Committee where I worked made up of

representatives from the nonprofessional groups in the office — housekeepers, duplicating staff, accounting, secretaries and receptionists. Monthly meetings were held with the Executive Director and the Human Resources Director. Lunch was served. There was a certain amount of "prestige" in being on the committee; however, it was a sham. Decisions were already made before they were presented to the committee. Concerns could be brought up at the meetings, but there wasn't much hope that anything positive would be done about them.

38. Machung, "Word Processing," 129.

39. Ursula Franklin, *The Real World of Technology* (Toronto: CBC Enterprises, 1990; reprint, Concord, ON: Anansi, 1992), 51, 25.

40. Heather Menzies, *Whose Brave New World? The Information Highway and the New Economy* (Toronto: Between the Lines, 1996), 105–107.

41. Herzog, "People: The Critical Factor," 8.

42. Mary Anne Wichroski, citing Robert Howard, *Brave New Workplace* (New York: Viking, 1985) in "The Secretary: Invisible Labor in the Workworld of Women," *Human Organization* (1994), 37.

43. Ibid., 35.

CHAPTER THREE : GOOD JOBS, BAD JOBS, FLEX JOBS, NO JOBS, 106–125

1. Helen Potrebenko, *Life, Love and Unions* (Vancouver: Lazara Publications, 1987), 55.

2. Mike Burke and John Shields, *The Job-Poor Recovery: Social Cohesion and the Canadian Labour Market* (Toronto: Ryerson Social Reporting Network, Ryerson Polytechnic University, 1999), 9

3. Ibid., 3.

4. Ibid., 13

5. Suzi, e-mail to author, 8 September 1999.

6. Jim Streb, interview by author, Toronto, ON, 26 July 1999.

7. Zoë, e-mail to author, 8 March 2000.

8. For an informative selection of essays looking at a variety of issues regarding the changing look of work today, see Ann Duffy, Daniel Glenday, and Norene Pupo, eds., *Good Jobs, Bad Jobs, No Jobs: The Transformation of Work in the 21st Century* (Toronto: Harcourt Brace and Company, Canada, 1997).

9. Pat Bird and Alice deWolff, *Occupational Analysis: Clerical Occupations in Metropolitan Toronto.* Report to the Clerical Workers' Centre (Toronto: Clerical Workers' Center, 1997).

10. Toronto represents a very rich environment in which to conduct this type of research. It is a major large North American city with a broad employment base that includes most of the major business sectors — financial, educational,

commercial, public, industrial. So while deWolff's findings reflect the employ-
ment pool of the women in this book, they could also be transferred and
compared with other major North American cities.

11. Alice deWolff, *Changes in Office Occupations in Toronto 1991–1996: Analysis of the 1996 Census* (Toronto: Clerical Workers' Centre, 1999), 2,16.

12. Statistics Canada, "Labour Force Update: Canada–U.S. Labour Market Com-
parison, 1989 to 1997," *The Daily*, 24 November 1998, 6.

13. Burke and Shields, *The Job-Poor Recovery*, 12. Emphasis in original.

14. Statistics Canada, "Labour Force Update," 6.

15. Times Change Women Employment Service Job Board.

16. 9to5, National Organization for Working Women, et al. "Statement on Changes
to Current Labor Laws Necessary to Address The Critical Needs of The
Contingent Workforce," submitted by 9to5 before the Commission on the
Future of Worker–Management Relations (Washington, DC: US Department of
Labor, 1994), 2.

17. Audrey Freedman, a New York consultant, coined the term "contingent
workforce" to describe this new and different configuration of the American
workforce back in the 1980s. Beverly Geber, "The Flexible Work Force: Using
Contingent Workers Wisely and Humanely," *Training* (December 1993), 24.

18. Geber, "The Flexible Work Force," 24.

19. Stanley Aronowitz and William DiFazio, *The Jobless Future: Sci-Tech and the
Dogma of Work* (Minneapolis: University of Minnesota Press, 1994), 1.

20. Geber, "The Flexible Work Force," 25.

21. Heather Menzies, *Whose Brave New World? The Information Highway and the
New Economy* (Toronto: Between the Lines, 1996), 84.

22. Suzi, e-mail to author, 8 September 1999.

23. Jackie Krasas Rogers, *Temps: The Many Faces of the Changing Workplace* (Ithaca:
IRL Press, 2000), 28.

24. Gerber, "Flexible Work Force," 24.

25. When my former employer outsourced the messenger service, they chose a
contractor who did not offer any health benefits to its employees. This meant
that these workers became not only the lowest paid workers in this law firm,
they also became the only ones not covered by health insurance — a very
serious predicament if you live in the United States. The duplicating personnel,
on the other hand, faired somewhat better. They were taken over by the Xerox
Business Services (XBS). So while they lost their personal attachment with the
firm, some of them at least kept a job. According to a XBS employee, it is up to
the company whether the old employees will be interviewed for jobs with
Xerox; it is not an automatic presumption. Some companies evidently want to
clean house. If hired, these employees' years of service with their former em-
ployers do not count towards Xerox seniority, but they do get Xerox benefits
right away.

26. Meg, interview by author, Toronto, ON, 20 March 1997.

27. Megan Park, "Desperate Remedies and Slavish Labour," *The Globe and Mail*, 21 February 1997, A22.

28. Ibid.

29. "Corporate Information. Kelly/Adderley Inteview." *Kelly Services.*

30. Jan Larson, "Temps Are Here to Stay," *American Demographics* (February 1996), 28.

31. Harry Braverman, *Labor and Monopoly Capital: The Degradation of Work in the Twentieth Century* (New York: Monthly Review Press, 1974), 341.

32. "Fortune 5 Hundred 2000." *Fortune.* <http://www.fortune.com/fortune/fortune 500>. 6 September 2000.

33. Geber, "The Flexible Work Force," 26.

34. Brogan, Timothy W. "Annual Analysis." *American Staffing Association.* <http://www.natss.com/staffstats/analysis.htm>. 17 March 2000.

35. Chris Benner, "Shock Absorbers in the Flexible Economy: The Rise of Contingent Employment in Silicon Valley," *Executive Summary* (Working Partnerships USA: 1997).

36. Ibid.; Steven Theobald, "Temping Is Here to Stay," *The Toronto Star*, 21 October 1998, D1.

37. James Aley, "The Temp Biz Boom: Why It's Good," *Fortune*, 16 October 1995, 53.

38. National Temporary Help Week was organized by the American Staffing Association (formerly the National Association of Temporary and Staffing Services); I don't know if Hallmark and other card companies are participating. "Outsource International Salutes National Temporary Help Week." *Outsource International.* <http://www.outsourceint.com/outsource/prtempwk.htm>. 17 March 2000; "Up Toronto Streets Without a Paddle," *The Toronto Star*, 8 October 1998, B2.

39. National Staff Leasing Association, as quoted in Christopher D. Cook, "The Downsizing of Labor Rights," *Z Magazine* (March 1997). <http://www.lbbs.org/zmag/articles/mar97/cook.htm>.

40. Brogan, Timothy W., "Annual Analysis." *American Staffing Association.* 17 March 2000.

41. Research in Canada showed that 65% of temporary workers want permanent work — thus making them *involuntarily* temporary workers. Grant Schellenberg and Christopher Clark, "Temporary Employment in Canada: Profiles, Patterns and Policy Considerations," *Social Research Series*, Paper No. 1 (Ottawa: Centre for International Statistics at the Canadian Council of Social Development, 1996), 8.

42. Newspaper advertisement for large temporary agency in Toronto, ON.

43. Bobbi, informal conversation with author, Toronto, ON, March 2000.

44. Brogan, Timothy W., "Annual Analysis." *American Staffing Association.*

45. Burke and Shields, *The Job-Poor Recovery*, 3.

46. Grant Schellenberg, "Involuntary Part-Time Workers," *Perception 18 (1994)*, 23.

47. Ibid.

48. Geber, "The Flexible Workforce," 27.

49. Lorraine, e-mail to author, 28 March 2000. Lorraine wrote later that, "According to Kelly Services and others, the new industry standard and terminology [for temp-to-perm] is now temp-to-regular. It has become the acknowledged truth that there is no such thing as a permanent job!" Lorraine, e-mail, 31 March 2000.

50. "CallCenterOps." *Call Centers and Call Center Operations.* <http://www.callcenterops.com>. 25 March 2000.

51. "1999 Report on the American Workforce," *U.S. Department of Labor,* (Washington, DC, 1999) 18. <http://www.b/s.gov/opub/rtaw/rtawhome.htm>. 6 June 2000.

52. "Canadian Calling Centres," *Industry Canada — Information and Communications Technologies.* <http://www.strategis.ic.gc.ca/cgi-bin/basic>. 30 March 2000.

53. Tyler Hamilson, "Call Centres Flip Their Fast Food Stereotype," *The Globe and Mail,* 8 October 1998, C9. It is interesting to note that like their fast-food predecessor's Hamburger University, call centres also have their own university — the Call Center University in Tennessee, where they offer "hot topic" seminars, including "Call Center 101: Overview of the Modern Call Center." "About Call Center University." *Call Center University.* <http://www.callcenteru.com/about2.html>. 20 June 2000.

54. Anonymous, informal discussion with author, 28 March 2000.

55. "(CCSR) Call Centre Service Representative, Certificate," *Cambrian College.* <http://www.cambrian.on.ca/FullTime/DisplayCourse.cfm>. 29 March 2000.

56. "CallCenterOps." *Call Centers and Call Center Operations.*

57. Trish Crawford, "High-Tech Feeds Teeming Ranks of Teleworkers," *The Toronto Star,* 2 September 1996, A7.

58. Angie Calabrese, HR Associate, Wealth Management, Canadian Imperial Bank of Commerce, "Career Opportunities in Banking," Workshop, Clerical Workers' Centre, Toronto, Ontario, 28 January 1999.

59. Fieldnotes, 1999.

60. "Canadian Calling Centres." <http://www.strategis.ic.gc.ca/cgi-bin/basic>. 30 March 2000.

61. Natalie Southworth, "New E-Slaves: People Who Handle E-Mail Flood," *The Globe and Mail,* 3 April 2000, A1.

62. Alice deWolff and Associates, *The Impact of E-Business on Office Work* (Toronto: Office Workers' Career Centre and Human Resources Development Canada, 2000).

63. Geber, "The Flexible Workforce," 27.

64. Ibid.

65. Margaret Maruani, "Hard Times for Working Women." *Le Monde Diplomatique* (September1997). <http://www.monde-diplomatique.fr/en/1997/09/?c= women>. 4 January 2000.

66. Carol Kleiman, "Flexible Temp Work Preferable for Some," *The Toronto Star*, 10 December 1998, C24.

67. "Newsletter." *TempNetwork*. <http://www.tempclub.com/newsletter>. 17 March 2000.

68. "Code of Conduct for Temporary Placement and Staffing Agencies." *Working Partnership Member Association*. <http://www.wpmembers.org/choose.htm>. 1 March 2000.

69. Aaron Bernstein, "Now, Temp Workers Are a Full-Time Headache," *Business Week*, 31 May 1999, 46.

70. There is one case in Toronto where the union challenged a college's practice of hiring contract employees for programs for which they were administering federal funds. The college administration felt that the positions fell outside the bargaining unit, since the employees were not on the "payroll" per se. As a result of the grievances filed, one program was closed down completely and forced to move to another site. For a second project, the college reluctantly agreed that two positions would become part of the bargaining unit — two other positions were kept on contract basis, forcing the organization to look elsewhere for an "employer" for these two positions or risk having to rehire every six months.

71. Thomas Claridge, "Contract Worker Awarded Severance," *The Globe and Mail*, 17 February 1999, A2.

72. Jonathan Eaton, "Shift Toward 'Temp' Workers Tests Legal Rules," *The Toronto Star*, 18 November 1996, C3.

73. Kirstin Downey Grimsley, "Temporary Workers Exploited, Group Says," *The Washington Post*, 24 May 2000, E1.

74. This is particularly crucial for single mothers. It was reported that, "despite a decade-long economic boom, every fifth child in the United States still lives in poverty." As people on assistance are forced off the roles and into workfare jobs, it has created a world where "three out of every four children living below the poverty line are in households where at least one adult works." Something must be done to guarantee that work pays enough to keep us and our families out of poverty, and that there are supports in place to help people who need to work. Paul Koring, "One in 5 U.S. Children Lives in Poverty," *The Globe and Mail*, 25 March 2000, A25.

CHAPTER FOUR: SICK AND TIRED FROM IT ALL, 142–157

1. Barbara Silverstein, an epidemiologist, as quoted in Penny Kome, Wounded Workers: The Politics of Musculoskeletal Injuries (Toronto: University of Toronto Press, 1998), 8.

2. Human Resources Development Canada, *Report of the Advisory Group on Working Time and the Distribution of Work* (The Donner Report) (Ottawa: HRDC, 1994), 7.

3. "Office Ergonomics Safety Guide — Overview." *Canadian Centre for Occupational Health and Safety.* <http://www.ccohs.ca/products/sampleoffice.html>. 5 April 2000; and "NORA Priority Research Areas — Organization of Work." *National Institute for Occupational Safety and Health.* <http://www.cdc.gov/niosh/worken/htm>. 4 April 2000.

4. Steven Sauter, PhD, and Gwendolyn Puryeaer Keita, PhD, "Introduction — Closing Plenary Session Work, Stress, and Health '99: Organization of Work in a Global Economy," *National Institute for Occupational Safety and Health* (March 1999). <http://www.cdc.gov/niosh/stress99.html>. 4 April 2000.

5. "Why OSHA's Ergonomics Standards Should Proceed," *AFL-CIO.* http://www.unionsmr.org/safety/ergoproc.htm>. 10 April 2000.

6. "Study to Probe Workplace Injuries, " *The American Academy of Orthopaedic Surgeons Bulletin* (vol. 47, no. 2, April 1999). <http://www.aaos.org>. 11 April 2000.

7. Statistics Canada, "National Population Health Survey: Cycle 2," The Daily Press Release, 29 May 1998. <http://www.statcan.ca/Daily/English/980529/d980529.htm>. 18 April 2000.

8. "Why OSHA's Ergonomics Standard Should Proceed." *AFL-CIO.* <http://www.unionsmr.org/safety/ergoproc.htm>. 10 April 2000.

9. Kome, Wounded Workers, 142.

10. Board of Certification for Professional Ergonomists (BCPE), as quoted in ibid., 120.

11. "Fact Sheet on RSIs," *AFL-CIO.* <http://www.aflcio.org/safety/ergofact.htm>. 10 April 2000.

12. Kome, *Wounded Workers,* 123–124.

13. "An Ergonomics Approach to Avoiding Workplace Injury." *American Industrial Hygiene Association.* <http://www.aiha.org/pr/ergo.html>. 10 April 2000.

14. Kome, *Wounded Workers,* Introduction, xv.

15. Ibid., 116.

16. "An Ergonomics Approach to Avoiding Workplace Injury." <http://www.alha.org/pr/ergo.html>. 10 April 2000.

17. Ibid.

18. Ilene Stones and Wendy King, "Office Overload: The Hidden Health Hazards of Modern Office Work," *OH&S Canada* (January/February 1991), 69.

19. "NORA Priority Research Areas: Work Environment and Workforce — Indoor Environments." *National Occupational Research Association.* <http://www.cdc.gov/niosh/worken.html>. 4 April 2000.

20. "Do I Work in a Sick Building?" *American Industrial Hygiene Association.* <http://www.aiha.org/infosick.html>. 5 April 2000.

21. "NORA Priority Research Areas." <http://www.cdc.gov/niosh/worken.html>. 4 April 2000.

22. Ibid.

23. Stones and King, "Office Overload," 63.

24. "Stress ... At Work." NIOSH Working Group (DHHS [NIOSH] Publication No. 99–101). *National Institute for Occupational Safety and Health.* <http.www. cdc.gov/niosh/stresswk.html>. 4 April 2000.

25. Ibid.

26. Christina Maslach and Michael P. Leiter, *The Truth About Burnout: How Organizations Cause Personal Stress and What to Do About It* (San Francisco: Jossey-Bass, 1997), 23. Emphasis in original.

27. "Stress ... At Work." *National Institute for Occupational Safety and Health.*

28. Louis Uchitelle and N. R. Kleinfield, "On the Battlefields of Business, Millions of Casualties," *The New York Times*, 3 March 1996, A1.

29. "Stress ... At Work." *National Institute for Occupational Safety and Health.*

30. Maslach and Leiter, *The Truth About Burnout*, 38.

31. Arlie Russell Hochschild, *The Time Bend: When Work Becomes Home and Home Becomes Work* (New York: Metropolitan Books Henry Holt and Company, 1997), 258.

32. Maslach and Leiter, *The Truth About Burnout*, 5.

33. Ibid., 44–45.

34. Ibid., 49.

35. Ibid., 55.

36. Barbara Moses, "Plight of Older Worker Hits Home Early in Youth-Obsessed Culture," *The Globe and Mail*, 27 September 1999, C1.

37. "NORA Priority Research Areas — Work Environments and Workforce: Special Population at Risk." *National Institute for Occupational Safety and Health.* <http://www.cdc.gov/niosh.worken.htm>. 4 April 2000.

38. Ibid.

39. Ibid.

40. Lisa Wright, "Pounding the Pavement Gets Harder with Age," *The Toronto Star*, 26 September 1998, E1.

41. Pamela R. Johnson and Julie Indvik, "The Boomer Blues: Depression in the Workplace," *Public Personnel Management* 26 (Fall 1997), 360.

42. Report of the Task Force on Health and Work (Toronto: Board of Health, 1997), 9.

43. Hochschild, *The Time Bend*, 247.

44. Mike Burke and John Shields, *The Job Poor Recovery: Social Cohesion and the Canadian Labour Market* (Toronto: Ryerson Social Reporting Network, Ryerson Polytechnic University, 1999), 17.

45. You know the problem must be growing when employers are now installing "mood meters" — an automated phone system that scans for depression. Callers listen to recorded descriptions of symptoms and punch in the one that best describes their blues and the number of times they feel that way. A recorded diagnosis is offered at the end. "'Mood Meter' Tells Workers If They're Feeling the Blues," *The Toronto Star*, 15 February 1999, C8.

46. J. Krohe, "An Epidemic of Depression," *Across the Board* (31), 23–40, as quoted in Johnson and Indvik, "The Boomer Blues," 361.

47. Johnson and Indvik, "The Boomer Blues," 360. It is also noted in this article that depression has become so prevalent at the corporate level, that Eli Lilly and Company now market Prozac as a cure for "depressed corporate productivity."

48. Kome, *Wounded Workers*, 10–11.

49. Maslach and Leiter, *The Truth About Burnout*, 21.

50. Kome, *Wounded Workers*, 95.

51. Ibid., 18.

52. Ibid., 95.

53. Sue Shellenbarger, "Overloaded Staffers Cope by Calling In Sick," *The Globe and Mail*, 24 September 1998, B15.

54. Kome, *Wounded Workers*, quoting Barbara Silverstein, 85. To illustrate this point further, in a front-page article in a Toronto paper, it was reported that Human Resources Development Canada showed "a deep suspicion" about the validity of the unemployment insurance claims made by people who quit jobs and claimed sickness benefits. The amount paid out under "sickness" had jumped in the last year by 11%. It was their perception that people were "faking" stress and other illnesses when they quit their jobs and were therefore "cheating the system." "UI Fraud Suspected As Sickness Claims Soar," *The Globe and Mail*, 23 March 2000, A1.

55. Kome, *Wounded Workers*, 5.

56. Ibid., 36.

57. Caitlin Kelly, "Catnapping on Company Time," *The Globe and Mail*, 15 May 1999, D5.

58. "Stress … At Work." *National Institute for Occupational Safety and Health.*

59. This criteria reported in "Stress … At Work" evolved out of a NIOSH working group's attempt to develop a comprehensive national strategy to protect and promote the psychological health of workers — recognized by NIOSH as a leading occupational health problem. For a more comprehensive look at the work of this group, see Steven L. Sauter et al., "Prevention of Work-Related Psychological Disorders: A National Strategy Proposed by the National Institute for Occupational Safety and Health (NIOSH)," *American Psychologist* 45 (1990), 1146–1158.

60. Maslach and Leiter, *The Truth About Burnout*, 77–78.

61. Ibid., 65.

CHAPTER FIVE: THE OFFICE WORKERS' FUTURE: TRYING TO TURN IT AROUND, 184–199

1. Zoë, e-mail to author, 2 February 2000.

2. Bumper sticker, Industrial Workers of the World. The story about the history of this bumper sticker told to me by Maureen Hynes is most interesting. "The IWW's secretary was asked to put in the regular order to restock their bumper stickers. Unbeknownst to the other staff, she added 'Nothing Works Without Clerks' — a new product that surprised the staff when it arrived." These bumper stickers are available from the IWW, 103 W. Michigan Avenue, Ypsilanti, Michigan 48197 USA for US$1.25, five or more, 40% off.

3. If you would like more information about any one of these organizations, see the Resources section at the end of this book.

4. Times Change is currently funded by Human Resources Development Canada, the Ontario Women's Directorate, the City of Toronto, the United Way and individual contributions.

5. Ann Eyerman, "President's Remarks to Times Change Women's Employment Service 25th Anniversary Celebration," City of Toronto Archives, 14 October 1999.

6. The Office Workers' Career Centre is currently funded by Human Resources Development Canada.

7. The research undertaken by Alice deWolff and Pat Bird on the changes occurring in the clerical field supported the inception of the OWCC. Pat Bird and Alice deWolff, *Occupational Analysis: Clerical Occupations in Metropolitan Toronto. Report to the Clerical Workers' Centre* (Toronto: Clerical Workers Centre, 1997).

8. Beta Sigma Phi — the Greek letters for life, learning and friendship — still exists today and boasts over 200,000 members. It was mainly what they call a "friendship sorority." The members participate in charity fundraising and social events. "The History of Beta Sigma Phi." *Beta Sigma Phi.* <http://www.betasigmaphi.org/Business/bspinfo/History.htm>. 4 February 2000.

9. Julie, e-mail to author, 4 February 2000.

10. "Make the Commitment," membership application form for International Association of Administrative Professionals (1998).

11. Elaine Daniels, interview by author, Toronto, ON, 5 August 1999.

12. International Association of Administrative Professionals, "The Winning Edge," pamphlet.

13. Daniels interview.

14. This has been proven through IAAP's National Secretaries' Day. The IAAP thought such a day would bring respect and recognition to secretaries, who too often are ignored not only in their workplaces but by society as a whole. Unfortunately, over the years, National Secretaries' Day has become a boom to

greeting card manufacturers and florists, and a hallow and often condescending event for the women it is meant to honour. IAAP is trying to bring back the original meaning of the day by changing its name to Administrative Professionals Day and by encouraging its chapters to celebrate it through lectures and workshops on pertinent issues. "Professional Secretaries Week Renamed Administrative Professionals Week: Change Is Effective with April 2000 Observance." *International Association of Administrative Professionals.* <http://www.iaap. hq.org/pswchange.htm>. 2 February 2000.

15. Trevor Cole, "Typecast," *Report on Business Magazine* (February 2000), 70.

16. 9to5, National Association of Working Women, "9to5 Dedicated to the Rights and Respect of Working Women, 1998–99" (Milwaukee, WI: 9to5, 1999), 1.

17. Ibid.

18. "9to5: Working for Working Women." *9to5.*<http://www.feminist.com/ 9to5.htm>. 6 December 1999.

19. "With Stakes at an All Time High, Why Are So Many Employers Still Failing to Stop Sexual Harassment?" *9to5.* <http://www.9to5.org/newsfr.html>. 6 December 1999.

20. Cindia Cameron, "Noon at 9to5: Reflections on a Decade of Organizing," in Jeremy Brecher and Tim Costello, eds., *Building Bridges: The Emerging Grassroots Coalition of Labor and Community* (New York: Monthly Review Press, 1990), 182.

21. Ibid.

22. Roberta Goldberg, *Organizing Women Office Workers: Dissatisfaction, Consciousness, and Action* (New York: Praeger, 1983), 133.

23. Roni Chaleff, interview by author, Toronto, ON, 28 April 1997.

24. Laurell Ritchie, "Why Are So Many Women Unorganized?" in Linda Briskin and Lynda Yanz, eds., *Union Sisters: Women in the Labour Movement* (Toronto: Women's Educational Press, 1983), 200.

25. Cameron, "Noon at 9to5," 180.

26. Ibid., 179.

27. Art Hilgour, "Into the Blue: How White-Collar University Staff Became People of Steel," *Our Times* (May/June, 1999), 35.

28. Alice deWolff, *An Activist Guide for Front Line Office Workers* (Toronto: Ontario Federation of Labour (CLC), 1998), 67.There is a difference between public/private sector employees in that public employees already have a sense of "belonging" to something and therefore may be an "easier" group to organize. There are very few private sector jobs, especially in banking or insurance, that are unionized. Perhaps the difference is that the government has a public image of "caring" for its people.

29. There had been an attempt at unionizing a few years before, but this was defeated (some say by the power of the university to drag the issues on until interest was lost).

30. Hilgour, "Into the Blue," 31.

31. Vanessa Lu, "Steelworkers at U of T: Union Drive 'An Odd Fit'," *The Toronto Star*, 29 September 1998, B5.

32. Hilgour, "Into the Blue," 34.

33. The University of Toronto staff actually borrowed this slogan from the Harvard University staff's successful organizing drive. Ibid.

34. "Temp work is no longer confined to the margins of labor market for fill-in help: the industry now plays a central role in staffing permanent positions with workers … who are cut off from earnings, benefits and promotional opportunities available to traditional permanent staff." "Improving Job Quality for Contingent Workers," *Organizing: A Newsletter on Jobs, Transportation and Welfare Reform Organizing* (May, 1999, issue #15). *Center for Community Change.* <http://www.communitychange.org/organizing/bergen15.htm>. 7 January 2000.

35. Aaron Bernstein, "A Leg Up for the Lowly Temp: Advocates Are Lobbying for Better Benefits and an Employers' Code of Conduct," *Business Week*, 21 June 1999, 102.

36. "Temporary Worke Home Base." *Working Partnerships USA.* <http://www.at work.org/temp/index.html>. 5 February 2000.

37. 9to5, National Association of Working Women, "Illegal and Unfair: Milwaukee Temp Agencies Fail Employment Testing" (Milwaukee, WI: 9to5, 2000), 9. There are other organizations in the US who are drafting similar codes for their jurisdictions. For instance, the Labor Council of Bergen, New Jersey with funding from the AFL-CIO, the local county government and the United Way created The New Jersey Temp Workers Alliance. The Alliance provides temporary workers a place to meet and "share their concerns, tips and issues." On a very practical level, and one that made a difference to temporary workers throughout the state, they created a "Consumer Guide to Best Practices Temp Agencies" to help unemployed workers locate the temp agencies that would give them the most support and stability. "Improving Job Quality for Contingent Workers." *Center for Community Change.*

38. Jo-Ann Mort, ed., *Not Your Father's Union Movement: Inside the AFL-CIO (New York: Verso, 1998).*

39. Alice deWolff, interview by author, Toronto, ON, 10 January 2000.

40. Ibid.

Selected Bibliography

Armstrong, Pat. *Labour Pains: Women's Work in Crisis.* Toronto: Women's Educational Press, 1984.

Aronowitz, Stanley, and William DiFazio. *The Jobless Future: Sci-Tech and the Dogma of Work.* Minneapolis: University of Minnesota Press, 1994.

Bakker, Isabella, ed. *Rethinking Restructuring: Gender and Change in Canada.* Toronto: University of Toronto Press, 1996.

Barker, Kathleen, and Kathleen Christensen, eds. *Contingent Work: American Employment Relations in Transition.* Ithaca: Cornell University Press, 1998.

Barndt, Deborah, ed. *Women Working the NAFTA Food Chain: Women, Food and Globalization.* Toronto: Second Story Press, 1999; now available from Sumach Press, Toronto.

Bird, Pat, and Alice deWolff. *Occupational Analysis: Clerical Occupations in Metropoli-tan Toronto. Report to the Clerical Workers' Centre.* Toronto: Clerical Workers' Centre, 1997.

Braverman, Harry. *Labor and Monopoly Capital: The Degradation of Work in the Twentieth Century.* New York: Monthly Review Press, 1974.

Briskin, Linda, and Lynda Yanz, eds. *Union Sisters: Women in the Labour Movement.* Toronto: Women's Educational Press, 1983.

Burke, Mike, and John Shields. *The Job-Poor Recovery: Social Cohesion and the Canadian Labour Market.* Toronto: Ryerson Social Reporting Network, Ryerson Polytechnic University, 1999.

deWolff, Alice, and Associates. *The Impact of E-Business on Office Work.* Toronto: Office Workers' Career Centre and Human Resources Development Canada, 2000.

Duffy, Ann, Daniel Glenday, and Norene Pupo, eds. *Good Jobs, Bad Jobs, No Jobs: The Transformation of Work in the Twenty-First Century.* Toronto: Harcourt Brace and Company, Canada, 1997.

Duffy, Ann, and Norene Pupo. *Part-Time Paradox: Connecting Gender, Work and Family.* Toronto: McClelland and Stewart Inc., 1992.

Franklin, Ursula. *The Real World of Technology.* Toronto: CBC Enterprises, 1990; reprint, Concord, ON: Anansi, 1992.

Garson, Barbara. *The Electronic Sweatshop: How Computers Are Transforming the Office of the Future into the Factory of the Past.* New York: Penguin Books, 1988.

Goldberg, Roberta. *Organizing Women Office Workers: Dissatisfaction, Consciousness, and Action.* New York: Praeger, 1983.

Greenbaum, Joan. *Windows on the Workplace: Computers, Jobs, and the Organization of Office Work in the Late Twentieth Century.* New York: Monthly Review Press, 1995.

Hammer, Michael, and James Champy. *Reengineering the Corporation.* New York: Harper Business, 1993.

Hochschild, Arlie Russell. *The Time Bend: When Work Becomes Home and Home Becomes Work.* New York: Metropolitan Books, 1997.

Kome, Penny. *Wounded Workers: The Politics of Musculoskeletal Injuries.* Toronto: University of Toronto Press, 1998.

Lowe, Graham S. *The Quality of Work: A People-Centred Agenda.* Don Mills, ON: Oxford University Press, 2000.

Maslach, Christina, and Michael P. Leiter. *The Truth About Burnout: How Organizations Cause Personal Stress and What to Do About It* .San Francisco: Jossey-Bass, 1997.

Menzies, Heather. *Whose Brave New World? The Information Highway and the New Economy.* Toronto: Between the Lines, 1996.

Mort, Jo Ann, ed. *Not Your Father's Union Movement: Inside the AFL-CIO.* New York: Verso, 1998.

Noble, David. *Progress Without People.* Toronto: Between the Lines, 1995.

Rifkin, Jeremy. *The End of Work: The Decline of the Global Labor Force and the Dawn of the Post-Market Era.* New York: Tarcher/Putnam, 1995.

Rogers, Jackie Krasas. *Temps: The Many Faces of the Changing Workplace.* Ithaca: IRL Press, 2000.

Sachs, Karen B. and Dorothy Remy, eds. *My Troubles Are Going to Have Trouble with Me: Everyday Trials and Triumphs of Women Workers.* New Brunswick, NJ: Rutgers University Press, 1984.

Sennett, Richard. *The Corrosion of Character: The Personal Consequences of Work in the New Capitalism.* New York: WW Norton and Company, 1998.

Teeple, Gary. *Globalization and the Decline of Social Reform.* New Jersey: Humanities Press International Inc., 1995; Toronto: Garamond Press, 1995.

Terkel, Studs. *Working.* New York: Ballentine Books, 1972.

Resources

9TO5, NATIONAL ASSOCIATION OF WORKING WOMEN
231 West Wisconsin Avenue, Suite 900
Milwaukee, Wisconsin 53203-2308
(414) 274-0925
Job Survival Hotline: 1-800-522-0925
E-mail: naww9to5@execpc.com.
www.9to5.org

**INTERNATIONAL ASSOCIATION OF ADMINISTRATIVE
PROFESSIONALS (IAAP)**
10502 NW Ambassador Drive
PO Box 20404
Kansas City, Missouri 64195-0404
(816) 891-6600
E-mail: service@iaap.hq.org
www.iaap-hq.org

OFFICE WORKERS' CAREER CENTRE (OWCC)
365 Bloor Street East, Suite 1802
Toronto, Ontario M4W 3L4
(416) 415-4620
E-mail: owcc@officeworkers.org
www.officeworkers.org

TIMES CHANGE WOMEN'S EMPLOYMENT SERVICE
365 Bloor Street East, Suite 1704
Toronto, Ontario M4W 3L4
(416) 927-1900
E-mail: women@timeschange.org
www.timeschange.org

WORKING PARTNERSHIPS MEMBER ASSOCIATION
2102 Almaden Road, Suite 107
San Jose, California 95125
E-mail: temp@atwork.org
www.atwork.org

Index